The Vanishing Signs

The Vanishing Signs

Essays by

Cam Scott

ARP Books | Winnipeg

ARP Books (Arbeiter Ring Publishing)
205-70 Arthur Street
Winnipeg, Manitoba
Treaty 1 Territory and Historic Métis Nation Homeland
Canada R3B 1G7
arpbooks.org

Cover artwork and design by Scott Fitzpatrick.
Interior layout by Relish New Brand Experience.
Printed and bound in Canada by Imprimerie Gauvin.

ARP Books acknowledges the generous support of the Manitoba Arts Council and the Canada Council for the Arts for our publishing program. We acknowledge the financial support of the Government of Canada and the Province of Manitoba through the Book Publishing Tax Credit and the Book Publisher Marketing Assistance Program of Manitoba Culture, Heritage, and Tourism.

Earlier versions of several of the essays appearing in this collection have been previously published in *The Believer Logger, Berfrois, Blind Field Journal, Full Stop Newsletter, periodicities: a journal of poetry and poetics, The Poetry Project Newsletter, Social Text,* and *Sonder Magazine.*

LIBRARY AND ARCHIVES CANADA CATALOGUING IN PUBLICATION

Title: The vanishing signs : essays / Cam Scott.
Names: Scott, Cam, 1985- author.
Identifiers: Canadiana (print) 20220251150 | Canadiana (ebook) 20220251177 | ISBN 9781927886649 (softcover) | ISBN 9781927886656 (ebook)
Subjects: LCGFT: Essays.
Classification: LCC PS8637.C6833 V36 2022 | DDC C814/.6—dc23

Contents

Preface

The Vanishing Signs is a collection of essays on literature and social space written between 2013 and 2022. These pieces are occasional and occasionally fanatical, enacting the highest tribute that I understand as a reader, which is to extend the time of an artistic encounter indefinitely by attempting to think alongside a cherished work. Because these pieces were gifted separately to their various contexts, their means of demonstration often overlaps. An observation here suffices there; serendipity presides, as any book refracts its recent company. Patterns emerge, of an obsession or a practice, and this collection proposes to read those patterns in turn.

The essays themselves originate from book reviews, para-academic talks, solicited responses, and ongoing conversations. Written for unspecified publics prefigured by the company of friends, these works are for the most part unsummoned, and their only credential is enthusiasm for the text and the topic at hand. These topics include Dennis Cooper and the Sadean postulate of immortality; Guy Hocquenghem and the temporality of AIDS memoir; Renee Gladman's prose architectures and the graphological afterimage of language; Renata Adler's modular cosmopolitanism; Lyn Hejinian and the differential textures of avant-garde writing; David Lynch and the religious architecture of the detective story; Jordy Rosenberg and the political vocation of historical fiction; Harryette Mullen and lyric poetry in the age of logistics; and any number of tangents therein. If most of these essays commence from one of several influential theories of the novel, this is only because the exhibits under discussion together propose a non-standard definition of this technology, as a literary structure somehow homologous to its society. The novelism under examination here encompasses websites,

poetic daybooks, drawings, an opera libretto, and a TV show, among many other forms.

If this collection has a throughline, it would be the conviction that, because every work of art is socially beholden, literature discloses something of the world and politics upon which it depends. Beyond a standard symptomatic treatment that construes art as passively reflective of surroundings, rendering criticism a practice of recovering past presentisms, these essays were written in the belief that the material determinations of an artwork, literary or otherwise, manifest a conscious form of which disparate subjects partake. Artworks help us think about the world, not as a goad to agreement, but as modules of consciousness, a word for when the world appears to a knowing participant.

As literature can model social transformation, these pieces have two theses in common: that thought is not private, and nothing should be. The first of these is axiomatic and presumes the subject of thought to be constituted in and by language. The second issues a demand for a better world, prefigured by the general intellect of which this work joyfully partakes.

Zac Descending

The Attractions of Dennis Cooper

The novel may be morbid by design—its word-people held in place, passed from reader to reader, forced to return upon their every triumph and misfortune. And few writers revel in this fated stasis with the insistence of Dennis Cooper, whose prolific output tests the limits of both reader and receptacle. From *Little Caesar*—his iconic zine of the early punk era—to near-daily blog entries—graphomaniacal excavations of slacker esoterica—Cooper has been working at the sharp edge of various media for more than four decades, and his fiction likewise attests to the myriad vivisections of form.

At the junction of novelism and anthology, two executive attempts upon a wide array of cultural material, Cooper's visual novels—*Zac's Haunted House* and *Zac's Freight Elevator*—offer a shocking reply to a coy question: what can a novel do? Spanning technical epistemes in their uneasy legibility, these projects are assembled from hundreds of collected gifs, arranged suggestively in descending columns and chapters. Here reading enacts a falling rather than a turning, like a Choose Your Own Adventure without options. Discrete animations repeat on loop, a churning eternity unto their own; and yet, despite the clockwork fury of his presentation, Cooper has rarely seemed so playful in the course of his controversial career.

The reasons for this controversy are many and predictable. Cooper makes no apologies for the sadistic killers and fatedly vacant youth who people his pages, nor does he pathologize them. Moreover, in the world of Cooper's novels, gayness is de facto and unnamed, and never treated as a social difficulty in itself. In this sense, Cooper's works are

hopeless, but utopian. This relative autonomy is more likely to provoke the would-be censor than any explicit content per se. Nonetheless, Cooper's writing may be collated across time with a canon of literary transgressors who have been gradually assimilated to contemporary taste, including Genet, Bataille, Burroughs, Acker, and of course, prefiguring and in many ways exceeding all of the above in extremity, D.A.F. Sade. Cooper himself identifies a youthful phase of his own process with the Marquis in a bracingly plainspoken poem:

> When I started writing
> I was a sick teenaged
> fuck inside who partly
> thought I was the new
> Marquis de Sade, a body
> ready to communicate
> with Satan ...[1]

Sade's licentiousness may have been an impetus for a young Cooper to receive Satan into his prose, but this work isn't sadistic in a popular, adjectival sense. Cooper's novels hover uneasily alongside a continuum of properly Sadean literatures, treating fantasies of mechanical insistence and quantitative obsession, unrestricted by any standard of propriety whatsoever. However, as Leora Lev notes, "Cooper's writing styles and novelistic architectonics are more polychromatic and inventive than the aristocratic libertine's clear but notoriously wooden style and monotonous structures of orgy-disquisition-orgy."[2] Moreover, Cooper's work is an obsessional procession, suffused with angst, marking it apart from many strictly quantitative works of Sadean repetition. Both Sade and Cooper, however, revel in the sovereignty of writing, which allows for infinite torturous and permutatory designs upon the captors of the novel; and where accumulation and repetition are concerned, as formal means as well as themes, *Zac's Freight Elevator* considerably extends this sinister tradition.

1 Dennis Cooper, *The Weaklings XL* (New York: Sententia Books, 2013), 48.
2 Leora Lev, *Enter at Your Own Risk: The Dangerous Art of Dennis Cooper* (Madison and Teaneck: Fairleigh Dickinson University Press, 2006), 28.

Google/Books

A few preliminaries are in order when examining a book that isn't one, let alone a book which almost wasn't; so it's difficult to write about *Zac's Freight Elevator* without alluding to the circumstances of its near-destruction and subsequent recovery. The life of this work was endangered in 2016 when Google summarily deleted Cooper's email account and blog from their servers without warning. Cooper's email is nobody's business, for which reason its deletion should be everyone's concern. His blog, on the other hand, is a longstanding repository of queer, transgressive, and non-denominationally outré writing and criticism, perhaps one of the earliest examples of a serious engagement with the platform. Google's reasons for the confiscation went unstated for weeks, in which time petitions attracted the attention of high-profile and improbable supporters such as PEN America. Finally, months later and with little ceremony, the contents of both blog and email were restored, including the material comprising *Zac's Freight Elevator*, then in-progress.

Perhaps Google's attempted destruction of Cooper's work heralds a new, monopolistic era of censorship, in which a state-backed moral majority is less overtly threatening than the whims of private corporations. *Zac's Freight Elevator* would be a fitting riposte to this regime: sculpted from images in general circulation, the work is hardly more upsetting than the miasmal mass-kink of the web that spawned it. This collective inculpation is lost on Google, however, who ultimately have the ability to confiscate whatever content they wish. As usual, the greater threat to bourgeois order is organization; and Cooper's recombinatory authorship enacts an agenda or design, such that a popular assemblage may be prosecuted.

With this in mind, one might ask after the agency of the archive. It was a complaint about an image, Google claims, that caused Cooper's blog to be shut down in the first place. By comparison, there is a hermeticism to written language and the discrete book that resists the opprobrium of the conservative non-(or anti-)reader. The labyrinthine prose of *The Marbled Swarm*, Cooper's most obviously Sadean work, is defense enough against sensitive eyes. But the image is contaminating, instantaneous, accessible. Questions of legality open immediately onto

the matter of legibility; and Cooper's gif novels don't so much pose a problem to legibility as they open up this category to consideration, in which consists a kind of reading. Page over page, one is made complicit in the reproduction, for reading is an act of seeing that presumes interest; morbid, perhaps, only measured to taste.

Does this captive reading necessarily postulate a corresponding literature? Perhaps not in itself; but Cooper's gif novels provoke and extend this storied form in more than name. These are serialized and cumulative works, with recurrent characters and themes, in which key attributes of page literature are retained. Cooper thinks in paragraphs if not frames, despite evocations of filmstrip and social media scroll; and his selections of gifs are partitioned so as to preserve this suspenseful organization. The separate components work at cross-rhythms to one another, and the effect is nothing short of poetic conjuncture. Here ease of reading is a test of writing; and, as usual, deceiving. Pain, after all, begins in pleasure, and confusion in the threat of comprehension.

Writing Reading Writing

In 2014, artist Xu Bing produced *Book From the Ground*, a novel composed entirely of pictograms. "Twenty years ago I made *Book from the Sky*, a book of illegible Chinese characters that no one could read," Xu explains: "Now I have created *Book from the Ground*, a book that anyone can read."[3] The result may travel less well among the sighted than advertised, however, for some training is required to follow so many typographic elements and emojis; regularized placeholders of facial plasticity. Further, the total rebus of *Book From the Ground* depicts one day in the life of a white-collar worker; a quotidian sequentiality that lends itself to a directory of emotional traffic signs, whilst presuming the reader inured to a relatively arcane doldrums.

Similarly, Cooper's gif novels seize upon the expressive purposes of found images in order to elaborate upon them laterally, or vertically. But Xu Bing's workaday realism is all fixated surface, whilst Cooper's moving image exerts a different quality of fascination. As an ultra-condensed, often hyper-referential quotation, gifs more or

3 Xu Bing. *Book From the Ground* (Cambridge: MIT Press, 2014).

Fig. 1. Xu Bing, *Book From the Ground* (Cambridge: MIT Press, 2014).

less work as transferrable punchlines, nodal points of online discourse, reducing any foregoing text or conversation to a familiar joke. Much as Cooper's cult novels evoke the blackhole of sinister vacuousness belying counterculture, his gif works appear to seize upon the repetition compulsion implicit in this traffic of images, and by so many cuts and combinations, create a magically stalling tableau. Writing here is collecting and cross-referencing, a suitably obsessive and secluded pastime.

Without a stable set of actors, Cooper's recurrent characters are shapes, patterns, gestures, colours. Human cameos, interchangeably anime and flesh, are distant echoes of a type; so many worked-up auditions for the part of Expendable Boy. Like any good melodrama, *Zac's Freight Elevator* relies upon strong leitmotifs. Several moods predominate, and symbols recur in a kind of sight-rhyme; an x followed by a y followed by a z: a hand squeezes a lemon and rain falls acidly. These associative chains appear to follow a kind of dream logic, retracing the letter of an obsession. The unconscious trains upon concatenations such as these, as Freud demonstrates in "From the History of an Infantile Neurosis":

> Many months later, in quite another connection, the patient remarked that the opening and shutting of the butterfly's wings while it was settled on the flower had given him an uncanny

Fig. 2. Dennis Cooper, *Zac's Freight Elevator*, gif stills, (Kiddiepunk, 2016).

feeling. It had looked, so he said, like a woman opening her legs, and the legs then made the shape of a Roman V, which, as we know, was the hour at which, in his boyhood, and even up to the time of the treatment, he used to fall into a depressed state of mind.[4]

Such susceptibility to recurrence is already readerly. Literary critic Viktor Shklovsky's theory of narrative prose follows the work of Alexander Veselovsky, who defines the simplest unit of narrative in formal, and then imagistic, terms, as a repeatable motif. According to Shklovsky, however, the acculturated reader is automatized: "prepackaged" word-objects are "grasped spatially, in the blink of an eye," for the sake of expediency if not pleasure. The calling of art, Shklovsky then famously posits, is to de-automatize consciousness by elongating perception.[5]

Shklovsky focuses on methods of "deceleration" that work against the narrative current, a tension that affirms the inexorable direction

4 Sigmund Freud, *Three Case Histories* (New York: Macmillan Publishing Company, 1993), 282.
5 Viktor Shklovsky, *Theory of Prose*, trans. Benjamin Sher (Champaign, London, Dublin: Dalkey Archive, 1991), 5.

of a text. These are poetic tricks—sonic or thematic correspondences, rhythmical parallelism, tautology—and the sight-rhyme binding Cooper's gif novels spans these stalling methods. By Shklovsky's account, prose style disappears without inner impediment: and Cooper's visual prose is intransigent, that one may return upon each image, and each image itself may return; picturesque eddies at cross-rhythms to a narrative stream. Morbid continuity notwithstanding, each "page" or grouping of images rewards attention, as the gifs are of uneven length and undergo constant realignment over the course of sustained viewing. From time to time, the images appear to click in a moment of near-mechanical synchronization, but this too has the feeling of readerly serendipity more than laborious design.

This rhythmical synchronicity conveys literary to cinematic formalism, as *Zac* occupies a space between the two. Consider director Sergei Eisenstein's concept of "the attraction":

> An attraction ... is any aggressive aspect of the theatre; that is, any element of the theatre that subjects the spectator to a sensual or psychological impact, experimentally regulated and mathematically calculated to produce in him certain emotional shocks which, when placed in their proper sequence within the totality of the production, become the only means that enable the spectator to perceive the ideological side of what is being demonstrated—the ultimate ideological *conclusion*.[6]

One could enumerate the attractions of *Zac's Freight Elevator* to critical ends, as Eisenstein condenses the action of Ostrovsky's *Wiseman* into twenty-five exhibits, revealing a metaphorical system of the play. Of special interest here is Eisenstein's description of the "lines of action" connecting segments, and his method: "free montage of arbitrarily selected independent (also outside of the given composition and the plot links of the characters) effects (attractions) but with a view to establishing a certain final thematic effect—montage of attractions."[7]

Resonating with the content of Cooper's horror novels, Eisenstein's handiest examples of "attractions" are the gory vignettes of the Grand

6 Sergei Eisenstein, "Montage of Attractions," trans. Daniel Gerould, in *The Drama Review: TDR* 18, no. 1 (1974): 78.
7 Ibid, 79.

Guignol. And insofar as Cooper's gif selection constitutes an online "agit-Guignol," its succession of images is regulated not only to suggest a story, but to stimulate a plot-response in the reader. This extended reliance on found and prefabricated shocks draws out the ideological dimension of reception for examination, where the constituent elements of plot are apparent as so many affective nodes.

What Happened Next

The overture of *Zac's Freight Elevator* consists in line drawings and abstract forms, less vignettes than static mandalas—musica universalis, closed loops emblematic of a world at peace. An animated line drawing of a boy with tousled hair looks blankly up at the reader. "oh hi," the first words in the novel, scroll by in italics beneath his acknowledgement of our, or someone's, presence. Perhaps his under-elaborated beauty and reticence is the first sign that we are in a Dennis Cooper novel—a world in which beauty and fragility foreshadow sadness and death. The archetype ought to be familiar: George Miles's first appearance in *Closer* is sitting for a portrait: "Facial features appeared on the page as random shaky lines, fine as the hairs on a barbershop floor …

oh hi.

Fig. 3. Dennis Cooper, *Zac's Freight Elevator,* gif still, 2016.

John studied the portrait, then George's face, then the portrait, and made the eyes look like caves. It looked more like an ad for some charity. He tried to erase the eyes. The paper tore."[8] Or compare lines from the opening chapter of *The Marbled Swarm*: "So taken was I with the drab atmospherics and festive details of this crosshatched-seeming boy that I was caught quite off guard when his morose eyes rose just far enough to spot the bulge he had occasioned in my slacks."[9]

Chapter two commences with a colourful explosion. Metal vocalists and hurtling meteors recur, played against each other for relief, as assured extinction renders any millenarian subculture merely bathetic.

Fig. 4. Dennis Cooper, *Zac's Freight Elevator,* gif stills, 2016.

8 Dennis Cooper, *Closer* (New York: Grove Press, 1989), 6.
9 Dennis Cooper, *The Marbled Swarm* (New York: Harper Perennial, 2011), 5.

An occult causality conveys the gifs to sequence: one thing makes another happen, elsewhere. Pairings of halved faces advance like a flipbook, eyes fixed on a common disaster. All sad boys' eyes turn skyward, penitently: "SOMETIMES I WANT TO DISAPPEAR," one thinks, but the end times make suicidal ideation oddly less viable. Finally, a songbird, lighted on an American Ararat, prays for the reader: "I HOPE YOU FIND A WAY TO BE YOURSELF SOME DAY IN WEAKNESS OR IN STRENGTH."

The next sequence opens under a blood red moon upon the wages of survival. Pillared gifs depict scenes of debauch and subsistence, and when the final image announces that this is the end, the reader, without skipping ahead, knows this to be wishful thinking. True to this false promise, the most rhythmically incessant section follows: head-banging, foot-stomping, type-pounding, waves-crashing, fist-bumping, drum-beating, blood-spraying, car-crashing images collide the onlooker's eyes with mechanical insistence. Here the focus of the violence has changed; no longer visited indifferently upon a populace from on high, it is lateral, interpersonal, aimless, and frustrated.

The epilogue is a literal fall: gifs arranged in a solid black column descend the digital page, in the shape of an eponymous elevator shaft. A vacant-looking blond boy, fleshly counterpart to the sketch from chapter one, blinks his eyes in disbelief. Like Devon Sawa in the live action Casper movie, he is come of age, only too late. The moments of symmetry between chapters one and six are striking; blossoming flowers, line drawings of hands, and other modest signs of beauty recur; quotations from a simpler time. "The connecting moments, when there is no direct transition, are used as legato elements and interpreted as the varying arrangement of apparatuses …"[10] Then the archaic trope of the Singer, both Orpheus and Virgil of our journey, thanks us for coming "and, uh… shit," we're out. The penultimate image is a stroboscopic slide, the mechanism of the novel's constituent parts reduced to a binary assault on the senses, and then everything goes black.

10 Eisenstein, "Montage of Attractions," 84.

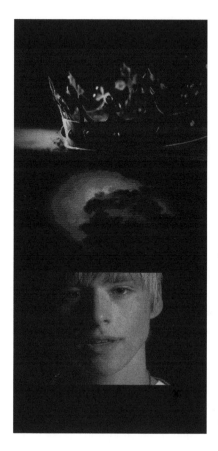

Fig. 5. Dennis Cooper, *Zac's Freight Elevator*, gif stills, 2016.

The Book Is Mortal

Cooper's visual work appears implicitly to understand and respond to the slasher film, plot points reduced such that happenstance is indiscernible from fate; much as the film consists in retrospect as several indelible scenes of stylized violence. Everything hangs on the anticipation and recollection of such scenes: the rest is a time capsule of teenage fashion and vernacular.

Filmic then, if not a film: if *Zac's Freight Elevator* is the least overtly homoerotic of Cooper's works, it would still be the easiest to masturbate with. Pornographic, properly Sadean, tendencies of Cooper's work

appear built into the gif itself, as it enacts a fantasy of infinitely repeatable, perfectible, death; of willful murder with indefinitely forestalled consequences; of meaningless acquiescence to the whims of another. Each discrete gif remains in its place, repeating indefinitely, even as one scrolls past the paragraph to which it belongs; and the same may be said of any sentence of a literary work. Says Shklovsky, "it is easy to see that, in addition to a progressive development, there exists in a story also a structure analogous to a ring or, rather, a loop."[11]

No work of experimental literature strains against progress so distractingly as Macedonio Fernández's *The Museum of Eterna's Novel*, a book boasting fifty-odd stalling prologues in order to stave off the painful separation implicit in every beginning. The author begins with a naive question: how is eternal love possible when everyone must experience death? Fernández affirms belief in an "eternity of Personal memory, individual memory, of all that once made up someone," the transcendental guarantor of which is not the author-function but the reader.[12] So the novel, for which one may imagine an infinity of possible readers, is a sentimental technology by which to immortalize the fleeting moment of the beloved. Fernández mocks the credulity of readers who suppose that characters have contrasting lifespans allocated them; rather, he says, "as people of fantasy, the characters all die together at the end of the story."[13]

There is an unexpected correspondence between Fernández's description of the novel as an immortalizing technology and *Zac's Freight Elevator*, composed of so many repetitious vignettes depicting global cataclysm and its frantic aftermath. Not only does each discrete interval of distress continue to repeat in a seconds-long loop after one "turns the page," these continue indefinitely in concert, and it is only within the finite totality of the book that these macabre dioramas attain to order, tempting closure. All told, it's difficult to imagine a more artful description of apocalypse than that we each die our miniature deaths, albeit together, at the end of the book. As Fernández writes, "the book itself is mortal."[14]

11 Shklovsky, *Theory of Prose*, 52.
12 Macedonio Fernández, *The Museum of Eterna's Novel*, trans. Margaret Schwartz (Rochester: Open Letter, 2007), 117.
13 Fernández, *The Museum of Eterna's Novel*, 11.
14 Ibid.

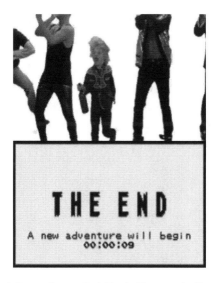

Fig. 6. Dennis Cooper, *Zac's Freight Elevator*, gif stills, 2016.

The not infrequent accusations of sadism levelled against Cooper and his peers also concern the nervous policing of a boundary between reader and author, a hazy distinction which Cooper specifically repudiates. As noted, the completist prodding characteristic of Sade misses much of Cooper's work, whose vivisectors are far less executive in their desires, often appearing lost, even loving, themselves. Hapless contingency is the rule: there is no moral system structuring encounter. George Miles is not quite Sade's Justine; though each remains immaculate over the course of their trials, there is a difference between pure passivity and improbable piety, let alone a would-be bottom and a wanting supplicant. In this sense, *Zac's Freight Elevator* and the body of work to which it belongs could be considered from the direction of masochism instead.

Karmen MacKendrick ventures a comparison between sadism and masochism as literary styles rather than personal dispositions: "Sadism (in the sense of Sadeanism) is the wild repetition of reason, Masochism of imagination, each preoccupied with the death instinct as fragmentation and stillness."[15] Sacher-Masoch's aesthetic is visual, MacKendrick continues, in a description that closely corresponds to Cooper's visual

15 Karmen MacKendrick, *Counterpleasures* (New York: SUNY Press, 1999), 57.

project: "The sequentiality of process and change, the movement of hearing, kinaesthesis, and to some extent touch, the developing and unfolding of words or acts in life or literature, interests him only insofar as it can be stopped. Masoch places the fetishistic elements of his images next to, not after, one another visually."[16]

Sadistic repetition is a practice of discursive reason, MacKendrick says, whereas masochistic repetition fixates on the image. So, one could suggest that while certain of Cooper's novels, *The Marbled Swarm* in particular, are indeed Sadean in their linguistic performance of endless justifications, *Zac's Freight Elevator* (and its prequel) comprise a masochistic counterpart to such abstraction. In 'Coldness and Cruelty,' Deleuze traces this distinction, as though to elucidate Cooper's project:

> Sensuality is movement. In order to convey the immediacy of this action of one soul against another, Sade chooses to rely on the quantitative techniques of accumulation and acceleration, mechanically grounded in a materialistic theory: reiteration and internal multiplication of the scenes, precipitation, over-determination ... The novels of Masoch display the most intense preoccupation with arrested movement; his scenes are frozen, as though photographed, stereotyped, or painted.[17]

In certain respects, the gif echoes the bygone arrangement of tableaux vivants, theatrical and pre-cinematic staples of the late nineteenth and early twentieth centuries. Both engage "the form or temporality of the fantasy" in its relative fixation, where a frame rules upon a relationship of figures. Like the tableau vivant, each gif is self-enclosed, asynchronous. Flesh falls off a face; an eye opens and closes. A narrative breach spans each pole of this binary, fort-da mechanism. This simple oscillation contrasts those gifs that appear to form a seamless loop—a rotary figure, a finger tapping ad infinitum—such that the image is eternalized in stasis. Sacher-Masoch's fetishism, as MacKendrick describes it, places visual elements next to, not after, one another; and Cooper elaborates an internal relationship of elements within a visual chain or sequence. *Zac's* best paragraphs enact a contemporized asynchrony, corresponding to the evocation

16 Ibid.
17 Gilles Deleuze, *Masochism*, trans. Jean McNeil (Brooklyn: Zone Books, 1989), 70.

by Deleuze of an image in which "all the elements (of a fantasy) are conjoined."[18]

Much like *The Marbled Swarm*, *Zac's Freight Elevator* is a readerly mystery. One must reconstruct the dissipation of a central character into a maze-like and megastructural dreamworld for oneself, moving between the hidden chambers of a sprawling manor or the "floors" that Zac's elevator doors open upon. Similarly, a masochistic thrill at convolution inheres in the tension between a multitiered plot and the incessant linearity of its presentation. One may not turn the page, but one scrolls: a slight gestural adjustment to the inspection of a bound totality, now unfurling a new destination in the moment of arrival.

End Timing

The Sadean text may inculpate the reader in its reasons, identifying their attention with the desire of the author-vivisector; but the masochistic text shows reason's aftermath, an imagistic résumé for sensual consideration. Reading Cooper, one feels voyeuristic, as though partaking in another's private fascination. The overall design, however, suggests that this compendium was arranged with an onlooker in mind; placing the reader on the side of many a hapless Cooper character, having stumbled upon something sordid and irreversibly upsetting. This masochistic excitation at the altar of an image, as distinct from the executive authorship of the Sadean book, poses a special kind of challenge to the archival regimes of Google and its governments, where algorithmically hierarchized information is at every moment operated by the arcane criteria of a given user's desire. All the information in the world still awaits interpretation, after all; as in montage, movement derives from an arrested totality.

This structural insight offers an important clue to Cooper's work, which charts the decomposition of a narrative body in its finality. By the time of *Period*, the final novel in the George Miles cycle, its eponymous fatality is an urban legend, a posthumous celebrity memorialized online by admirers, who tend to his memory repetitiously. Says one webmaster: "The George Miles Zone is nondesigned, like a high

18 Deleuze, *Masochism*, 72.

school year book. It's a square grid of thumbnails, showing 'George' in several outfits, locales, and emotional states. Scrolling down, there's a link to my index-in-progress of characters, scenes, dialogue, and ideas."[19] Here George is lusted after as an index, and the living theatre of his memory, updated fantasy by fantasy, consists over the course of so many sensual "attractions," as montage. The anthologist explains: "my fascination lies not in 'George''s myriad problems, per se, but in the novel's tricky, ulterior form."[20] Naturally, this living index requires the fixity in death of its adored subject. Likewise, *Zac's* cataclysmic action seems to respond to the narrative requirement that teleologically, we the written are already dead. Given the millenarian mandate of the age, Cooper's novel feels especially timely: less a survival guide than a compendium of ecstasies attendant on descent.

If Sade were to have his way, nobody would survive the book, nor would they die—to which indefinitely delayed end, Fernández's novel seems to coincide with Heaven as envisaged by the Talking Heads: "There is a party, everyone is there. Everyone will leave at exactly the same time." Conversely, consider the soft sadism of Luis Buñuel's *The Exterminating Angel*, which depicts a dinner party that no one can leave, try as they might. Like Buñuel, like Sade, Cooper's hospitality is total; no less so for that the event and the invitation are both in a book.

19 Dennis Cooper, *Period* (New York: Grove Press, 2000), 45.
20 Ibid, 49.

Book-Sex and Multi-Specificity

Drive at the End of History

In 1981, Los Angeles-based publishers Semiotext(e) released *Polysexuality*, an iconic omnibus culled by the post-Lacanian psychoanalyst François Peraldi. Designed for maximum provocation and divided into sections such as "Soft Sex," "Child Sex," "Violent Sex," "Corporate Sex," and "Philosophical Sex," Peraldi's selection intersperses articles of transgressive literature with variously heady staples of the genre that Semiotext(e) would help to consolidate in North America as "French theory." Along the way, the reader hears from regal cannibals and coprophagous human pets, archaic punks and their attentive sitters, dazzling sophisticates of the total clinic. Tearful excerpts from Georges Bataille's wartime journals concerning the death of his partner and accomplice, Laure, nestle a court transcription of the prosecution of a homosexual, implying a proximity of grief to judgement. According to Peraldi's introduction, the collection represents a multi-authored indication of the "real of sex"—the death drives (plural in Peraldi's writing) obverse to any erotic pursuit. These drives, writes Peraldi, impel the practice of politics, too: "from cover to cover, this whole issue is nothing else, in our opinion, than the textual working through of this thesis."[1]

Commencing in self-directed reverie, with Pierre Guyotat's exquisite account of masturbation as a kind of ur-writing, *Polysexuality*

1 François Peraldi, ed. *Polysexuality* (New York: Semiotexte, 1995), 11.

immediately proceeds by displacement. Sex is the impossible, desire founders and flourishes upon the impropriety of any and all approach. Thus the collection sorts itself by specialization, even as the scandal of its chapter headings consists in the implied indifference of their objects in the final instance. The implicit hierarchization (we begin with "self sex" and through animal and alimentary mediations arrive at the apex of "critical sex") appears mock-dialectical, as the gradual sublation of content proves to have been but sublimation all along; so many subjective thematizations ultimately resolvable into an impersonal oblivion.

The logical difficulty with anthologizing transgression is that methodological perversity precludes and contradicts the desire of each and every exhibit, where one understands perversity to necessarily retain the normative standard that it (normatively) contravenes. Mandatory aberration, or total deviance, is not only impossible but, despite its many object specifications, hopelessly abstract. Throughout, the book elides the effete effrontery of actually existing homosexuality in favour of extreme proclivities, where a poetic principle conveys one exhibit to the next, skirting specifics so as to render multiple practices homogeneous in their common antagonism.

In a long note on masochism, Peraldi offers a broad definition of polysexuality: "an infinitely diversified sexuality which constitutes the potential sexuality of every body."[2] This sexual metaphysic is attributed to Freud rather than Spinoza, where sexuality names an affection of the absolute, refuting every dualism:

> We are not really interested in the restrained sexuality of our psychoanalysts; our aim is to give shape to a new notion—polysexuality—and to describe the many processes through which polysexuality becomes a "fact of life." Such processes are totally alien to classical oppositions: man/woman, husband/wife, homo-/hetero-, active/passive, etc. … In fact, they have to be studied along certain lines of increasing intensity: violent sexualities, visual sexualities, liquid sexualities, alimentary sexualities, obese sexualities, etc. Considered along these lines, polysexuality determines a new cut-up of the city as well as of the erotic body of people, independent, on the one hand, of

2 Peraldi, *Polysexuality*, 168.

the opposition of classes and, on the other, of the biological opposition of sexes.[3]

Several contradictory assertions cleave this passage, which signals at least as many metanarratives of ontological strife, sexual difference, and class war, in order to conflate their alleged simplicity. Peraldi proposes sexuality to map onto a contestable civic space, sutured by the social form of the enclave. This urbanistic thesis grounds an otherwise disorganized attempt to speak aggregately to "the real of desire"; but it can hardly be asserted that these social settings of desire, however furtive, are innocent of capitalist social relations. Peraldi himself is forced to qualify the autonomy of the pervert, spatially and conceptually: "Contrary to what Sade tells us in *Les 120 Journées de Sodome*, the pervert does not need a deep and dark cave to have kinky sex, far from God's sight; he simply walks along the streets, taking sufficient precautions to avoid both police and 'pervert hunters.'"[4]

The non-competitive contemporaneity of the pervert and the neurotic heterosexual nevertheless requires an urban strategy of separation, and throughout Peraldi's anthology, one can't help but notice the omnipresence of a police. If the pervert is a neighbour, he remains a criminal, which is the far more salient category where the two coincide. Moreover, the "lines of increasing intensity" along which Peraldi proposes to study the facts of desire are typically vectors of criminalization, such that a new master dichotomy appears to overrule all of the differences that polysexuals proliferate—that of the hunter and the hunted. Then is polysexuality, as a proposed term for the unlimited potential of the body, an effective synonym for perversity, necessitating restraint?

Félix Guattari's provocative call comprises a kind of meta-thematic centrepiece in this regard. Homosexuality, Guattari says, enacts a kind of corporate secrecy against straight morality, in which respect it remains a perversion, despite well-intentioned attempts by progressives to redeem homosexual practices as an equal but alternative object choice. Then there are instances of "avant-garde" or militant homosexuality, in which "homosexuality confronts heterosexual power on its

3 Ibid.
4 Ibid.

own terrain."[5] Between these cultures, something like Frantz Fanon's dialectic of decolonization transpires—co-dependency superseded by confrontation. Of course, Fanon's sketch anticipates an autonomous cultural expression, one no longer addressed, however elliptically, to one's oppressor, whether in seeking approval or exacerbating conflict. Guattari, however, collapses back into abstraction; proposing a molecular purview that looks for similarities among "all forms of sexual minorities once it is understood that in this realm there could only be minorities."[6]

This superficially solidaristic statement encapsulates the mandate of *Polysexuality*, sans Thanatic teleology. Guattari disaggregates gay collectivity, alongside every other enclave of desire, in a libertarian manoeuvre that re-entrenches bourgeois civil society as a minoritizing apparatus. Where everyone is a single minority unto themselves, only those whose identity already consists in the repression of particularity as such, or its supremacist hallmarks, are empowered to avail themselves of individuality and its benefits. However singularly we elsewhere consist, Guattari's poetic program of political psychosis implicates the social as a tyrannical falsity, rather than a site of creative traction.

Peraldi's overarching thesis emphasizes the most intimate extremity, a deathly denominator in light of which any vivacity presents ironically, at best. In its macabre literalization of the Freudian death drive, *Polysexuality* appears as a memento mori, scarcely concerned with the lived conditions under which one must experience, and defend, desire. The universality of drive reduces politics to one perversity among many, lamentable for its normative aspirations. This contempt for organization, which is not without its own eroticism, permeates the collection, even tragically. As Peraldi writes: "The death drives, which centrificate politics, have been presentified in this text by images of political disasters, massacres, genocides, crimes of war: our daily lot. The theory of catastrophes is at the very core of the theory of politics and it has to be thought of as giving shape to this other side of libido."[7]

What then is the political situation that this anthology must pathologize in order to repress? Two catastrophes with special bearing on this

5 Peraldi, *Polysexuality*, 86.
6 Ibid.
7 Ibid, 12.

> THIS PUBLICATION IS AN EXACT REPRINT
> OF THE ORIGINAL EDITION PUBLISHED
> IN 1981, EDITED BY CANADIAN
> PSYCHOANALYST FRANÇOIS PERALDI,
> WHO DIED OF AIDS ON MARCH 21, 1993.

Fig. 7. Colophon to the 1995 edition of *Polysexuality*.

material intervene between the first printing in 1981 and the second in 1995. Firstly, the collapse of the Soviet Union brought about the unprecedented delusion in the capitalist core of the end of politics. In 1981, Peraldi could take for granted the idealized non-rapport broadly descriptive of the Cold War, an impossible-to-consummate intercourse encapsulated in the slogan of Mutually Assured Destruction. This would bring us full circle, for just as the symbolic intervenes against the impossibility of a sexual relationship, desire in its morbidity proliferates extreme positions.

The second intervening condition is the AIDS crisis, which particularly afflicts the proliferation of "minority" positions valorized and otherwise ignored by Guattari. Over the course of this decade in particular, the social and material mediations of cloistered collectivity that Guattari romantically repudiates assert themselves with genocidal bearing. Peraldi's locutions would seem glib were they not reinscribed as a troubling stamp of authenticity. Already by 1995, the second printing appears as a time capsule and precise facsimile; the colophon itself becomes a cenotaph for the book's editor.

By no means falsified by tragedy, *Polysexuality* nestles alongside all manner of affirmatively seedy cultural ephemera of the nineteen-eighties, and encapsulates many classics of this era itself. Together, these index a distinctly American moral panic—such that the book was wielded in the United States Congress as a prop in a highly theatricalized culture war. This alone attests to the political stakes of the terrain on which Peraldi and his publisher, Sylvère Lotringer, sought to intervene—even evading the obscene requirements of representation by attempting to anthologize the unrepresentable, or "drive." In one sense, the project was always destined to run aground on the shores of

the normal; offering, at last, a highly original theory of straight society by way of its discontents.

More importantly, perhaps, *Polysexuality* endures as a formal argument, luxuriating in an historical pact of the anthology form with all manner of deviant content—variety conveyed to a moral readership. As Peraldi offers, "*Polysexuality* is not only a set of texts written by carefully chosen authors and illustrating the plural aspects of sexuality. *Polysexuality* is a text in itself, the editors of which are the authors."[8] However dissembling of authority, Peraldi's suggestion of an auto-anthologizing textbook surely accounts for whatever aura hasn't rubbed off of the book today—a criminal fraternity in words, less separate than convicted.

8 Ibid, 11.

The Hospital of History

Reading Guy Hocquenghem's
The Amphitheater of the Dead

Few figures of the French left are as non-forthcoming in posterity, let alone English translation, as Guy Hocquenghem. Author of the influential monograph *Homosexual Desire* and a founding member of le Front Homosexuel d'Action Révolutionnaire, Hocquenghem both preconfigures the ascendance of "queer theory" as a specialization, and frequently appears to reject many of its projects and positions in advance. Hocquenghem's theses remain fiercely personal, which befits his cause; for sexuality baffles the empty universality of much political address, insofar as it introduces a contingency with the urgency of a demand: homosexuality, and not just homosexuals, appears to *want something* by way of desirous redress.

This tension crystallizes a compelling theme of Hocquenghem's work—desire itself as an historically produced situation, to which his living subject is obliged. Homosexual desire, the namesake of his influential text, does not exist, Hocquenghem insists, except *a posteriori*. "Capitalist society manufactures homosexuals just as it produces proletarians, constantly defining its own limits."[1] This is not, however, a homology upon which the project of a gay communism might come to rest, for in Hocquenghem's description, both subjects are produced by a set of conditions to which they are eventually opposed, but not identically.

1 Guy Hocquenghem, *Homosexual Desire*, trans. Daniella Dangoor (Durham: Duke University Press, 1993), 50.

More valiantly than many sexless philosophers, Hocquenghem grappled with the situation of the derived individual, and what this means in particular for those whose desires are prosecuted. In a sense, Hocquenghem stands out amongst his fellow soixante-huitards as a theorist of identity, however reluctant, rather than of action, and his contrarianism may even derive from this difference in emphasis. Furthermore, this obliges Hocquenghem to questions of both narrative and style—crucial operators of gay identity, the terms of which must be recreated in an adverse society.

Then one quarrelsome guise in which a present readership inherits Hocquenghem is that of a self-styled revisionist. How could one live otherwise, Hocquenghem appears to ask, when the content of experience is largely unforeseeable, and politics entails a certain fidelity to form? Elsewhere, in an existential turn of phrase, Élisabeth Roudinesco describes the political heroism of those philosophers who risked the futurity of their oeuvre in submission to historical circumstance. Under pressing conditions, the necessity of action excludes any psychological subject altogether, Roudinesco claims, thus producing a tragic figure.[2] In Hocquenghem's caustic appraisal of May 1968, a worse fate befalls the individual in the aftermath of a perceived defeat: "there's no longer any point in acting, struggling, writing, cries the tragic voice."[3] Hocquenghem describes a reactionary post-history, a non-age of scarcely differentiated flows. Here, without a revolutionary signifier, "*there is no subject at all.*"[4] And yet, this double-edged requiem to militancy can't but attribute despair, to a voice that cries out as a witness to a thwarted event.

Inanticipation

Such a voice narrates Hocquenghem's posthumous memoir-of-sorts, *The Amphitheater of the Dead*, written in 1988 on the author's deathbed. Set in the year 2018, thirty years after the author's death from

2 Élisabeth Roudinesco, *Philosophy in Turbulent Times: Canguilhem, Sartre, Foucault, Althusser, Deleuze, Derrida*, trans. William McCuaig (New York: Columbia University Press, 2010), 13.

3 Guy Hocqenghem, "Volutions," *baedan: a queer journal of heresy* 2 (Seattle: baedan, 2014): 193.

4 Ibid, 191.

complications of AIDS, the book is billed as an "anticipated memoir," predicting a future in which HIV is a manageable condition and an object of biopolitical investment rather than a death sentence. This strange futurity commends these recollections to our present, where palpable advances in treatment and prevention have realized Hocquenghem's modest science fiction. At the same time, his words resonate as a bittersweet cenotaph, for these improved standards are no benefit to their prophesier.

Hocquenghem produced this manuscript within weeks of his death, which final burst of creativity he transposes to the twilight of a Biblically allotted lifespan: "I'm 70 years old. For thirty years, I've believed I'm going to die tomorrow, or at least in the next three weeks; I don't know why, but this delay is the exact measure of my medical misery."[5] The question of subjective measure drives the obsessive fulminations of the text. As a young man, Hocquenghem explains, he had vowed never to live past forty, a post-Rimbauldian goalpost for precocious youth who wish posterity to be visited upon their gorgeous years. This quintessentially literary fallacy, where by never growing old one may remain forever young, motivates this text at its fantastic basis: "Writing saves," the dying author explains. "Doctors are experts. The drive which is at the origin of a book assures a whole lifespan. You don't die while writing a novel."[6]

This wishful temporality not only resonates with the existential predicament of being toward death, but shapes the fated text, set to terminate upon the author's "next infection."[7] A paradoxical aspect of the autobiographical drive reveals itself here; for life-writing is largely conditioned by the interval of composition, and the uneventful time of retrospection can't encompass the eventuality of trauma, even in anticipation of its wake. Writing arrests the interregnum. Symptomatically perhaps, Argentine writer Macedonio Fernández describes his ideal book as an immortalizing technology, "a mnemonic personal eternity," within the bounds of which nobody dies.[8] In this respect, the novel

5 Guy Hocquenghem, *The Amphitheater of the Dead*, trans. Max Fox (New York: Guillotine Press, 2019), 21.
6 Ibid, 29.
7 Ibid, 30.
8 Macedonio Fernández, *The Museum of Eterna's Novel: The First Good Novel*, trans. Margaret Schwartz (Rochester: Open Letter, 2010), 59.

enacts what physical love cannot—it secures the immortality of the beloved alongside that of the author.

Hocquenghem describes his post-dated memoir in amenable terms: "In the end, my literature will look like my life, borrow the remains of my life, which has fictionalized itself for thirty years already," he states with mortal certainty.[9] This pre-novelized alternative reality forms the personal basis of Hocquenghem's testament, which could not be other than it has become: "It's why, a little cruelly, I say sometimes that my youth was the only youth the world has known, even until now."[10] If Hocquenghem's vocation ensures his survival, as both author and object of text, the terms in which his character's lover, R., responds to his diagnosis are revealing: "the most enraging thing is that, in ten years, you would have become a popular novelist," R. fumes immodestly on his partner's behalf, a funerary Alice Toklas.[11] In the alternative 2018 that Hocquenghem projects, he is become just that: a celebrated author, knowingly embarked upon his final project.

This authorizing purview places the writer, nevertheless mortal, somewhat at odds with and outside of history. At some length Hocquenghem describes an elderly survivor who has lived for decades in and out of care: "the whole hospital staff knew his history; and as they knew he was a writer, a warm atmosphere of understanding gentleness surrounded him as soon as he passed through the examining room doors. After all, if anyone other than death could say they were at home in the hospital, it was him."[12] This fantasy, of a mutual recognition that transpires between technicians of the body and the self-appointed chroniclers of its affairs, poignantly miniaturizes Hocquenghem's grander claims as to a pact between physical endurance and social posterity.

Chance and Identity

"I don't believe people die until they've done their work," remarks W.H. Auden, "and when they have, they die. There are surprisingly few incomplete works in art. People, as a rule, die when they wish

9 Hocquenghem, *The Amphitheater of the Dead*, 32.
10 Ibid, 35.
11 Ibid.
12 Ibid, 51.

to. It is not a shame that Mozart, Keats, Shelley died young: they'd finished their work."[13] This sounds superstitious on one hand, setting aside that the vast majority of people on the earth choose nothing of their circumstances, and simply truistic on the other. It feels dubious to suggest that the potentiality shored in the living person John Keats could exceed his capacity for its realization; to restate Auden's provocation atheistically, one might say that anything Keats didn't write, he couldn't have.

This mock-Hegelian circumspection feels impossible to maintain in the cases of death from AIDS, however, which differ from other, less collective forms of political assassination. From a tragic perspective, politicized death has the effect of post hoc historical conscription where a popular response confers narrative necessity to an otherwise senseless state of affairs. Something else transpires in the case of AIDS, however, where the popular capacity to respond is itself threatened. The mortal subject of this affliction is collective life itself, or such was the morbid teleology of the height of the plague; which continues in many communities with genocidal salience today. In the penultimate chapter of *Homosexual Desire,* Hocquenghem theorizes a group formation "stronger than death" because it supersedes the individual: "The homosexual subject group—circular and horizontal, annular and with no signifier—knows that civilisation alone is mortal."[14] And yet he wrote in a moment when civilization threatened to outlive its homosexual antagonist.

This affliction of the social also threatens any literary solution. What is a book without a reader, what is a tragic hero with no chorus? And if tragedy, as per Lacan, is an effect of beauty on desire, what chance is there for any heroism that isn't of the other? For Hocquenghem and Auden alike, narrative appears to lend necessity to happenstance; whereas in the cases of death from AIDS, one confronts an irremediable contingency. Naturally, all deaths are truncating and desolatory; but AIDS shows us something of the fateful situation of the desiring subject *whose desires are socially foreclosed.* Desire is not an ahistorical posit here, but conditioned. Tragedy designates the alignment by which one selects actions rather than outcomes, and where the

13 W.H. Auden, *Lectures on Shakespeare,* ed. Arthur Kirsch (Princeton: Princeton University Press, 2002), 296.
14 Hocquenghem, *Homosexual Desire,* 147.

latter remains at every moment unthinkable within the logic of the former; a situation within which subjective necessity contradicts any practical agenda.

Much as the rhetorical gambit insisting that queer life is auto-originating and pre-social—that one is "born this way"—obviates choice, making one a passive object of both desire and advocacy, plague logic sutures one's identity to a means of suffering. In both cases, identity is mediated by the terms of a terrible social-historical obstacle to one's (well-)being; and wherever there appears a tension between being and identity, universal and particular, a living person is likely to proceed by the latter term. Put otherwise, no one would die for anything if they didn't have to die already; and no one would come out of hiding if one didn't have to choose to become what one already is.

The thought of AIDS—nearly unapproachable from a subjective standpoint, that of desire—obliges one to consider contingency within a logic of identity. It might have seemed for a long, terrifying moment to a generation of queer forebears that the wages of identity were death; but in no way was this ordained, nor in the final instance chosen. Nevertheless, the identity of homosexuality with suffering appears at a certain point in the history of its repression with the cynical persuasiveness of syllogism. Throughout the seventies Hocquenghem describes this expectation as a straight fantasy which manifests real effects and places the homosexual in contradiction to society. In 1972, this contradictory identification was the proposed site of a horizontal revolution. By 1988, however, Hocquenghem's political reality resembles a palliative stasis, even corroborating the image of the suffering homosexual and moreover, posing serious questions as to the stakes of reform as a means of survival. In *The Amphitheater of the Dead*, Hocquenghem plots the becoming-thinkable of AIDS, its liveability and sociality, which necessarily corresponds to a twofold acceptance, much as the AIDS epidemic visibilized prejudice.

Homosexual Desire

For all this, many fascinating passages of *The Amphitheater of the Dead* concern the same conceptual difficulties described in *Homosexual Desire* more than fifteen years earlier—namely, the relation between

identity and politics. Recalling his youth, our narrator is not politicized by homosexuality; rather, to take him at his word, he is homosexualized by political activity during the nineteen-sixties, insofar as both commend transgression. This trajectory produces novel combinations in itself: as Hocquenghem confesses, "we had no idea of anything, of homo- or heterosexuality; only vice interested me."[15] Refreshingly and frustratingly, the co-theories that issue from this spirit of experimentation are not seamless: "I have never stopped living in two registers," Hocquenghem insists: "Homosexual on one side, militant on the other, and later writer and invalid, I always had something to hide from half of my relations."[16]

To Hocquenghem, even the prospect of "sexual liberation" appears falsely conciliatory: "I became a leftist, like I became a homosexual, to belong to the Circle," he avers in a self-pathologizing bout of explanation.[17] Nonetheless, his desire to be the opposition of the opposition appears less mercenary than flirtatious; no sooner than the reader begins to feel frustrated at this caginess, there appears a heartbreaking passage in which Hocquenghem is confronted by a homophobic comrade about his sexuality and plays Peter to his own proclivities: "a response I am still ashamed of a half-century later," he writes.[18]

The figures upon which a budding sexuality fixates metamorphose over the course of the author's recollection; a misaddressed letter of recommendation handed to a teacher soon to be a lover, an unexpected death and a consoling proximity, the excitement of the barricades, experimentation with a panoply of substances. "This is what frightens me about life's choices: they are such fruits of chance and habit."[19] Breathtakingly, without an afterword, the memoir ends in the midst of a chemical bacchanal in California, an absent signpost of the author's passing. This non-ending secures one of the "surprisingly few incomplete works in art," attesting to the unfinishable negativity of its author's being.

15 Hocquenghem, *The Amphitheater of the Dead*, 60.
16 Ibid, 64.
17 Ibid, 84.
18 Ibid, 89.
19 Ibid, 84.

Beyond Finality

In the work of David Scott, contingency entails acquiescence to finitude.[20] Scott refines his essentially tragic thinking of contingency in a one-sided correspondence with the late Stuart Hall, for whom the concept was decidedly more open. Both thinkers agree, Scott says, that contingency entails a slight to agency; but much depends on how one opposes its relative circumscription. Where Hall counsels *practice*, oriented toward a common goal or horizon and in hopes of making history, Scott opts for the heroizing incomprehensibility of *action*, undertaken in relative ignorance of its ramifications.[21]

Hocquenghem himself grapples with the temptation to manifest heroism in the form of an act: "when I am certain, or at least very sure, for whatever reason, because one can irrevocably condemn oneself to dying imminently, then … Then, I will undertake a courageous act that stuns the world and makes me feel like I haven't been useless."[22] Adapting Roudinesco's terms, one might suggest that this terroristic fancy falls considerably short of heroism, for the dreamer holds too much of himself in reserve. The pure act that Scott and Roudinesco have in mind knows nothing of forethought, practicality, or punctuation. One can no sooner imagine a cathartic finish as transpiring for oneself than one can assimilate the unthinkable to thought; the negation of one's person never arrives as a companion.

But Hocquenghem's subject position effectively refutes Roudinesco's initial description of tragic praxis, for the vexed position of the homosexual in politics—pre-martyrized, at this point—changes the meaning of sacrifice. In Roudinesco's description, a political situation may require that one sacrifice desire to history; but Hocquenghem's homosexual desire attempts precisely to evade this fatal limit, and there is something profound about the way in which he insists on the primacy of his written oeuvre and the suffering and community to which it attests.

The Amphitheater of the Dead is in some sense a way for Hocquenghem to fantastically evade the contingency of death—Scott speaks of one's

20 David Scott, *Stuart Hall's Voice: Intimations of an Ethics of Receptive Generosity* (Durham: Duke University Press, 2017), 55.
21 Ibid, 81.
22 Hocquenghem, *The Amphitheater of the Dead*, 30.

"last conjuncture"—projecting himself into a future that proves all too thinkable. The text then reinscribes the life that it depicts inside of history; and this banalizing drive, directed at the day-to-day, may even contradict the solitude of death and deathly acts.

Perhaps the eponymous amphitheater, a dissecting room that our ailing narrator visits in the days leading to his death, stands for a similar endeavour to the immortalizing work described above: "The dead, in the amphitheater in question, constitute not the audience but the spectacle itself, incessantly renewed, where one never performs more than once."[23] In this, Hocquenghem not only asserts his own personal finitude, but movingly conveys the irredeemable time of one's final performance to the fate of others gone before:

> No matter; pushing open the pre-war steel doors pierced by portholes and entering the vast room with its glaucous light, I saw all my dead reunited, not somber and silent but agitated, breathlessly chirping, thrilled to see each other again.[24]

This overseeing viewpoint doubles as an invitation, welcoming comrades to an alternative society of those missing and excluded from the present time. Such a reunion is not simplistically wistful, nor does it only reflect a literary will to immortality. One might suggest that Hocquenghem presents the reader with an eerie afterimage of political utopia, where the finite body and its often painfully proscribed desires endure as meaningful representation; of an extra-bodily politic rejecting separation for amorous congress. Neither tragedy nor literary haunting, Hocquenghem's text requests at least this much optimism of the time in which it is set.

23 Ibid, 20.
24 Ibid.

"What characterizes a god?"

On Robert Glück's
Margery Kempe

"In the 1430s, Margery Kempe wrote the first autobiography in English. She replaced existence with the desire to exist," writes Robert Glück.[1] And in the early nineteen-nineties, Glück wrote *Margery Kempe*, a fictionalization of the would-be saint's life, shot through with anecdotes of the narrator's own contemporary love affair. Although the intervening centuries impel comparison, Glück's *Margery Kempe* depicts the transhistorical affinity of lovers at the end of time, conveying the eschatological fervour underwriting a Medieval scenery to the ambient fright of the AIDS epidemic and its constant aftermath. In collating these lover's tales, Glück himself offers a compelling instance of memoir-as-self-replacement. Just as Kempe's desire outlives her historical existence in writing, Glück backdates his own desirous being by some five-hundred years, offering her life as an interpretive gloss on his own.

From the first pages of *Margery Kempe*, Glück revels in the salacious details of his retelling; his Margery is sexually assertive, sensuously avid, awaiting the arrival of Jesus Christ in her life with unrequited conviction: "If Jesus had not abandoned her, would she be so vehemently attracted?"[2] In explicit prose, Glück narrates Margery's relationship

1 Robert Glück, *Margery Kempe* (New York: New York Review of Books, 2020), 3.
2 Ibid, 8.

with Jesus, interspersing anecdotes of his narrator Bob's contemporary dalliance with the wealthy, beautifully aloof L., whose single initial stands for both tell-all veridicality and a gossip's restraint. As an amateur Medievalist with scandalous designs upon his source text, Glück is in good company. In 1993, one year prior to the appearance of *Margery Kempe*, poet Catriona Strang published *Low Fancy*, an experimental rewriting of the Carmina Burana, an anthology of lascivious poetry and song compiled by Benedictine monks in the eleventh and twelfth centuries. At moments, Strang's writing within this treasury could furnish Glück's sexual pilgrims a credo: "Characterized by a bitter antisacerdotalism and a certain love of SPEED, the wanderers' constant vigilance produced a dangerous abundance of interceptions, and pigmented the imagination of an entire century."[3]

Indeed, a reconstructed Medieval imaginary has proven useful for all manner of transgressive art. In the nineteen-seventies, Pier Paolo Pasolini's films used this scenery to allegorize an extant class society and its sexual mores, offering an overripe physicalism as the reflection of spiritual hypocrisy. Earlier still, Georges Bataille, a trained medievalist, maintained an essentially religious dualism throughout his fiction, in which desire tortures a body that it must eventually outstrip. In a 1941 story, *Madame Edwarda*, the narrator fatally pursues a sexual relationship with God in the shape of an aging sex worker; and while she sacrifices her body to this encounter, her client, in a twist straight out of a Medieval morality tale, exposes his soul totally.

Text-Metatext

What of the Middle Ages does *Margery Kempe* retain and adapt? From a Jewish standpoint, wary of Christian martyrology, Glück adopts the mystic's expectation of ecstatic physical rapport with Christ. Adapting variously esoteric doctrines of physical incarnation, Glück uses the scaffold of religious experience to present a vivid account of romantic love as a structure of lack and supplication. In Kempe's original account, she keeps company with Christ, whose palpable presence forbids physical excess: "boldly clepe me Jhesus, thi love," he instructs

3 Catriona Strang, *Low Fancy* (Toronto: ECW Press, 1993), 19.

her, "for I am thi love and schal be thi love wythowtyn ende."[4] In Glück's imitation, however, the arc of Kempe's life is rewritten as a sexual encyclopedia, and her relation to Godhead as a rotating tryst. In this updated version, the pleasure of God in his subjects models a bodily jouissance, transcending phallic sexuality—and the narrator's present-day dalliance is captioned accordingly, as a feminine desire. As Glück's narrator, Bob, writes:

> I perform my story. By lip-synching Margery's loud longing but I wonder if that visible self-erasure is just a failure to face L. I want to be a woman and a man penetrating him, his inner walls rolling around me like satin drenched in hot oil, and I want to be the woman and man he continually fucks. I want to be where total freedom is. I push myself under the surface of Margery's story, holding my breath for a happy ending to my own.[5]

Bob's longing borrows body and volume from Kempe's precedent, but this is no masquerade. Rather, as the lover has no body of their own but may be gratified only through the beloved, Glück's narrative affair requires the mediation of another, and thus appears a lustful supplement to someone else's scripture. For this reason, and others readily perceptible, *Margery Kempe* becomes a touchstone of queer experimental writing.

This prosocial cause was vigorously pursued by the group of writers identified with New Narrative, a tendency with which Glück's name is virtually synonymous. Formalized in a Bay Area writing workshop during the nineteen-seventies, New Narrative begins as a movement of experimental writing with a particular interest in sexuality as textuality; as a candidly queer reply to the contemporary undertakings of Language writing; and above all, as a communal endeavor. This community extends between texts, too, as many early New Narrative experiments involve a "writing-through" of literary precedent: with his friend Bruce Boone, Glück produced a rewriting of the fables of La Fontaine in 1981; and important works by Steve Abbott and Dodie Bellamy gesture to Samuel Johnson's *Lives of the Most Eminent English Poets* and Bram Stoker's *Dracula* respectively.

4 Lynn Staley, ed. *The Book of Margery Kempe*, https://d.lib.rochester.edu/teams/text/ staley-book-of-margery-kempe-book-i-part-i.
5 Glück, *Margery Kempe*, 49.

In his *Long Note on New Narrative*, Glück credits Boone with the elaboration of its trademark mode, "text-metatext." In such writing, a running narrative appears with a parallel level of commentary that "asks questions, asks for critical response, makes claims on the reader, elicits comments ... In any case, text-metatext takes its form from the dialectical cleft between real life and life as it wants to be."[6] This cleft encompasses Kempe's writing too, at least in Glück's description, which renders her in terms amenable to his own program. Between existence and desire, real life and the life-to-be, Glück posits the consistency of writing, as a body other than his own. It's hard to imagine a more appropriate intertext for this demonstration than the biography of a Medieval mystic, who claimed physical visitations from the Holy Spirit, and who took upon herself the proprietary task of biblical exegesis in spite of her professed illiteracy.

Words Made Flesh

In her study of the historical Margery Kempe, Karma Lochrie proposes that the mystical memoirs of the Middle Ages exemplify a "feminine writing of the body"; how so? According to Lochrie, women of this era were identified not with the body but with the flesh, as a sensuous impediment to bodily communion with the spirit. In her description, this corporeal surplus both "threatens the masculine idea of the integrity of the body," and forms the basis for the mystic text, which construes the author herself as a medium of transformation.[7] The mystic, Lochrie says, makes claim "to a privileged language, the Word made flesh and uttered through the flesh," thereby entering into an affinity with Christ, in whom the spirit is legible.[8]

Infamously, Jacques Lacan describes Medieval mysticism as a feminine enterprise, opposing a world of imputed essence under the banner of the not-all; which is otherwise to say, supplementing positive appearances from a standpoint of desire, or lack. As for this feminine or

6 Robert Glück, *Communal Nude: Collected Essays* (South Pasadena: Semiotext(e), 2016), 17.

7 Karma Lochrie, *Margery Kempe and Translations of the Flesh* (Philadelphia: University of Pennsylvania Press, 1992), 6.

8 Ibid, 45.

mystical jouissance, "it is clear that the essential testimony of the mystics consists in saying that they experience it, but know nothing about it."[9] From this description, it would seem that mystical experience must necessarily elude the text to which it appears dedicated.

Somewhat differently than Lacan, Lochrie situates the woman mystic at the threshold of signification: "she seeks to transgress the limits of a language which is hopelessly exterior and which excludes the marvelous," frequently citing the insufficiency of language before experience.[10] In the fourteen-thirties, one might say, Margery Kempe sought to replace the inert word of social convention with a physical transmission: "*Je* pushed out, then *sus*, inward and under her tongue," Glück writes, the name spanning inside and out, becoming breath. In Margery's pronunciation the two syllables of Jesus' name blur into the private incantation that "I am."[11]

By its own account, Glück's novel is deeply concerned with the bodily mediation of writing, as well as the constructed threshold between man and woman, body and soul. But Lochrie's suggestion of a somatic writing, closely identifying the feminine with an abundance of bodily self-evidence, risks inverting the phallic order of appearances to the temporary benefit of an historically female—rather than feminine—subject. Lacan, by comparison, locates the feminine position within a structure: that of love, for example, in which nothing is exchanged but exchange itself. This permutating relationship, of supplementary rather than complementary elements, drives the many transformations of *Margery Kempe*. "Gender is the extent we go to in order to be loved," Glück writes; and this dynamic description, admitting joy in partiality, approaches Lacan's meaning when he speaks of feminine jouissance as belonging to the body. One shouldn't, however, presume to know anything of the body under question.[12]

Rather than chastely devoting herself to the idea of Christ, Margery not only receives but reciprocates Jesus' touch. In this sensory communion, Margery adjusts the feminizing asymmetry of courtly love—

9 Jacques Lacan, *The Seminar Of Jacques Lacan Book XX: Encore*, trans. Bruce Fink (New York: W.W. Norton, 1999), 76.
10 Lochrie, *Margery Kempe and Translations of the Flesh*, 47.
11 Glück, *Margery Kempe*, 6.
12 Glück, *Margery Kempe*, 57.

a complex of Medieval conventions whereby an admirer professes unconsummated love for a noblewoman beyond his standing, modelled on the hierarchies of feudal and religious society at once. Lacan describes such distant loyalty as a "highly refined way of making up for the absence of a sexual relationship, by feigning that we are the ones who erect an obstacle thereto."[13] In Bob's affair, it's clear that this devotional curve serves L., whose wealth and inaccessibility only compound Bob's idealization. The Godlike distance of the beloved from their idolater is superimposed onto an actual geography: L. lives on the opposite side of the country inasmuch as he lives anywhere, thus securing "his larger existence, the imperative that meaning stay with him, the mobility to retreat from the deep surrender he inspires."[14]

In a note from 2000, Glück explicitly proposes that this unequal arrangement is compounded by, and reflected in, the present society: "L.'s ruling class status equals the divinity of Jesus," he explains.[15] This adds a compelling layer of interpretation, where the non-relationship of the lover and beloved initiates love, as capital mediates the non-relationship of the working and ruling classes. This comparison would come as no surprise to Lacan, who describes the constitutive asymmetry of desire as producing "surplus jouissance," going so far as to claim that Marx discovered the symptom before Freud.[16] Contrary to the expectation that a power differential must obtain between unequal essences or symbols, Lacan reminds us that it must be constantly reproduced as a relation over the course of its parties' employment. For Lacan, pleasure is always on behalf of the other; and insofar as they occupy this position, both L. and Jesus live off the desire of their admirers. "Jesus does not miss Margery," one reads, "though he seems to need her."[17]

Christ the Modernist

These themes are elaborated throughout Glück's first novel, *Jack the Modernist*, published almost a decade prior. Like *Margery*, *Jack*

13 Lacan, *The Seminar Of Jacques Lacan Book XX: Encore*, 69.
14 Glück, *Margery Kempe*, 12.
15 Ibid, 167.
16 Jacques Lacan, *The Seminar Of Jacques Lacan Book XVII: The Other Side Of Psychoanalysis*, trans. Russell Grigg (New York: W.W. Norton, 2007), 75.
17 Glück, *Margery Kempe*, 48.

exemplifies a staple subset of New Narrative—the Novel of Unrequited Love as Vehicle for Sublimatory Digression. Similar in function to L., the eponymous Jack is effusive, well-liked, comprehensively read, but emotionally unavailable; and Jack's asymmetrical relationship to the narrator, Bob, incites the novel, from its indelible first sentence ("You're not a lover til you blab about it") to its dishy end, dispensing heart-sick with a kiss-and-tell insouciance. The earlier novel even appears as a point of reference in *Margery Kempe*, when L. quippingly addresses "Bob the Moronist," mocking at the author's romantic credulity without addressing his own typecast counterpart.[18]

Over the course of this book, Bob traverses the fantasy of Jack—the Lover-Intellectual, the proficient Modernist—arriving at an image of castration so anticlimactic in its literality as to lampoon the foregoing anguish. Jack claims that he has been sexually remote because he's afraid of Bob's profligacy at the baths; after their breakup, Bob finds out that Jack had contracted gonorrhea from a fling, and was instead withholding out of embarrassment and a secretive consideration for Bob's health. The punchline, 'gonorrhea,' is a trifle, and like every late arrival retroacts a fatal absurdity upon a novel's worth of escalation.

"What used to be my sex appeal/Is now my water spout," Bob recites, a bit of phallic doggerel for Jack in his authoritative absence. This there-and-gone-again refrain repeats in different playful registers: "Seize the day, I said to Jack, remember death."[19] The schoolboy Latinisms of this plea are obverse in their superegoic obscenity; go on and live, you'll surely die. The metaphysical assumptions of this text are less explicit; but much like the figure of L./Jesus in *Margery Kempe*, Jack's enjoyment requires distance. This absent presence underwrites a series of sexual adventures that give body to longing, at the same time as the author's longing overreaches any actual person available to its purposes, of which Jack remains the unwitting—and unwilling—beneficiary.

Remember death, runs the Latin instruction; both a stoical reminder to enjoy the moment and a Christian platitude regarding the life to come. *Jack the Modernist* is a paean to the deindividuating effects of sex and obsession, and a robust defense of the deathly as it bears on desire. Notably then, the novel precedes the AIDS epidemic by several years,

18 Ibid, 67.
19 Robert Glück, *Jack the Modernist* (London and New York: Serpent's Tail, 1995), 123.

permitting a metaphorical treatment of these themes. In a heartbreaking afterword from a 1995 reissue, Glück describes his own retreat from bathhouses and cruising spots, the book's facilitating scenery, as the virus ravaged his community. For this reason, any contemporary reading is bound to feel haunted in retrospect. Certainly Jack's bacterial imbroglio comes as an extra shock in its benignity, an ironic token of sexual innocence; and the religious morbidity of Glück's metaphorical language assumes an added weight in light of what's to come.

The Place of the Skull

As Margery aims to lose herself crossing the distance between two irremediably separate entities, "to be engulfed but to retain that loss of self in the memory of her skin," her capture of the moment is death-hued, too.[20] And Glück's ventriloquizing of Margery, on the basis of her ecstatic's knack for "self-erasure," enacts a miniature oblivion in writing. As quoted above: "I want to be a woman and a man penetrating (L.), his inner walls rolling around me like satin drenched in hot oil, and I want to be the woman and man he continually fucks. I want to be where total freedom is."[21] This echoes the mortal concerns of *Jack the Modernist*, in which Bob glosses his pleasure with an illustration, C. Allan Gilbert's *All is Vanity*:

> Getting fucked and masturbated produces an orgasm that can be read two ways, like the painting of a Victorian woman with her sensual hair piled up who gazes into the mirror of her vanity table. Then the same lights and darks reveal a different set of contours: her head becomes one eye, the reflection of her face another eye and her mirror becomes the dome of a grinning skull/woman/skull/woman/skull—I wanted my orgasm to fall between those images. *That's not really a place.* I know. The pious Victorian named his visual pun 'Vanity.' I rename it 'Identity.' I relinquished the firm barrier that separated us—no, that separated me from nothing. I might have liked to shoot for boundlessness but when I get fucked in the ass that rarely happens, it just spills.[22]

20 Glück, *Margery Kempe*, 132.
21 Ibid, 49.
22 Glück, *Jack the Modernist*, 55.

Compared to the similar passage from *Margery Kempe*, this fantasy is less bisexual than sacrificial; omni-, and not inter-, personal. Even so, "total freedom," or "identity," is placed athwart sexual difference, as the property of the other, whose enjoyment is a formal output of own's own incompleteness or desire. Strikingly, Glück places this threshold between one and the same person, in the realm of their own fantasy, rather than between two equal or complementary partners. Furthermore, the earthly attempt at boundlessness "just spills," shy of its impossible target.

In *Vanitas*, one sees another figure of the other-as-threshold for desire; for this is how the conventional sign of death works in the visual allegory that Glück regards at length. Gilbert's memento mori places the gaze in a manner not unrelated to Holbein's *Ambassadors*, which so fascinated Lacan. By comparison, the skull in Holbein's portrait is not only concealed, but appears to be floating distorted, separated from or rending pictorial space. In this respect, the skull no longer functions as part of a standardized vocabulary, placed in accordance with convention, but *does* what it otherwise *says*, severing the image from itself.

Likewise, the optical illusion of Gilbert's illustration dynamizes the allegory. The appearance of the skull, looking at the viewer as they are looking elsewhere in the opposite direction, marks an entirely excessive aspect of the representation that "reflects our own nothingness, in the figure of the death's head," Lacan writes.[23] Such an apprehension of Holbein's image, however, requires a shift in position, as the painting uses the "geometral dimension of vision" to capture the subject in its trap.

As a visual puzzle, *All is Vanity* requires no such physical displacement of the viewer. Rather, its surprise works on a similar principle as the famous duck-rabbit illusion, which Ludwig Wittgenstein used to mark the difference between "seeing" and "seeing-as." The latter optic, according to Wittgenstein, is practically superfluous except in the case of doubtful reinterpretation: one doesn't say that one sees something as a rabbit or a skull, for example; one simply sees a rabbit. The grammatical doubling that occurs in cases of ambiguous or multiple interpretations occasions creativity. "'Seeing as …' is not part of perception," Wittgenstein asserts, but it makes the world flare selectively

23 Jacques Lacan, *The Seminar of Jacques Lacan Book XI: The Four Fundamental Concepts of Psychoanalysis*, trans. Alan Sheridan (New York: Norton, 1977), 92.

Fig. 8. Allan Gilbert, *All is Vanity*, 1892.

before one's ken.[24] Theologian John Hick adapts this demonstration as a touchstone of his religious epistemology; expanding on the simple "reapperception of a puzzle picture" to present a multi-faceted notion of "experiencing-as."[25]

According to Hick, religious faith entails an attribution of meaning to available experience, such that nothing more than reality is required by way of evidence. In this way, Hick explains religion as a subjective decision: "knowing God" is a particular experience of the world, in spite of which "there is no extra person, whom we call God, in addition to the world."[26] This differs from pantheism, however, for the worldly phenomena under examination need not be regarded as divine in itself. Rather, the world appears to the believer "*as media of*

24 Ludwig Wittgenstein, *Philosophical Investigations*, trans. G.E.M. Anscombe, P.M.S. Hacker, and Joachim Schulte (Chichester: Wiley-Blackwell, 2009), 207.

25 John Hick, *Faith and Knowledge: A Modern Introduction To the Problem of Religious Knowledge* (Eugene: Wipf and Stock, 2009), 143.

26 Hick, 144.

God's activity towards him." In Glück's novel, Margery expresses as much in effluvial detail: "All we know of the external world is our own shit, piss, tears, sweat, spit, snot, come, pus, babies, and sometimes blood," and yet, "flesh was not all flesh but partly appetite."[27] Desire gives something to experience, non-additively; for, as Lacan says, "if beyond appearance there is nothing in itself, there is the gaze."[28]

Returning to Glück's gloss on the ghostly boudoir, one might observe a difference between getting fucked and getting fucked-as, where the latter, transitive verb describes the kind of de- and re-subjectivation during sex that Bob craves in each of the passages above. With Hick's God and Lacan's gaze in mind, one could describe the difference in terms of attendance; for the desire that remediates experience on sight is never one's own, but an attribute of the other. Moreover, the oscillating image ("skull/woman/skull") is "not really a place," one is told, but a process; and the most interesting transformations that occur over the course of *Jack the Modernist* and *Margery Kempe* are not of a relationship itself, but of a lover's manner of relating to a non-relationship.

Exacting Turmoil

In Margery's quest after Jesus, the metonymic substitutions driving religious devotion attain to fleshly autonomy of their subject, offering a fantastic solution to an impasse of phallic sexuality. In one explicit passage, the lovers explore one another's bodies with mechanical versatility: "they pushed fingers inside each other and strummed as though trying notes till they located the nerve of an exact turmoil."[29] For love's purposes, Jesus wears an orifice in his side for the devotee to feel and see: "Jesus's asshole seemed like a flaw that drew her attention more than the beauty it marred, till finally the flaw became an expression of herself by dint of her struggle."[30]

Perhaps everyone is a doubting Thomas in lust, demanding sensory verification of a wishful rapport. On this principle of transmutatory

27 Glück, *Margery Kempe*, 137.
28 Lacan, *The Seminar of Jacques Lacan Book XI*, 103.
29 Glück, *Margery Kempe*, 15.
30 Ibid, 15.

attraction, any detail excerpted from the body carries a powerful charge. Margery all but indirectly quotes Stendhal on the limitations of beauty, who speaks of the concentration of attention on the blemish as a token of reality; an example of what Lacan calls objet petit a. "Beauty can only supply us with probabilities," Stendhal writes, "while the glances of your mistress with her small-pox scars are a delightful reality, which destroys all the probabilities in the world."[31]

Our narrator's present-day fixation on L. charts a related movement—from the limitless abstraction of attraction to an acquisitive specificity. The effects of fascination are paradoxical, however; for the process by which the beloved is selected from a world of beauty requires the further abstraction of a trait from the beloved, by which they may be represented to desire. Accordingly, the object that negates the secular, or probabilistic, world not only functions as sensible media of the other—it metonymizes the lover's desire, rather than the body of the beloved per se. Posing demurely with his cock out of his pants, "L., as Jesus" taunts our narrator: "L.'s cock testifies to the human form he chose," Glück writes of this earthly incarnation—"so strange to him that he will not let me touch it, as though keeping co-conspirators from meeting."[32] Describing L.'s endowment as a collaboration, Glück reminds us directly that only desire can make a phallus of human form.

A Trinity in Two Parts

In this account, love is essentially dualistic, giving something to reality that cannot be deduced from appearance. Bob calls his friends to actuate his love: "In the theaters of their consciousness I stage my drama," he writes: "That my love for L. is possible, actual. That my joy exists. Interaction shifts the ground of the finite … Margery turns the cosmos into the witness of her love."[33] A fantastic co-theory issues from this social appeal, whereby Glück's friends are identified with the whole of divine creation, summarizing his earthly joy from above. As Bob the Moronist might say, you're not a lover 'til you blab about it; for language affords the next best thing to spilling.

31 Stendhal, *Love* (New York: Penguin Books, 1975), 68.
32 Glück, *Margery Kempe*, 118.
33 Ibid, 12.

Lacan attests to this witnessing function when he insists that God surely exists, if only as a formal requirement. God, Lacan suggests, exists as "the third party in this business of human love," triangulating the one and the other so as to impel attraction.[34] God then names a condition of encounter, marking the necessity of symbolic intercession between two irremediably separate beings. Bob's fervency of belief, maintained with a little help from his friends, parallels the physical ecstasy of Margery with Jesus, who is God's body, after all; and to suggest that Bob's community mirrors that of God is to extrapolate queer kinship from one of the kinkier articles of Christian faith.

In Saint Paul's epistle to the Ephesians, husband and wife are described as one flesh. The church submits to Christ as wife to husband, and a body redeemed thereby—"that He might sanctify and cleanse it with the washing of water by the word."[35] Karma Lochrie has this Pauline doctrine in mind as she details the feminine bearing of the flesh, quoting Saint Augustine: "Your flesh is like your wife ... Love it, rebuke it, until it is made into one harmony, one bond [of flesh and spirit]."[36] In this analogy, Lochrie explains, the feminine remains unrepresentable until bonded with the word.

That the conjugal body of an upright couple models the correspondence of a social body to God sets a physical precedent for religion, and Glück takes the marriage motif to extremes. On November 9, 1414, Glück writes, God the Father is married to Margery. "Daughter, I'm glad," God tells her, "especially because you love the manhood of my son."[37] This double entendre offers a startlingly literal affront to the trinity, which maintains the identity of God the Father and his human incarnation. Thus Margery's desire for Jesus' manhood, or his member—"the strongest pleasure that can exist occurred in Jesus's cock"—represents devotion to the Father, whom she marries in his stead.[38]

This bifurcated home life corresponds to the structure of patrilinear marriage rite. Margery, "more like a human spy than a bridge," can

34 Lacan, *The Seminar Of Jacques Lacan Book XX*, 70.
35 Eph. 5:26 KJV.
36 Quoted in Lochrie, *Margery Kempe and Translations of the Flesh*, 19.
37 Glück, *Margery Kempe*, 74.
38 Ibid, 70.

only fuck the body, or the son; as she can only marry spirit, or the father. Likewise, to marry is to take another father's name, for want of an errant, or actual, copy. As for the terms of their marriage, "the father, Mary, and Jesus were reversible; they juggled amongst themselves the conditions that defined Margery: daughter, wife, mother, her need for money, her mortality, her desire."[39] Glück wields the doctrine of identity as a feminist allegory of domestic life, where Margery's enrolment in the Holy Family divides material interest from subjective desire, as different aspects of the same relationship. "Now she's wedded to Jesus, but father and son decline to remember which is which."[40] Relatedly, in Lacan's account of surplus jouissance, it is God himself who enjoys.

The Writers Who Love Too Much

The two obsessive affairs blur somewhat in the narrator's account— Jesus, after all "had L.'s Scottish face"—but for the most part, one plot explicates the other at a distance. "How can the two halves of this novel ever be complete?" the author asks incredulously.[41] Perhaps there is no relationship between the two, only a space of difference, suffused with desire; a gulf motivating identification. In her voraciousness, Margery appears both prototype and composite of Glück's coterie, laughingly designated by L. as "the Writers Who Love Too Much."[42] Furthermore, her mystical conversions correspond to the ambiguities of gay social life centuries hence: as Glück writes, "the tension between masculine-feminine and inside-outside pervades all levels of my community."[43]

By way of Margery's travels, Glück finds flashes of a liminal community amid a company of disassociated pilgrims; and with the worldliness of one cast to the street, Glück's Margery makes a religion of her raw experience: "Margery had not founded an order like St. Bridget or promoted church reform like St. Catherine. She looked for glimpses of Jesus in handsome men on the streets of Rome."[44] This invested derivation of religion has a textual complement, as well; for

39 Ibid, 76.
40 Ibid, 77.
41 Ibid, 41.
42 Ibid, 137.
43 Ibid, 48.
44 Ibid, 75.

just as Margery bases her image of Christ on a survey of her social surround, their sexual escapades borrow shape from Glück's peers, from whom he solicited morsels of personal description: "I asked my friends for notes about their bodies to dress these fifteenth-century paper dolls ... My friends become the author of my misfortune and the ground of authority in this book. We are a village common producing images."[45]

Glück's choice of words alludes to the village collective as a productive unit, and to the modicum of traditional rights that communities enjoyed under feudalism, prior to the land enclosures that definitively ended the Medieval world that Margery inhabits. (One of the earlier significant uprisings against enclosure, Kett's Rebellion of 1549, took place in Norfolk near the place of Kempe's birth.) In this quick comparison, Glück suggests that the bourgeois novel enacts a privatization of the world it depicts, as he sets out to redistribute his authorial prestige. In the village novel of his suggestion, Glück dotes on these descriptions, quoting from flesh as a painter might enlist a model, and luxuriating in a surplus of erotic trivia. On both counts, the author's arousal exceeds the requirements of religious allegory.

Stigmata

At the same time, Glück takes license from the anatomically baffling and frankly pornographic detail of Medieval depictions of Christ. Margery's contemplation of Christ surpasses religious merit: "She liked skinny men and wanted to climb his body like a ladder."[46] Reciprocating her excitement, he fingers himself provocatively: "Jesus shoves two fingers between the lips of the wound in his side. He was not in pain; he aimed his tight excitement at Margery as he exposed himself."[47] Sumptuously, Glück sexualizes the various devotions that attend the Holy Wounds, as the suffering Christ becomes a vehicle of God's own exhibitionism; in which, as Lacan explains, "what is intended by the subject is ... realized in the other."[48]

45 Ibid, 90.
46 Ibid, 37.
47 Ibid, 37.
48 Lacan, *The Seminar of Jacques Lacan Book XI*, 183.

Reading Julian of Norwich, Lochrie suggests that the wounds of Christ comprise a memory system, upon which a devotee may physically train their faith.[49] This psychosomatic affinity manifests a conduit between bodies, exemplified in the various stigmata worn by mystics in their deepest sympathy with Christ. In the fourth and final section of *Margery Kempe*, the crucifixion parallels Bob's break with L., and Margery herself bears the searing pain of Christ's final hours: "she was ripped in two: half of her was the absent Jesus."[50] Just as love intervenes where there is no relation, this feeling of absence finally connects the pair.

Hélène Cixous—whose *écriture féminine* is prefigured in the mysticism of Margery Kempe, Lochrie suggests—theorizes a lacerating, painful paradigm of writing that she calls the 'stigmatexte.' Describing the relation of literature to incident as that of a scar to a wound, Cixous counsels her reader to cultivate inscription from experience: "in fleeing, the flight *saves* the trace of what it flees."[51] Thus writing purposes itself at an object with resurrectionary zeal, ultimately asking passage of the very time it would repair. Without the distance that permits relation, and the difference underwriting repetition, suffering is prior to inscription. As Glück relates, of Bob's pain by way of Margery's pathos, "it was too soon to bind this injury with strands of language—to make it inevitable, normal. She was just a wound."[52]

This mystical account of textual attraction establishes Bob Glück in relation to Margery Kempe as Margery Kempe stands in relation to Jesus Christ; as a distant admirer writing in bodily overlay, swapping physical attributes across time. Margery becomes the literary principle, or term of non-relation, by which faith and love are possible: "She had access to the body of Jesus—that is, belief in the value of life and such ecstasy as my corruptible tongue cannot express. I reconstruct the memory of that access as a ruin, a hollow space inside meaning, a vehicle for travel. Still, Jesus can lift me out of time to be his lover."[53]

49 Lochrie, *Margery Kempe and Translations of the Flesh*, 34.
50 Glück, *Margery Kempe*, 146.
51 Hélène Cixous, *Stigmata*, trans. Eric Prenowitz (London and New York: Routledge Classics, 2005), xi.
52 Glück, *Margery Kempe*, 49.
53 Ibid, 161.

Love in Space

The Christological pretense of this break-up novel permits, and perhaps entreats, the reading reproduced above; but even as love beckons transcendence, the options for its expression are historically conditioned. While the novel's eroticism enacts a timeless blur between subject positions, Glück vividly involves the reader in the historical circumstances of Margery's pilgrimage, if only to pursue further comparison. Specific dates and details punctuate Margery's travelogue, corresponding to civil wars and crusades, to an accelerating slave trade, and other territorial conquests. Such material detail relativizes Margery's religious quest, situating her self-overcoming in an all-too-real world that cannot be circumvented by the immediacy of divine transcendence. "She looked up in surprise. It was 1420; experience was crumbling."[54]

In this moment of surprise, an intimation of historicity threatens subjective coherency, and opens onto the indifferent externality of material reality: "It amazed her that pleasure was so mechanical, so located in space."[55] Margery's love itself becomes an object in history, however otherwise fantastic; pursued by plague and circumscribed by patriarchal offices, of lecherous mayors and faithless friars. Furthermore, Margery's historicity obliges Glück to clarify his own:

> Margery lived during the Hundred Years War, the collapse
> of feudal systems, and the plague. Towns had walls; at night
> the gates shut. At the beginning of modernity the world and
> otherworld lay in shambles. Margery was an individual in a
> recognizable nightmare: the twentieth century will also be
> called a hundred years war.[56]

Written in the early nineties, during the salad days of neoliberal hegemony and at the height of the AIDS crisis, *Margery Kempe* glosses innumerable crises of politics and personal experience at once, if obliquely. Along her journey, pilgrims pay Margery to entertain them: "Two ladies of quality love each other entirely," one story begins. "One of them falls sick with plague and desires to see the other, who will

54 Ibid, 133.
55 Ibid, 133.
56 Ibid, 31.

not come, fearing catching it."[57] After her death, the afflicted party appears to her lover, as a final goodbye and a forerunner of illness. This story fantastically portrays plague law as impediment to, and therefore proof of, physical love, where only death and its preparations can separate two wholly devoted lovers.

In the present day of Bob and L.'s affair, Bob explains that "L. has joined ACT UP and does AIDS graphics. I encourage, approve—he needs some human scale in his life. I also take part in political demonstrations, but I aim my desire for freedom at myself and L. in the form of total arousal."[58] In this passage, beyond which AIDS is scarcely mentioned, Bob opposes the rapport of activists to that of lovers; but the condition of this comparison is that, if only as a terrible contingency, these stations refer to a common adversary.

The difference between *Margery Kempe* and *Jack the Modernist*, post- and pre-AIDS, is marked; where the earlier novel is dialogue driven and highly episodic, moving from gathering to gathering, bathhouse to bar, and rendering the author's community in anecdotal form, *Margery Kempe* interprets a relatively secluded love affair through the experience of a distantly bygone interlocutor, whose ecstatic religious conversion established a one-to-one relationship with Jesus Christ; an historically furnished experience that nonetheless posits itself outside of history as such. In a reflective essay, entitled "HIV 1986," Glück summarizes the culture that furnishes *Jack the Modernist* its backdrop:

> In short, it was gay community—well organized, inventive, imperfect, equipped for urban life in the seventies and eighties, and subject to its pluses and minuses. Unlike older communities, ours thrived in an urban setting, in commercial institutions like bars and baths and cafés; it added its own chapter to the history of love in those decades. What other population could respond to urban anonymity by incorporating it into the group's love life as anonymous sex? To the degree that my own aroused body expressed the sublime, it broke every social contract, while invitation to the sexual act unified a community and was its main source of communication,

validating other forms of discourse. As we created the community it taught us a new version of who were, then we became it. Such a shift in perception about oneself is almost mystical.[59]

This mystical reorganization of the self certainly describes *Margery Kempe*, and underwrites the author's transhistorical affinity with Margery herself. Perhaps the mysticism of *Margery Kempe* proceeds upon the tremendous social specificity of *Jack the Modernist*, though each is present in the other, as a kind of retreat from the conditions of anonymous conviviality described above; in which case the attributed cameos of friends' bodies take on a daring significance, insisting on the possibility of physical love.

Eroticism

Of all the obstacles to love that this book stages in order to overcome, or at least to symbolize, mortality remains the most persuasive. At the outset of his study of eroticism, Georges Bataille writes that for humans, "discontinuous beings that we are, death means continuity of being."[60] This deathly ecstasy, however, obviates social being altogether, as another expression of the super-human desire for continuity. Glück celebrates this striving above, describing a tension between sublime arousal and the social contract. For this, Bataille affirms, "eroticism can only be envisaged dialectically, and conversely the dialectician, if he does not confine himself to formalism, necessarily has his eyes fixed on his own sexual experience."[61]

The contradiction that Glück names, between desire and the state, is not quite a restaging of the contradiction between the individual and the collective, except insofar as the life of the collective often requires the death of the individual ego. (Bataille speaks of the religious necessity of "dying to oneself.") In Glück's description of gay social life, civic deindividuation even hones desire. All of these stakes, of course, were exaggerated and actualized by AIDS with a cruelty too acute for commentary, and perhaps the initial phase of New Narrative

59 Glück, *Communal Nude*, 237.
60 Georges Bataille, *Eroticism*, trans. Mary Dalwood (London: Penguin, 2001), 13.
61 Ibid, 254.

concludes with the foreclosure of some staple tropes regarding limitless transgression. "AIDS creates such magnitude of *loss* that now death is where gay men experience life most keenly as a group," Glück writes in a moving summation of this era.[62]

This, perhaps, is where *Margery Kempe* confronts and eludes the stakes of its moment. The religious scaffolding is not simply an allegorical means of relating a love story, but a structure of feeling appropriate to the ravages of contemporary experience, conditions of which are crumbling before the author's eyes. Where these tribulations are concerned, the novel's eroticism is ineluctably escapist, separating the individual from the world if only to surpass this distinction altogether; and Margery's Christian lexicon is once again an historical contingency, standing for something far more basic in the way of demand.

For Bataille, "flights of Christian religious experience and bursts of erotic impulses [are] part and parcel of the same movement"— from separation to communion—and Glück's novel surely agrees.[63] Discussing the importance of sexual excitement to mystical experience, Bataille decrees the mystic to have ascertained the identity of life and death, pleasure and pain, at once. This creed furnishes *Jack the Modernist* its central illustration, and Margery her calling. But just as eroticism recommends death, love demands everlasting life, and the implication of one in the other makes the Christian worldview useful to Glück's work of longing. As Margery writes of Jesus, or Bob writes of L., "intimate touch made a promise of immortality."[64]

Ironically, eroticism only names so many fantastic solutions to the absence of a sexual relationship. But L., Glück reminds his reader, is "the god of non-relation," in which role he compels desire absolutely, such that longing suffuses Bob's entire world.[65] As Bataille writes in the preface to *Madame Edwarda*, frustration brings us back to God as supplicants; "yet this God is a whore exactly like all other whores. What mysticism cannot put into words (it fails at the moment of utterance), eroticism says; God is nothing if he is not a transcendence

62 Robert Glück, "HTLV-3," in *A Sulfur Anthology*, ed. Clayton Eshleman (Middletown: Wesleyan University Press, 2015), 233.
63 Bataille, *Eroticism*, 9.
64 Glück, *Margery Kempe*, 61.
65 Ibid, 161.

of God in every direction."[66] It is only because eroticism is a mode of experiencing-as—of seeing God in the world, however otherwise vulgar—that L., who may himself be nothing other than a common flake, becomes a principle of life.

If *Margery Kempe* has any religion, it would surely be as antisocial as Bataille's. But Glück's desires, one might add, are too historically beholden to permit any such metaphysical obscurantism with respect to their object. One may designate the needful standing of its narrator by any of its historical names, but Glück's novel commends itself to everyday use by its keen sense of the social vicissitudes of desire, which are both structuralized and situated throughout. "This novel records my breakdown," Glück admits: "conventional narrative is preserved but the interest must lie elsewhere. Like L., Jesus must be real but must also represent a crisis."[67] By this, Glück designates a misalignment of real life and fantasy; of text and commentary; of history and the individual, that writing can preserve if not repair. Correspondingly, the true love story here concerns the feeling with which Bob engages Margery across time, and the community of witnesses that see to their agreement. It is a reader's fortune, then, to vigilantly authorize the lover's interpenetrating worlds, and to enjoy what they can only suffer, together, alone.

66 Bataille, *Eroticism*, 269.
67 Glück, *Margery Kempe*, 80.

Extreme Remedies

The hallmarks of poet and novelist Kevin Killian's style are various—variousness, in fact, may be counted among them. Writer Dodie Bellamy, who married Killian in 1985, speaks of his "protean slips between high and low culture," modeling an absolute equality of sources and means, and Killian clearly thrills to this combined effect, oscillating registers wildly. Killian's writing savors the contingencies of gay identity—from celebrity obsession, conscripting alternative icons from Hollywood and beyond, to the criminal sympathies of Pasolini or Genet—effectively splitting the difference between violent pulp and a theory-savvy gossip rag.

Refusing dialogic realism in favor of hyper-referential pop cultural pastiche, Killian's writing spans argots with little regard for finessed consistency. Throughout his 2012 novel *Spreadeagle*, the time of which spans decades of death and uncertainty under the sign of AIDS, Killian's trademark unevenness of style seems to derive from the mixed company that it depicts, as though its characters were inhabiting different genres themselves. More than innocuously discursive, the high-low antinomy that Killian wields to slapstick effect issues real comparisons between enfranchised and peripheral subject positions, plumbing the vast stratifications of queer life under capitalism.

At its core, *Spreadeagle* fictionalizes the death of experimental writer Sam D'Allesandro, a friend and muse of Killian, whose words are woven into Dodie Bellamy's 1998 epistolary novel *The Letters of Mina Harker*. Although D'Allesandro died from complications of AIDS in 1988, the action of *Spreadeagle* projects an alternative timeline, extending his life into the twenty-first century. This single death,

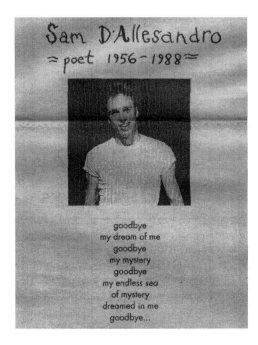

Fig. 9. Sam D'Allesandro memorial program, December 1998.
(GLBT Historical Society Online Obituary Project).

however, is narrated over the course of a digressive literary thriller, whose separate plots depict the indifferent opulence of bourgeois society and the opportunistic racketeering of a criminal underclass at once. Initially, the novel gathers around popular gay novelist Danny Isham and his coterie, who drift in and out of D'Allesandro's life with philanthropic unconcern. The second half transpires in the company of D'Allesandro's likely killers—peddlers of a sham cure for AIDS—and rapidly descends from gay pulp into sordid noir. Killian's preferred unit of plot is the imbroglio, the more embarrassing the better, and he delights in placing his characters in dire straits, such that any hint of elegy sits in uneasy tension with the novel's sadistic design.

Below the Pleasure Principle

This Sadean pleasure-seeking poses a political limitation, initially. But the salacious fatalism of this approach isn't Killian's prerogative alone,

insofar as it refracts the values of the neoliberal interregnum in which *Spreadeagle* takes place. This period encompasses the aftermath of the collapse of the USSR at the so-called End of History as well as the AIDS crisis, which likewise escalated to a genocidal scale during a period of unprecedented government deregulation. One need only examine the present epidemic of HIV infection in former Soviet Bloc countries to grasp the urgency of this co-theory, linking massive programs of liberalization to contemptuous extremes of state neglect.

As New Narrative, the loose school of experimental writing from which Killian is inseparable, formed against the backdrop of escalating crisis, one might suggest that its insistence on the pleasure of the text assumes twofold importance, where writing is both a reflection of social reality and a refuge from its difficulties. In the late nineteen-seventies and early eighties, the New Narrative writers called attention to the collective contexts of individual pleasure-seeking, documenting their queer community as so many mutually implicated texts. After the appearance of AIDS, however, this program of utopian intertextuality appeared to retreat from its source world, becoming increasingly fantastical, interior, and referential. In a devastating afterword to the second printing of his 1985 novel *Jack the Modernist*, Robert Glück laments that AIDS has since conferred anachronism on its settings and society—the author himself stopped visiting the baths shortly after its publication. Killian observes this shift in a 2012 plenary on poetry and AIDS:

> In the seventies gay poetry had been dominated by the liberation of the body, but the excesses of the body were banished as though by fiat when AIDS came to haunt us … for much of gay poetry, the body was blamed for the plague; the rectum had shown itself a grave; it was a time when the spirit returned, or when language took on the materiality that had once been the body's province.[1]

This remark is striking; for the movement whereby language assumes bodily salience also conveys the body to a symbolic order that precedes any single point of view. Thus language doesn't flatly

1 Kevin Killian, "Activism, Gay Poetry, AIDS in the 1980s," in *Paideuma: Modern and Contemporary Poetry and Poetics* 41 (2014): 3–19.

represent or quote from reality, but registers subjective discrepancies in its many provenances. More so than most prose stylists, even among his contemporaries, Killian embraces the embarrassing dissonance of sentences placed at cross purposes, which enriches another trademark of his writing; namely, the micro-historical textures of a compulsive litany of proper nouns and pop cultural reference points.

This comparative tack is doubled at the level of plot. The first section of *Spreadeagle*, "Extreme Remedies," reads as a comedy of manners, while the second half, "Silver Springs," descends into the seedier terrain associated with certain of Killian's direct peers, such as Dennis Cooper. But where Cooper's novels appear strategically evacuated of historical concern, transpiring in a utopic space of de facto gayness where violence is largely inconsequential, Killian's omnivorous referentiality situates its characters in historical concert, incessantly name-checking the mass cultural touchstones that mediate each particular vantage. As a result, the sexual and political nihilism of *Spreadeagle* appears qualified, as an outsourced product of liberal malaise, rather than endemic to an undifferentiated social whole.

Killian's fiction stages scenes of ultra-violent ribaldry with buoyant humor, and yet refuses the ameliorative designs of straightforward satire, as well as the easy catharsis of so-called transgressive literature. As a Great Recession-era work of counterfactual historical fiction, *Spreadeagle* appears less concerned with puritan boundaries of good taste than with the immiserated underside of respectability politics, where offense is assured because conditions of life are offensive. In this sense, Killian conveys the depoliticization of AIDS to the myriad displacements of financial crisis, all over the course of a single macabre comedy.

Extreme Remedies

In the opening pages of "Extreme Remedies," AIDS activist and professional layabout Kit Kramer arrives at the home of his boyfriend and patron, successful gay novelist Danny Isham, from a politically motivated trip to the socialist republic of Cuba. Kit has been travelling on Danny's dime, "seeing how Castro's treating the AIDS patients," whereas Danny's geographical ignorance evinces a distinctly American

brand of security-in-stupidity: "it was only this past September that he'd found out Vietnam wasn't a Caribbean island but somewhere totally different and Asian."[2]

Such language, hamming up racial insensitivity, pervades Killian's character sketches: always attributed and always uncomfortable, facing down and thematizing the hegemonically white standpoint of the author's queer personae with unflinchingly feigned innocence. Early on, one learns of Kit and Danny's attempt to adopt a young Black girl out of the Valencia Gardens housing projects, filling their home with tokens of contemporary Black culture: "I'm glad we're past all those tiresome identity politics," Danny says, "and people are starting to realize that yes, two gay white men can give an African-American child both a loving home and a working knowledge of her culture! It gets better, is my message I guess."[3] This punchline, coopting a progressivist slogan of gay rights, caustically sends up the liberal endgame of cultural assimilation in multiple registers.

Poetically mindful of the polysemy that envelops and extends each noun, where pre-personal association makes chutes and ladders of all language, Killian links San Francisco's Castro District, a gay enclave named for Mexican military commander José Castro, to the revolutionary socialist state of Cuba, popularly condemned by American ideologists for its putatively anti-gay legislation.[4] Nonetheless, Kramer appears to speak facetiously when he extols Fidel Castro's government: "To honor his recognition of homosexual freedom, we named our primo gay district after this still living fighter!"[5]

This overture, glossing AIDS and US imperialism in a flash, takes place in the secure company of Danny Isham, America's second-most successful chronicler of gay San Francisco, after Vietnam veteran and novelist Armistead Maupin, whose *Tales of the City* double as homonationalist paeans to an ever-more inclusive society. Isham has a particularly anxious relationship to Maupin—in a running gag, he is frequently mistaken for the older author, as an unrelated purveyor

2 Kevin Killian, *Spreadeagle* (Hudson: Publication Studio, 2012), 9, 12.
3 Ibid, 46.
4 For more on this topic, see Leslie Feinberg's *Rainbow Solidarity in Defense of Cuba* (New York: World View Forum, 2008).
5 Killian, *Spreadeagle*, 12.

of apolitical "gay kitsch." Danny is the estranged son of infamously appetitive poet Ralph Isham, widely known for his activism, and his fanatical disdain for this comparison evinces more than a little Oedipal compunction—while his writing lacks a politics, it is apparently more serious than that of his more famous counterpart. Such are the subtle differences upon which bourgeois self-opinion depends.

The Celebrity Novel

This blending of real-life personages with the antics of fictional peers is a key device whereby Killian advances his comedic critique of society. If the political vocation of the historical novel concerns its interweaving of small lives with those of major historical actors, Killian's celebrity fixations have a greater-than-satirical significance, as mass cultural linchpins of popular consciousness. In Marxist literary critic György Lukács' description of the historical novel, the appearance of famous figures at a distance points up the gulf between societal strata, initiating a literature from below. Killian's incessant namedropping offers a mediatized version of this inverted agency, from the standpoint of the quintessential observer—namely the fan, who is never far from being a fanatic.

This libelous insouciance extends throughout the entire book. In the concluding section, "Silver Springs," the hero, Geoff Crane, makes a living forging celebrity autographs from a trailer park in the fictional town of Gavit—a depressed backwater ravaged by the spread of methamphetamines, an afternoon's drive from the wealth of Silicon Valley. Geoff's racket, as a celebrity impersonator working at the level of the individual letter, traverses the tremendous socio-economic gulf that intervenes between the stars of Hollywood and their earthbound admirers. Nearby, Danny Isham, "the surviving child of a rich man," cavorts with a real-life literati, whose names litter the page as though the massively distributed punchline of an inside joke—Michael Chabon, Lemony Snicket, and countless more inscrutably situating cameos that lend body and reputation to Isham's society.[6]

Isham's own success stems from a series of novels documenting the lives of Rick, "the rich, light-hearted playboy of the Castro" and

his partner Dick, "the poor, ethnically-mixed street hustler with an attitude, but a heart of gold."[7] This storybook complementarity seems a cheaply allegorical emanation of the uneven social planes on which AIDS is experienced, and an obvious commentary on the many strained and complicated pairings that comprise the novel's cast. Kit and Danny's own relationship is less symmetrical, though a modicum of jealousy is required to smooth over the fact of financial dependency. For want of a nuisance, their relationship is triangulated by a live-in fanboy, Eric Avery, who at the same time insinuates himself into the company of Kit's ex-boyfriend, the writer Sam D'Allesandro, dying of AIDS in his cramped apartment.

Zones

From his first appearance, D'Allesandro is in desperate straits and declining health. After his breakup with Kit, "Sam had retreated to this cheerless, empty interzone, where all you saw were people smoking crack or hauling giant slabs of debris into artists' live-work lofts to make public art for the walls of the Yerba Buena Center downtown."[8] The Yerba Buena Center, a stone's throw from San Francisco's so-called skid row, is a representative icon of development atop, or nearby, dereliction, and was once the focus of a bitter legal struggle between low-income tenant organizers and the San Francisco Redevelopment Agency. The interzone of which Killian speaks, where D'Allesandro whiles away his final hours, is a space of combined and uneven despair, where AIDS death and the transient residency of those struggling with addiction and unemployment factor into the machinations of private developers.

Here too Killian juxtaposes a specific inventory of the city with his own embellishment, as a fictional overlay to the actual, historical world in all its brutality. D'Allesandro's characterization derives from this bizarro-realist program, too—as noted, D'Allesandro was a friend of Killian's before his untimely death and remains an underrated writer to this day. Killian's decision to resurrect his muse on the page offers nothing like simplistic wish fulfilment, however; for the fictitious D'Allesandro appears ailing, piteous, even after having outlived his historical counterpart by decades. In this guise, D'Allesandro

7 Ibid, 129.
8 Ibid, 142.

assumes looming significance, for his death and the question of its attribution drive this novel and divide its two halves.

In the first half of the novel, a sickly D'Allesandro is visited by a manipulative salesman, Gary Radley, who offers him an experimental therapy called Kona Spray, at cost of his entire savings. Radley's business, Extreme Remedies, corresponds to any number of unscrupulous ventures whose profits are parasitic of precarity. The marketing language of Extreme Remedies indexes fantastic distance, too, peddling a primitivist idyll wherein a neo-colonial consumer may infuse their personal space with Edenic innocence: *"People in Hawaii don't get HIV,* the copy says, *because they bask all day and night, all year round, in the healing blossoms of the Kona plant. Now you can bring the healing power of Kona to your own bedroom or office."*[9]

Naturally, the therapy performs no miracle, and when Avery discovers D'Allesandro dead in his apartment, he panics and retreats from the scene, nabbing a laptop as a memento. This is the final wedge between Kit, Danny, and their listless houseguest. "You mean he's dead and you just let him lie there?" Kit spits incredulously at Eric upon hearing the news. Guilt rears up as Danny's bitterness impedes Kit's grief: "He was dying for years and *you* just let him die there," Danny accuses, jealous of a corpse.[10]

Silver Springs

D'Allesandro's diagnosis might have coincided with his breakup with Kit Kramer, but the time of his sickness corresponds to a descent in both strata and scenery. The correlation between illness and downward mobility is well-observed, but these vectors of harm appear throughout *Spreadeagle* as two mutual metaphors, each representing the other, as the action drifts from San Francisco in an era of cultural resignation after the height of AIDS to small-town California as one site of an incipient methamphetamine crisis.

Both epidemics and their ravages concern the sociality immanent to the individual body, and Killian graphically describes the physical ravages of addiction as a sexual affliction, too. Identifying drug use

9 Ibid, 391.
10 Ibid, 254.

from weight loss and skin sores, Geoff Crane's doctor appeals to his vanity: "soon you'll have those crystal bumps up and down your *penis*, Geoff, and how are you going to explain those away?"[11] Here formication is a social symptom, linked at its basis to both folkloric and somatic manifestations of AIDS.

In "Silver Springs," portions of which were anthologized as early as 1991, Crane, a hapless counterfeiter living with addiction in the trailer park of Gavit, enters the orbit of the evasive and homicidal Gary Radley, whose appearance in the economically downturned town alludes to darker purposes than Geoff's seduction. The mystery deepens when Eric Avery, now a semi-famous porn star known for his ability to take a spanking, materializes at behest of an elderly discipline enthusiast. When Avery reveals to Crane that he has footage of Sam D'Allesandro's murder, Radley promptly executes the only witness to the crime, implicating Geoff in his death. Guilt-addled and pushed further into debt by drug-fueled escapism, selling his possessions and eventually his trailer, Crane's capture soon appears the inevitable culmination of his affair with Gary Radley, a Sadean mafia unto himself.

"Silver Springs" is a horror novel compared to the rollicking satire of "Extreme Remedies," but it proceeds by the same formal means, relying upon Killian's signature collisions to disclose the brutality that small-town life barely conceals. If anything, the subjective violence of this latter section is obverse to the cruelty that bourgeois society outsources and represses. Sam D'Allesandro dies in secret, his apartment a correspondent shambles, while Gary Radley's trailer is a revolving door for mortal prey, rendered in malodorously Huysmanian detail.

In allegorical fashion, the novel proliferates awkward and adversarial dualisms. The sinister twins Gary and Adam Radley, recurring characters from the conspiratorial subplot of "Extreme Remedies," face off against the criminally implicated Geoff Crane and his brother Jim, a small-town policeman: "Jim's a county cop and kind of a hick, wears a big .45 on his hip like so many guys in our town, only he gets paid for it."[12] Jim represents the lawful obverse of a lumpen company, policing the people that the Radleys exploit—including his own kin. Questions of relation and resemblance follow a richly incestuous trading of places

11 Ibid, 485.
12 Ibid, 371.

from scene to scene, mixing the moral typologies of George Bataille's *L'Abbe C* with the fraternal archetypes of Bruce Springsteen's "Highway Patrolman." As Crane's own sympathies are torn between erotic fascination and family obligation, he pivots between societies, though his company is ultimately determined by the escalating physical possession of drug addiction.

However chaotic it appears on the surface, the symmetrical design of *Spreadeagle* is a higher-order emanation of Killian's manic paragraph, a multi-register juggling act where the left hand always knows what the right hand is doing. Toggling between genres, Killian relies upon the reader's conversancy in Hollywood lore for a sentimental charge as well. Spending time with his prose is like bonding with a stranger over a common fixation, and his characters are never so relatable as when they are themselves obsessed. Geoff Crane, for example, summons the innocence of Audrey Hepburn's character in *Wait Until Dark* as he descends into criminal life, turning a blind eye to his own misdeeds. Through this identification, he can redeem and glamourize his lack of agency, as even fatedness requires another's example.

A Dream of History

More than a fantasy by which to deal with the untimely death of a friend, resurrecting a specific casualty of AIDS in order to kill him less senselessly and concentrate the blame, Killian's roman noir implicates myriad subjective and objective forces, from true love to real estate, in the making of a single death. The fictionalized D'Allesandro remains as fated on the page as in reality—even in sickness one dies too soon. Over the course of this slapstick thriller, Killian socializes the only apparently private stakes of a people's illness, such that one man's tragic mishandling by friends and conspirators becomes an allegory of liberal neglect. Rewriting tragedy as farce, and comedy as crime, Killian forces closure, and *Spreadeagle* ends in an improbable jubilee. The ending, he has said, appeared to him after years of waiting, in a dream.

This morsel of trivia reframes the book, reminding its reader that the effortlessness with which Killian appears to write nonetheless crests atop historical and subjective necessity. In a 2019 interview with Ruby Brunton, Killian explains that it took him twenty-three

years to complete *Spreadeagle*, the conclusion of which finally arrived as though a godly visitation, something out of an historical machine. Traces appear in Killian's earlier story collections, such as *I Cry Like a Baby* and *Little Men*, and in numerous publications starting as soon as 1991. What caused this delay, such that *Spreadeagle* may be described as both its author's first novel, and his last? As Killian explains, "the nineties were spent largely in hoping for a cure for AIDS. We didn't get a cure, exactly, but we got enough."[13]

While the writing of *Spreadeagle*'s good-enough ending seems to have awaited the uneven abatement of AIDS, its narrative design demonstrates against foreclosure. Treating a dual exploitation of the gullible ill and the pliable poor, Killian's macabre plotting insists that one cannot speak of an end to the AIDS crisis, despite its increased management within affluent and largely white enclaves of the imperial core, where the economic vectors of infection persist.

Much as HIV and AIDS chiefly afflicted gay men during a period of cultural persecution, it continues to impact marginalized populations today. HIV appears an index of proletarianization, which is precisely why a liberal rhetoric of inclusion can only fail politically: as a highly selective means of crisis management, official strategies of recognition simply outsource privation to the nearest periphery. This process forms the mercenary backdrop to the action of *Spreadeagle*, which depicts one character's hellish descent only insofar as narrativization negates objectification. This, to be clear, is the best thing a novel can do for the people whose predicament it borrows, reintroducing movement to the prejudicial portraiture of popular opinion.

Perhaps it's only fitting that *Spreadeagle* took its otherwise prolific author a quarter-century to complete. With respect to its scale and the interpenetrating depth of its comparisons, *Spreadeagle* is an historical novel of the long present. Even so, one needn't propose a politically instrumental reading of this labyrinthine text, nor undervalue those respects in which it may also be a love letter to a city and a violently departed friend. These layers are inseparable where Killian's mordant humor exudes a utopian imperative, and his taste-based transvaluations

13 Ruby Brunton, "On being unlikeable in your work," *The Creative Independent*, March 4, 2019, www.thecreativeindependent.com/people/writer-kevin-killian-on-being-unlikeable-in-your-work/.

extend the program he outlines above—to liberate the body and the word by way of one another, in a novel or a world. This is just one of the impossible dreams that Kevin Killian imparts, and it resounds throughout all of his work. Now it's up to his readership to make it resound everywhere else, in tribute to the slyly subversive optimism that was only one of his charms.

Bachelors
Have Windows

On Believing Kevin Killian

Full disclosure: I know Kevin Killian.[1] In one sense how could I not, having read his many bracingly divulgent texts? His is a quintessentially literary life placed on display, intrigue and all. In another sense, Killian is known to so many writers of queer and experimental prose and poetry as a tireless friend and enthusiast that it becomes difficult to talk about such writing today without glancing upon his name or discovering his influence. *Fascination*, edited by Andrew Durbin, collects three seamy, essential memoirs from the most reliable unreliable narrator of our time: *Bedrooms Have Windows*, a 1989 account of the author's "early search for homosexuality on the North Shore"; *Bachelors Get Lonely*, a previously unpublished collection of heartfelt pornographic vignettes; and *Triangles in The Sand*, a self-conscious account of a strained half-affair with the musician Arthur Russell.

But what does a reader really know about Kevin Killian? The memoirs collected here are complicated, bluffing and self-deprecating at once, rendered in multiple, often dissonant, registers from sentence to sentence. This characteristic style transcends the mandate of camp, where Killian hazards deep sincerity, only to pivot on a whim. Knowing Kevin Killian through this writing means embracing his occasional rascalian, imbibing hearsay as subplot, and remaining credulously smitten. There's no better word for this than *Fascination*,

1 This review was written in early 2019, after the publication of the collection *Fascination*. Kevin Killian passed away on June 15, 2019.

which offers ample occasion to get acquainted with Killian's tell-all generosity of spirit. These scarcely believable stories, like any rumour that appreciates in circulation, defy fact-checking; but the line between confabulation and confession is a locus of style, and with a knack for both befitting a Franciscan schoolchild, Killian holds giddily forth as a stylist of his own destiny.

There's something of a lovable Confidence Man about the narrator "Kevin Killian"—something that enables wild digression, ribaldry, auto-embarrassment, and reinvention. That something concerns the name as calling card or currency, immediately literary in circulation: "Sometimes I feel like a piece of paper … that you wrote your name on then pissed on," our young narrator—"Kevin Killian, from Smithtown, Long Island"—laments to his 35-year-old boyfriend Carey in the opening pages of *Bedrooms Have Windows*; and to a large degree these memoirs are about the degrading glamour of becoming name-on-paper.[2]

Perhaps this susceptibility to text, extending Durbin's introduction, describes New Narrative's stake in the corpus of so-called critical theory. Neither scholarly nor initially credentialed, the New Narrative writers—gathered around Steve Abbott, Bob Glück and Bruce Boone—attest in writing to the daily stakes of queer embodiment, corroborating a range of textual effects attending experience. Anybody with a name or gender already perceives themselves as a signifier; anybody who has ever been compelled to live a double life, selling their labour or concealing their desire, knows alienation firsthand. New Narrative proceeds from the vicissitudes of the symbolic, determined to find some kind of erotic kindling in this inter-subjective chafe. For this reason, Killian and other New Narrative writers are often said to have practised a kind of identity politics in the immediate wake of Language writing and its formalism; but one could sooner talk about the myriad identities, and identifications, that traverse any body, or body of work.

2 Kevin Killian, *Fascination: Memoirs* (Los Angeles: Semiotext(e), 2018), 26.

Bedrooms Have Windows

Certain embellishments of *Bedrooms Have Windows* will be instantly familiar to anyone who has lived in the closet. Before escaping Long Island, Killian lies to his parents about his relationship with an older man, explaining his baritone caller as a teacher from school, a writer from New York, or a piano salesman. This is no literary caprice, but an expediency in which Kevin revels. *Bedrooms Have Windows* dramatizes a particularly duplicitous moment in anyone's life: "At the same time as I was seeing Carey Denham," the narrator explains, "I was trying to maintain the normal life of a Long Island teenager. This wasn't always easy, but it gave me a unique distinction—or so I thought."[3]

Kevin's childhood friend, George, also seeks narrative advantage in personal mystery. Adopted, George forms grand theories of his "true parentage," and his imaginary lineages remind us that a family name cannot vouchsafe paternity. When George claims to have been abandoned on a doorstep with a note ("Please call this baby GEORGE") he effectively sidesteps an Oedipal dilemma, affirming the predestination of his own name-on-paper.

In many respects Kevin and George behave like adolescents, comparing lives while swapping baseball cards, another collectible roster of names. But the subjective discomfort that drives their camaraderie is crucial to this portrait of teenage angst. For Kevin, George's stories ground their affinity, and he consoles himself with these confabulations: "Wow, Kevin, you may be a queer but George Grey is really *really* fucked."[4] All that George wants is a connection, Kevin continues, "however tiny, improbable or precious, between the dancer, and the dance," summoning Yeatsian melancholia and Andrew Holleran's novel of gay desire in a phrase.[5] In lieu of this impossible rapport, George Grey and Kevin Killian find connection in writing.

As Kevin is gradually inured to bohemian taste, from Antonioni to the Romantic poets, George becomes a kind of stubborn foil, quoting the Beach Boys and more standard teenage fare. Killian's own voraciously inclusive aesthetic proceeds without distinction, collating

3 Ibid, 32.
4 Ibid, 33.
5 Ibid.

Italian horror with Hollywood rom-coms, mass culture with foreboding Modernism, lit-crit with louche kitsch. George becomes a kind of slacker-teacher in this eclectic enterprise, and with Promethean flair divulges his own method for writing: a practice of appropriative novelization where he rewrites Warhol movies from a first-person perspective. The pair proceed to rewrite everything from Agatha Christie to Gustave Flaubert, producing a quirky personal canon, full of inside jokes and coextensive of a life: "I read and re-read all our manuscripts repeatedly, clutching them to my chest, clumsy as a lover," Kevin confesses. Their Künstlerroman is consummated in a flash, as Killian discovers his destiny: "I'd fallen in love with a world of art that knows no consequences or reversals. Ever since then I've been the same person, no growth, no development, just an aging body falling faster and faster toward death."[6]

After the fashion of a Wildean aesthete, Killian proposes that the dissolution of the individual body corresponds to the fixity of an artistic ideal, though Killian's own consistency requires no such proxy. In this refusal of development, Killian implicitly places himself in the company of dear friends and collaborators who passed away too soon, forever artists immortalized in an alternative time of their creation. A similar drive underwrites much Sadean literature, which insists on the immortality of the body as a formal requirement of narrative escalation. Affectingly, one of Killian's hallmarks is to elaborate this insight in two directions, sinister and heartfelt. A Grand Guignol of sexual experimentation, often with slapstick repercussions, contrasts an affectionate gallery of rogues and rascals, friends and lovers, enshrined in a production of immortalizing chatter. When Killian litters names, it is for the safekeeping of posterity; a loving invocation nothing like literary encipherment.

In *Bedrooms Have Windows*, this newfound authorial hubris is hardly innocent of ego. Kevin develops a chip on his shoulder toward the older academics and luminaries he encounters in New York; for "they belonged to culture, whereas culture belonged to me, by dint of vanity and my increasing self-absorption," he admits.[7] This youthful precocity is narratively doubled, as Kevin's relationship with the much

6 Ibid, 64.
7 Ibid, 66.

older Carey begins to entail more and more involved, and public, fantasies. Carey brings Kevin with him to shop for his own teenage son, Nicky, and has Kevin play the part before the clerk. As Kevin discovers, it is easy to get hard, and harder to get on, wearing the trousers of another.

The novel proceeds by ill-pairings and off-putting conjunctions, always interrupted by an absurd stroke of happenstance, allowing the plot to advance in comically tidy triads. Kevin is performing magic tricks at children's birthday parties when he marries a witch. Toward the end of this ill-fated attempt upon heterosexual exclusivity, Kevin calls George, now obsessed with water skiing, to rescue him, and they move in together. As Kevin's domestic situation becomes more and more complicated, the action of *Bedrooms* becomes rapidly more allusive and distractible. Their literary partnership ends with cohabitation, and their eventual estrangement commences with sex.

Killian has mastered the art of the trivial reference, and each page of this book presents a plethora of dead-end factoids, dummy rifles and red herrings. George, we are informed as an aside, once tried to kill himself by swallowing a bunch of pipecleaners. The forgetful texture of the book underwrites repetition; Kevin introduces Carey from a half dozen different standpoints, always off the cuff, as if for the first time. It is difficult to sort these unreliable impressions into a chronology, though ages and years are signposted throughout. This discloses the stalling, stopping and starting, rhythm of a surreptitious affair, which takes place as so many discrete, in fact discreet, encounters, punctuated by disavowals and revisions of desire. "Never, never, never," Carey says to Kevin's suggestion that they go back to his apartment. "But oh yes, I sure did," our seductive narrator gloats.[8]

Auto-embarrassment is not always glamorous, and Killian's warts-and-all account retains wincing details of parochial suburbanity. In a litany of stereotypes derived from the typologies of nineteen-seventies sitcoms, Killian describes two Brazilian houseguests that he can't tell apart, resolving to "exorcise all racism out of [his] body somehow."[9] Such gaffes, after which the author scolds himself, are neither self-flagellating nor especially regretful. In a book that is manifestly

8 Ibid, 101.
9 Ibid, 104.

about bad behaviour, certain details are bound to read as distasteful, and Killian doesn't angle for redemption.

These moments of unattractive naivete and wilful blunder may be inseparable from the bare-all inhibition of Killian's program more generally. Throughout *Bedrooms Have Windows*, the bewilderment and vulnerability of the suburbanite newly arrived to the city pose literary advantages. This work seethes and sweats with the superficiality and excitement of fresh experience, circumventing the anticipatory nostalgia of the Bildungsroman. Rather than presume to let us into the narrator's head, unfurling vistas of interior experience, Killian seats the reader atop the author's shoulder, that he may beguile us with the telling instead.

Bachelors Get Lonely

This telling, too, is Killian's calling, as it relates to a dishier and more pleasurable genre of confessional; for wherever there's a telling there's already concealment. The stories of *Bachelors Get Lonely* begin in church, with the author's Franciscan education in the nineteen-sixties, bibliographic fodder for a series of asymmetrical sexual initiations. In stark and risky contrast to a more familiar genre, *Bachelors* relates a mutually exciting affair with an older friar: "Every semester he and the other few queer monks judged the new students like Paris awarding the golden Apple," our narrator explains with more pride than difficulty.[10] "Boys, after all, are tricky because they change from week to week … This was Jim's dilemma—when you're waiting for a perfect boy life's tough."[11] The changeability of youth, for want of which the friars must "trade up" semester after semester, contrasts the not-so Platonic interchangeability of the object of fixation. Nevertheless, when our narrator asks an older priest why he is being treated so well, the reply is inevitable: "Because you are who you are … You are Kevin Killian."[12]

This dangerously ambivalent account, in which the author gets what he wants from a pederastic cabal, opens a kaleidoscopically varied collection of sexual misadventure. The stories comprising *Bachelors*

10 Ibid, 142.
11 Ibid, 143.
12 Ibid, 146.

Get Lonely, previously unpublished, concern illicit thrills and dizzying confessionals, doubling up on indiscretion as a self-deprecating gloat. This peculiar affectivity is hardly incidental to the narrative, for the hook-up as written by Kevin Killian utterly transvaluates the stakes of homosexual secrecy in a phobic society, and the familiar experience of working through shame in dangerous conditions. His character revels in embarrassment and bad behaviour, assenting to bloodsport and deception along the way.

How does this play out on the page? Reading "Spurt," I'm traversed by sympathetic winces; a physical reaction proves the writing, which presumes bodily reply. The Bataillean mandate of this fiction is clear in the arrangement of religious symbol, literal evisceration, and sexual excitation. Moreover, Killian's polymorphously pro-social debauch seems to have no determinate object whatsoever, exceeding gayness in a spirit of escalation and experiment. Each story depicts a self-administered test of desire, which uber-egoic goading is an important aspect of initiation into any sexual identity whatsoever.

For all the manifest transgression of these stories, they remain staunchly affable, striving for community. This sociality is both contemporary and retrospective, for the tell-all intertextuality of New Narrative repeatedly declines separation between the living and the dead. Killian's escapades are interrupted by insistent recall of his missing friends ("they speak to me now without my asking them to") including Steve Abbott, Bob Flanagan, Kathy Acker, and Sam D'Alessandro.[13] These unsparing accounts, collected in the story "Ghost Parade," place Killian's writing in context of a vibrant social constellation at the same time as they situate the author in a company of survivors, unanimously tasked with recollection.

Killian haunts himself, too. In "Man and Boy," a script connecting Killian's dedication to poets theater, a 20-year-old Kevin Killian is visited by a 45-year-old version of himself. Describing his youth as a "phantom pain," the older Killian counsels himself to keep the "halo of idiocy" about his head, not to mention his "erection that sticks straight out 24 hours a day."[14] This encounter extends the parade of ghosts comprising Killian's personal canon, as it reverberates with the

13 Ibid, 203.
14 Ibid, 165.

Father-son dynamic of his Franciscan escapades in *Bedrooms Have Windows*. "Are you too old to have erotic feelings towards the boy you once were?" the young Kevin asks his elder self.[15] This is a literary fantasy par excellence, and the precocious flirt anticipates as much: "One of these days I'll remember this encounter, and I'll write about it and when I do I'll be cruel. Solipsistic and cruel. Grrrr!"[16]

Is It All Over My Face?

Killian's paeans to youthful indiscretion amplify embarrassment as if to retrospectively preempt regret; and in this spirit of self-sacrificial generosity, he repeatedly declines to spare his written counterpart. In the final of three memoirs, *Triangles in the Sand*, Killian recalls an ill-fated relationship with acclaimed musician Arthur Russell, offering a different, tempered perspective on the hubris of youth. In the opening pages of this account, he sounds a wistful version of the ghost parade:

> I'm not on top the way I used to be, and late in middle age I let things flutter by; even events and faces I thought I'd never forget end up in a blind alley bricked up to the sky. This sad brain lapse is counterbalanced however by people and places returning to me after many years—full-blown memories emerging from cold storage still with the original dew fresh on them, or apparently so.[17]

Killian then contradicts the sweetness of this reverie, pinching himself: "in other ways I can see myself more clearly now, and as I look back I see that I had a ruthless streak; I could be horrifyingly manipulative."[18] In a multi-layered comedy of close calls and near-misses, a young Kevin Killian encounters Arthur Russell for the first time as a traveling accompanist to poet Allen Ginsberg. In his mid-twenties, Killian is likely older than the elder poet's type, but is nonetheless determined to attract Allen's attention. Instead, he ends up driving

15 Ibid, 166.
16 Ibid.
17 Ibid, 249.
18 Ibid.

the demure musician back to the East Village, commencing an erotically strained friendship.

Russell isn't out of the closet, and an admittedly superficial Killian is disconcerted by his acne-scarred complexion. So many adolescent obstacles come between them, but none so uncomfortably as Allen Ginsberg, Kevin's quarry and Arthur's employer. At Riis Beach, Russell lazes beside Kevin, drawing triangles in the sand with his toe: "I felt a little embarrassed by these triangle drawings, thinking that somehow Arthur was snidely referring to my feeling that I was part of a triangle with him and Allen Ginsberg," Killian admits.[19] Arthur corrects Kevin's geometry: "We're not even really a line, you and me."[20]

Truly, the lines of desire and affiliation that people form throughout life are redrawn in recollection, and are rarely so straight as they appear in abstract. Killian describes his surprise upon reading decades later that the acclaimed cellist Arthur Russell had died of complications from AIDS in 1992, finally putting two and two together. But the solipsism of which Killian accuses himself can both blind one to synchronicity and materialize coincidence post hoc; it turns out that Killian has been dancing to the music of his former flame for decades in nightclubs, internalizing Arthur's words and rhythms unknowingly.

The memoir concludes with a poem from Killian's 2008 collection *Action Kylie*, written around a mantra from one of Russell's most infectious tracks: "Is it all over my face?" (A look of shock, a blush of genuine surprise, a telling glance; we wear our separate faces to the world in hopes of legibility.) "You caught me love dancing." Russell's former opacity and Killian's youthful disinterest motivate this vivid identification after the fact, a missed encounter beckoning poetic repair: "I told my friends he was not the boy for me," Killian sings, only to concede that perhaps the all-seeing author made an oversight.

Fascination

Needless to say, a reader could get into a lot of trouble asking themselves "What Would Kevin Killian Do?" But it's freeing to regard our folly through the disinhibited, already-literary lens that Killian extends

19 Ibid, 293.
20 Ibid.

to his reader. The far-out metaphors and knowing borrowings; the stoical moments of self-appraisal and rebuff of cheap remorse; above all the pervading affect of incorrigible delight: these attributes furnish the reader a handbook for queer writing practice, and attest to the endless generativity of Killian's work. Of this larger permissiveness, I can only say what a pleasure it is to coincide as a reader and a writer with the time of Kevin Killian's memoir—here's to his many further escapades.

Leaving *Lovetown*

The deep green of the trees is touched with night, even in the blank white of a Russian afternoon. A modest obelisk—once blessed by the Romanovs and rededicated in 1918 to a roster of "outstanding thinkers and personalities of the struggle for the liberation of workers"—rivals the trees for height, a white granite swatch next to the clouded sky. Wet cobblestones like bathroom tile reflect the light in patches. This is Moscow's Alexander Park as photographed by Yevgeniy Fiks, and there's not a passerby in sight. A nearby bench sits empty, as if the entire scenery has turned its back to the onlooker. Behind our borrowed point of view extends the west wall of the Kremlin.

In another of Fiks's unpeopled photographs, two brightly painted public toilets sit like sphinxes along the Nikitsky Gates. Their mouths are gated as though decommissioned, joining a staple of the capitalized city: a closed washroom. These documentary photographs not only tell the story of a rapidly deregulated and politically evacuated public space, following the functional overthrow of the USSR at the beginning of the nineteen-nineties; more directly, Fiks's 2008 portfolio preserves gay cruising sites in Soviet Moscow, frequented between the early nineteen-twenties and the advent of devastating neoliberal invasion.[1] As such, these vacated views of the city double as a negative pornography, asking the viewer to imaginatively merge the scenery.

Fiks's unattended representations make a suitable approach to the obscure status of homosexuality in the Soviet Bloc, as they foreground and frame an urban infrastructure of covert sexual expression. This paradoxical riposte to a contemporary demand for visibility has another

1 Yevgeniy Fiks, *Moscow* (Brooklyn: Ugly Duckling Presse, 2012).

function, however: asking us to see the socialist city as a portrait of the homosexual, in place and in spite of their official repudiation.

Lovetown

Lovetown, the debut novel by Polish writer Michał Witkowski, is a ribald and embedded ethnography of queer life on the outskirts of the Soviet bloc, and a powerful demonstration of the paradoxical optics of sexual freedom in a planned economy. Structured as a series of tell-all interviews with two elder queens, Patricia and Lucretia, *Lovetown* spans several urban sceneries as it moves back and forth in time from the couple's Wrocław apartment ("circa 1960. Stinks of piss.") and their differently odiferous recollections of a bygone age.[2] A rapid succession of epochs more so than chronological age has matured the pair; for the post-socialist sequence has visibly and practically altered their gender expression too: "since 1992, to be precise," Patricia and Lucretia have entered their mutual dotage as a pair of old men, living off inadequate pensions in a building overwritten by billboards and corporate advertisements.[3] The couple welcomes Michał, a young gay journalist, into their hyperbolic confidence, bursting to hold forth on their sexual escapades under the tacit permissiveness of socialism, where they fucked "in the park, behind the opera house, and at the train station."[4] Even today, Michał describes, their "flat is furnished like the waiting room of a clinic … somewhere to spend time between nocturnal forays."[5]

Michał's salacious mission begins with a simple question: "perhaps you could tell me something about life for homosexuals in Wrocław back then?"[6] From this gentle nudge proceeds an unrepeatable, oper-atic deluge of sex stories, traced with bitter laughter at those vanished from the ranks of legendary cocksuckers. In grottos, flowerbeds, pavil-ions, and latrines—piss-scented interstices of sanctioned public space and its many conveniences—legions of unsleeping divas meet in open secrecy to swap favours and fluids; an informal economy of crass utility.

2 Michał Witkowski, *Lovetown*, trans. William Martin (London: Portobello Books, 2011), 3.
3 Ibid.
4 Ibid, 6.
5 Ibid, 9.
6 Ibid, 10.

Patricia and Lucretia seem to enjoy scandalizing their young guest, whose interest intensifies with his revulsion: "This is horrible. Horrible and fascinating both at once. There's no way I can publish this," he thinks, "even though there's nothing criminal going on at all. There just isn't a language for this."[7]

Not only do the experiences of Patricia and Lucretia exceed all available terms of positive representation in the liberalizing post-socialist sphere, it even appears that this newfound visibility excludes their experience and identity altogether. "No faggot ever had it as good as we did," they affirm unquestioningly:[8]

> But that was a long time ago, back when the workers at Hydral and Stolbud still had energy at the end of the working day for things like ballet, back before phrases like "child molesting" had been invented, and newspapers were only interested in their own problems. Television had yet to come to the night shift, so people had to let their imaginations run at full steam, else they would die of boredom.[9]

Sexual Hegemony

This is a rather elliptical elegy to an unlikely gay heyday, in which public sex is only implied alongside "things like" ballet, as an index of leisure time. As importantly, increased visibility transpires on the side of persecutory fantasy in this melancholy sketch, where popular representations only sow moral panic. Accusations of pedophilia are commonly levelled at queer people in the right-wing media of the Third Polish Republic, and as homosexuality is visibilized, its variously enfranchised figures condense and encipher anxieties attendant upon economic liberalization. Notably, since *Lovetown's* publication in 2005, Poland's Solidarity-supported PiS (Law and Justice) Party, first as opposition and now as a majority government, has made a particular issue of public space, spearheading a campaign in conservative newspapers for "LGBT-free," or "ideology-free" zones.

7 Ibid, 21.
8 Ibid, 49.
9 Ibid, 5.

This contestation is typical of what researcher Christopher Chitty has termed "sexual hegemony"—a relationship of domination that may be observed "wherever sexual norms benefiting a dominant social group shape the sexual conduct and self-understandings of other groups."[10] More pertinently, Chitty's demonstration reconstructs a series of geographically specific attempts at the regulation of male homosexuality at key moments in early capitalist history, demonstrating the ways in which "cultures of sex between men were politicized amid much wider forms of dispossession during periods of geopolitical instability and political-economic transition; they are therefore world-systemic phenomena."[11]

Chitty's examples hew closely to the coordinates of the world-system as reconstructed by economist Giovanni Arrighi and his collaborators, from Renaissance Florence to post-war New York. In earlier case studies, sexual panic concerning sodomy focuses crises of legitimacy for an emergent bourgeoisie, where homosexual practices tended to flourish within religious and fraternal associations otherwise resistant to social transformation.[12] By the twentieth-century, Chitty argues, the defeat of anti-sodomy laws in advanced capitalist countries corresponds to a victory of the private citizen over state power in a period of liberal crisis management, part and parcel to the contraction of public space, rather than any straightforwardly progressive development. Here too history advances by its bad side, as homosexuality evolves from a secret society to a private enterprise.

With this in mind, *Lovetown* appears all the more argumentative; playfully and seriously demonstrating how the politicization of homosexuality at the end of the Soviet era corresponds not only to the incidental penetration of progressive norms into rapidly deregulating economies, but to the disappearance or contraction of the public spaces in which homosexual practices tacitly flourished as well.

The Lewd Beach

This post-socialist enclosure frames the second section of *Lovetown*, composed of short chapters detailing as many sexual misadventures

10 Christopher Chitty, *Sexual Hegemony: Statecraft, Sodomy, and Capital in the Rise of the World System* (Durham and London: Duke University Press, 2020), 25.
11 Ibid, 35.
12 Ibid, 55.

in the past and present of a seaside resort where multiple generations of queers convene. At Lubiewo, a nude beach ("cognate of *libido*"), Michał entices stories from the older regulars, on vacation from apartment stalls in the city. "It's a faggot *Decameron* I'm trying to turn out here," he quips, glistening with tanning oil off the beat. "The only problem is there's no such thing as sin anymore."[13] The dunes are no longer the covert cruising ground that flourished in the shadows of socialism, but a brazenly touristed resort; boasting less sex and more sexuality. Two Old Dears, wistful aficionados of communist-era exigencies, hold forth about the fallen world around them. It used to be that megaphones would appear in the trees whenever you found a good vacation spot, they explain, blaring Polish song, in a kind of cat-and-mouse game. Now all leisure transpires beneath the glaring lights of members-only getaways, where visibility is expected, and expensive. As a personification of these values, a liberal academic accosts the journalist, "Michalina la Belletriste," after a volleyball game:

> Write a novel about us. Us gays ... It should be a narrative about two middle-class, educated gay men, doctoral students in management and finance, who wear glasses and woolly jumpers ... Mornings they lounge around in the same bed watching the same telly together, and for breakfast they eat toast with sliced tomatoes off the same plate ... They've established a stable, long-term relationship, and now they want to adopt a child. But they've run into trouble, see. Society, you see, doesn't accept them, even though they're well bred and well behaved, as the reader can tell. You can make the contradiction even more apparent by giving them neighbours who have a wretched marriage, who drink all the time and beat their children.[14]

Michał facetiously agrees to write the novel, "the perfect gift for Valentine's Day," as he declines an invitation to "some gender-something queer-something conference at the university in Poznań ... informed by Judith Butler 'n' stuff."[15] This cloyingly progressive metanarrative, transpiring on behalf of a presumed collective identity ("us gays"), summarizes Michał's experiences with a younger generation on

13 Ibid, 81.
14 Ibid, 155.
15 Ibid, 156.

the beach: all cheerful arrogance and Anglo-Saxon aspiration. Michał has had enough, and his recoil motivates the novel's comparative ethnography: "I ran back to my blanket, to the sixties, to the seventies, to the flask, the tinned tomato soup that Old Dear No. 2 brought back from the Spółem cafeteria. I escape with them. With us—a flock of queeny trollops from the picket line, occupying the margins of post-1989 Polish society like a chancre on its arse."[16]

The Picket Line

The "picket line" in question isn't strike support, but tongue-in-cheek slang for the cruising grounds, Lucretia explains; and fittingly, the queens look after one another as comrades on this "pricket," keeping each other in work and out of harm's way. Furthermore, despite the official proscriptions of communist-era sexual conservatism, the queens are not without their fellow travellers; most notably, the Toilet Ladies; stoical washroom attendants who look the other way on public sex for several złoty. These staples of socialist public life act as informal co-conspirators in a queer redrafting of civic space, and in the cultivation of a para-urinary sexuality hidden in plain sight of police and passerby. "They can sit in there all day, for all I care," says one attendant in Oleśnica.[17]

In *Sexual Hegemony*, Chitty describes an inadvertent urbanistic ally to gay nightlife in the post-revolutionary renovations of French cities for the provision of "sanitary convenience." Thus Chitty finds in Haussmann's Paris a fascinating dialectic of discipline and permission, where middle-class outrage at public urinary rites produced a strong demand for city planners to shield latrines from view. As a result, "the new architecture of enclosure concentrated the exercise of such bodily functions around a few nodal points along busy thoroughfares and erotically intensified the experience of urination in public by providing a semiprivate, same-sex urban space."[18]

Insofar as Haussmannian environmental design informs so-called Stalinist architecture, especially in socialist realist enclaves such as Poland's Nowa Huta, a practical correspondence is clear—though

16 Ibid, 162.
17 Ibid, 260.
18 Chitty, *Sexual Hegemony*, 125.

the history of this public utility was subject to avant-garde elaboration under socialism too, having as much to do with experimental cultures of communal living. It's even tempting to describe these energized spaces as de facto "social condensers," after the famous concept of Soviet Constructivism—a multipurpose design intended to socialize the user and facilitate the creation of an authentically cohabitating citizenry. This is only incidental, but from the first European public toilets in eighteen-forties Paris to the all-but-chaperoned spaces of sexual encounter frequented by Patricia and Lucretia in nineteen-seventies Wrocław, a tacit permission flourishes in the very partitions by which a common decency is to be preserved.

As Chitty would have it, the "material history of urinals and the social history of their placement in urban space demonstrates the growing influence of concerned middle-class women" in the public sphere, as a domestic standard of "consent to copresence with sexual acts" extended from private households to the streets.[19] To a degree, this moral panic inverted or reversed the customary dynamic of nineteenth-century proletarian congress, where men sought privacy in public, apart from densely overcrowded, multi-generational households. But the attempt to corral male sexuality only furnished it new occasions and accomplices. This history instructively contrasts the activation of the public urinal by the queens of *Lovetown*, who memorialize their women invigilators, like the "Pissoiress of Central Station," as one half of a slapstick caper: "Oh heaven, it's them pervies again!" she proclaims on discovery. "Go back where you belong or I'll call the police! Back to your cubicles! Józek! We've got another slip-through on our hands! We'll have another wedgie in a moment! 'Cause I'm going to clean this floor, and once I get that mop in my hands I'll have you up against the wall!"[20]

Grunting

A riskier triangulation structures this surreptitious—subsidized, if not exactly free—love, where Michał's elder company are connoisseurs of "grunt." Patricia explains:

19 Ibid.
20 Witkowski, *Lovetown*, 320.

Grunt is what gives our lives meaning. A grunt is a bull, a drunken bull of a man, a macho lowlife, a conman, a top, sometimes a guy walking home through the park, or passed out in a ditch or on a bench at the station or somewhere else completely unexpected. Our drunken Orpheuses! A queen doesn't have to go lezzing around with other queens after all! We need straight meat! Grunt can be homosexual, too, as long as he's simple as an oak and uneducated—[21]

In spite of the risks involved in courting this macho pathology, which *Lovetown* details in brutal digressions, the brusque outcomes are as frequently affirming. As Patricia continues, theorizing his own experience directly, military conscription and the stationing of Russian troops swelled the ranks of available grunt, making nearly unlimited sex with avowedly straight men immediately accessible to the queens of the night. Soon it became a ritual to break into the barracks after-hours, where dozens of deployed men less discerning than at home would avail themselves of unlimited sexual favour:

It's true, they'll never forget us. They're lying there on the banks of the Don, married now, with children, old and fat in their deerstalker caps, no longer the young men they once were. But they're there — they told us they would be — looking up at the sky, at the stars, thinking: "Somewhere, under these same stars, my Andriyusha (Patricia) is at the barracks now, far away in Poland."[22]

The mutually buttressing norms of sexual hegemony in the Eastern Bloc then produced a particular co-dependency, within which arrangement the gender and sexual expression of the queens was intelligibly affirmed. "What do you mean I'm not a woman?" Patricia snaps at a second-guessing soldier. "I have a mouth, don't I? And a vagina, too," she says, flashing her asshole.[23] Functionalism aside, the gay argot by which the queens navigate the social ontology of gender is by no means simplistic or without distinction. Patricia insists that while the

21 Ibid, 12.
22 Ibid, 48.
23 Ibid, 47.

Legnica queens were predominantly trans, the "Wrocław school" was strictly gay, but opportunist; and however coarse the language of this basically respectful distinction, both scenes shared a gendered jurisdiction, diametrically marked by the self-understanding of remotely stationed trade.

As Chitty describes, the class alliances that founded early bourgeois republics also "generated institutions for cross-class sexual contact between men."[24] In overview of post-revolutionary France, Chitty will note the "explosive growth of a citizen army of bachelors," as comparatively equalized pay and mass conscription placed hundreds of thousands of men in common company, from peasants and artisans to clergy and the petty bourgeoisie.[25] And much as the socialization of both war and labour facilitated cultures of fraternal sex across class lines in the eighteenth and nineteenth centuries, the relative amelioration of the class society by full employment and state planning in the Eastern European socialist states created new cultures of surreptitious encounter, including the barracks sexuality in which Witkowski's queens revel.

Like Drugs, I Guess

For all of the shadowy escapades composing these collective memoirs, and the many contingent respects in which social planning furnished a gay underground its necessary infrastructure, it would be difficult to argue that the Eastern Bloc was a haven for homosexuals at any point in its existence. Nonetheless, we must insist that homophobia, in its official and unsanctioned forms, is incidental to the socialist project, rather issuing from pre-revolutionary and religious cultures subject to political modification by a particular state.

Certainly the queers memorialized in *Lovetown* lived outside approved society, in many ways eking out a life on the margins of socialist experiment. And yet, its many minimal amenities supported this officially disavowed lifestyle. As Patricia reminisces, "no one ever went hungry with that tinned soup, with those potatoes, the subsidies of socialism. There was always enough to eat and a roof over

24 Chitty, *Sexual Hegemony*, 38.
25 Ibid, 123.

your head; a lady doesn't need much to get by. Now they're building a great big shopping mall in that park of theirs; they're burying their entire history."[26] Michał's Great Atlas of Polish Queens makes a persuasive case that it's precisely the outcasts of the former Polish People's Republic who are least served by the liberal dawn; those such as Patricia and Lucretia and the Old Dears in their deregulated apartments, who, however much they were marginalized from the mainstream of socialist society, are further still from the middle-class beneficiaries of a post-socialist transfer of wealth.

Our narrator's second-hand nostalgia, contrarian at first, spans this distance, as his own sexual coming-of-age moves from a subterranean lovetown, collapsing under threat, to the unflattering light of capitalist day. Michał explains how he first met Patricia at the railway station in 1988, several years before their present interview, moments after hooking up with a man twice his fifteen years in a nearby cubicle. Michał shudders to process the experience: "love bites surfaced on my neck, reddening treacherously like the first symptoms of AIDS."[27] One year before the Solidarność movement would offer the west a foothold in the socialist bloc, and during one of the darkest periods of the global AIDS pandemic, his sexual awakening is already fraught with end-historical peril, in claustrophobic contrast to the harassed but uninhibited sexual freedom of his elder hosts over preceding decades.

The ghosts of AIDS dead haunt the heedless sexual accountancy of *Lovetown*, too: the pariah Zdzicha, or Jessie, the first of their crowd to contract HIV, who dies in delirium on a hospital table, following a hallucinated procession of family and friends. AIDS awareness was late in coming to the Eastern Bloc, an Old Dear explains, timed as if to coincide with the collapse of the socialist lifeworld: "around 1988 or so people started talking about it. It never occurred to anyone that anything like that could happen in Poland: it was a product from the mythical West, like pineapples; it was chic, a little bit like drugs I guess."[28] Such incredulity courts racism and xenophobia; but in spite of the deadly reality of HIV and AIDS, this extra-economic risk arrives

26 Witkowski, *Lovetown*, 7.
27 Ibid, 38.
28 Ibid, 194.

in the lives of Poland's queens as a coincidental indicator of deregula-
tion and downward mobility, as rates of sexually transmitted infection
peak alongside the rapid deterioration of public health infrastructure
post-"independence."

Antisystemic Sex

Rates of HIV infection in eastern Europe may index liberalization, but
it remains for a theory of post-socialist sexual hegemony to account
for the frightening uptake of state and civilian homophobia after the
advent of liberal democracy. In an essay on the significance of 1989,
Giovanni Arrighi, Terence K. Hopkins, and Immanuel Wallerstein
observe how the merging of former socialist states with the capitalist
world-system accompanies the disintegration of commensurate moral
communities. Under such conditions, of the declining capacity of the
state to moderate the world-economy, various competing cultures and
claims take root: new nationalisms which attempt to replicate "state-
ness" for an exclusive community, and new fundamentalisms which
attempt to negate the former jurisdiction of the state altogether.[29]

Contemporary Polish politics has been hospitable to both tenden-
cies; as sociologist Richard Mole describes, nationalism throughout
former socialist states after 1991 may be seen to fill an ideological
void after the abandonment of Marxism-Leninism. This has been
accompanied by a significant uptake in official homophobia, where
the traditional family is posited as the smallest self-sufficient unity
in which the nation is expressed. If anything, we could note the
transformation of a persistent homophobia from a productivist, state
injunction to an ethno-nationalist response to state obsolescence, where
the family as a miniature unity supplants a former social safety net
after the dismantling of socialism.

Moreover, Mole notes, a United Nations Human Development
Report on post-Soviet Latvia even suggests that communism had dis-
torted social relations between men and women, harming the family
unit. This is important to grasp, for even though homosexuality was

29 Giovanni Arrighi, Terence K. Hopkins, and Immanuel Wallerstein, "1989, the
 Continuation of 1968" in *Review* (Fernand Braudel Center) 15, no. 2 (Spring, 1992):
 221–242; 235.

debated as a criminal deviancy or psychological disorder through-
out the socialist bloc, its communities are nevertheless potentiated
by the weakening of traditional family bonds after increased gender
equity. [30] Notwithstanding the well-observed universality of homosex-
ual behaviour, which is certain to survive under even the most adverse
conditions, the socialist republics of Eastern Europe furnished several
objective conditions for gay culture, even as it was forced underground;
including civic conscription, rapid urbanization, women's emancipa-
tion, public infrastructure, and a high social wage. For all the informal
economies and backroom arrangements characteristic of queer life
under communism, it was infrastructurally underwritten; capacitated
if not permitted.

Where this sexual infrastructure is concerned, Arrighi et al offer a
suggestive formulation as to the relative autonomy of cultural enclaves
during a crisis of the state-form:

> Such communities grow as state power, crippled or deflected or
> bought off, recedes; and state power in and over them recedes
> as they become self-provisioning and, especially, self-protecting.
> They come to life, as is said, "outside the law" (and thereby
> outside civil society) and become centers for all manner of
> illegal relational activities whose spheres of circulation reach
> throughout the larger society and often abroad as well. Like
> secret societies everywhere, they are strict about membership
> and closed to outsiders (especially non-member state officials),
> but they occupy a territory and that makes them a substitute
> for state power, not just another source of its corruption. [31]

To the degree that the sexual picket of *Lovetown* can be read as such
a parasocial shanty, its antics map onto several late blows to the socialist
state, including but not limited to the "restructuring and acceleration"
of the Gorbachev era; drastic price hikes by Jaruzelski; political agita-
tion from Rome; American sanctions halving Polish exports; and an
unpopular state response to unrest, contrived and organic. Against
the backdrop of the market-led refeudalization of society, the queens

30 Richard C.M. Mole, *Soviet and Post-Soviet Sexualities* (Milton Park, Abingdon-on-
 Thames: Taylor and Francis, 2020), 6.
31 Arrighi et al, "1989, the Continuation of 1968," 235.

of *Lovetown* are crowned anew, supplying each other with work and cigarettes, distributing favour and official dispensation from the "party queens" upon whom fortune smiles. As liberal shock therapy descends, these informalities come to supplant moreso than supplement a waning state, as its merging with the capitalist world-system accompanies the disintegration of socialist mores.

At the same time, this disintegration commends "other loci of primary loyalty and moral direction—particularly when power itself is splintering and these alternatives also provide protection of person and property."[32] These would include a post-communist queer underground as soon as its religiofascist and nationalist antagonists—reactionary countertendencies to the more or less sudden replacement of the state by enterprise. Tellingly, researcher Gregory E. Czarnecki compares contemporary Polish homophobia to nineteen-thirties antisemitism, where both Jews and "sodomites" are perceived as a destabilizing, internal threat; a "state within a state."[33]

Post-Morbid Emancipation

This hard-won, unresourced, and encircled autonomy falls considerably short of sexual freedom. As Chitty writes, "gays and lesbians got a shot at the good life precisely at the moment of its political-economic liquidation"; and while Chitty concludes in overview of the post-Stonewall United States, this is only more starkly true of the former Socialist Bloc, where gay liberation has made only the slightest gains amid the complete dismantling of virtually all public institutions.[34] While a multicultural "politics of recognition" offers to restate homosexuality within the terms of bourgeois sexual hegemony, such an assimilation requires renunciation of those very experiences in search of recognition.

Lovetown renounces this renunciation, and Michał seethes defensively towards a gaggle of gay tourists as they tower above him and his elder coterie: "They're from the 'emancipation phase' (unlike us, hence the boundary running straight up across the beach, up by the

32 Ibid.

33 Judit Takács and Roman Kuhar, eds. *Beyond the Pink Curtain. Everyday Life of LGBT People in Eastern Europe* (Ljubljana: Politike Symposion, 2007), 333.

34 Chitty, *Sexual Hegemony*, 173.

defunct radar and the red flag)."[35] As if on cue, the Old Dears fade into the dunes, leaving Michał on the receiving end of another lecture:

> Something about adoption, equal rights, the right to marry, the Green Party, civil partners, monogamy, safe (monogamous) sex, and condoms. We're civilised people, you know. We want to do this right, with a sense of morality, with the sanction of society, wearing white gloves (so as not to soil ourselves by association with you). Then he began telling me how it's people like me who give gays such a bad name; and that while we (i.e., me, the Old Dears, the Blond, and other frequenters of the dunes) were going at it like dogs in the bushes, they'd come here with their volleyballs, athletics, and fitness regimens to drag us out of our pre-emancipatory, post-picketatory gutter—in short, they wanted to give us something useful to do.[36]

Michał and his nostalgic interlocutors decline to be rescued from the gutter; elsewhere, Chitty glances upon the work of theorist Michael Warner, whose nineteen-nineties polemic against homosexual conservatism posited a proudly transgressive homosexual identity, fostered in "tearooms, streets, sex clubs and parks" and other "scenes of criminal intimacy."[37] These counterpublics, however, remain highly provisional in their cultural and architectural specificity, such that Chitty finds this program of transgression to be "nostalgic for the weakening forms of bourgeois power that formed the counterpart of a resistant queer culture."[38]

The furtive enthusiasms of Patricia, Lucretia, and Witkowski's queens are certainly beholden to their opposition. But Michał's reconstruction of their socialist lifeworld exerts a series of demands that considerably exceed any one-sided social critique. *Lovetown* isn't only about the pursuit of pleasure in exigency, or the risks of visibility without hegemony, or the salad days of two charismatic lechers. In positing the homosexual as a measure of public space, rather than an emblem of individual freedom, Witkowski's communist-era fuckbook

35 Witkowski, 149.
36 Ibid, 150.
37 Quoted in Chitty, *Sexual Hegemony*, 180.
38 Chitty, *Sexual Hegemony*, 181.

implies an inventory of far-reaching demands for a world in which it is possible to love, anonymously or not, as one wishes, wherever. That these demands issue from an unfinished past, foreclosed upon in all its promise and repressiveness, ought to remind us of the many elders, outstanding personalities of the struggle for gay liberation, who have come before. Our corridors are their memorial, whatever state we find them in, and must be defended as such.

Who is the Blue Clerk?

Who is the Blue Clerk? In the first pages of poet and novelist Dionne Brand's book of the same name—an anthology of philosophical impressions, poetic micro-fictions, and illuminations—the Blue Clerk appears to the reader on a pier, at the threshold of water and continent; awaiting a ship to rendezvous her already immense cargo. The Blue Clerk watches the horizon:

> There are bales of paper on a wharf somewhere; at a port, somewhere. There is a clerk inspecting and abating them. She is the blue clerk. She is dressed in a blue ink coat, her right hand is dry, her left hand is dripping; she is expecting a ship, She is preparing. Though she is afraid that by the time the ship arrives the stowage will have overtaken the wharf.[1]

Thus, the first tableau that we receive is nearly indissociable from the scenery of world trade; of logistical regimes and spatial fixes; of migrancy and enslavement; otherwise, from the negative geography that sociologist Paul Gilroy will inventory as a system of cultural and commodity exchanges in itself, "the Black Atlantic." The Blue Clerk appears a figure in an original mythology of these things; and of a poetry commensurate in implication with the repressive violence of the world from which it originates.

The clerk, we're told, is keeper of the poet's left-hand pages: overwhelmed by folio on folio, continually arriving as freight. In this

1 Dionne Brand, *The Blue Clerk* (Durham: Duke University Press, 2018), 4.

outdoor office, the Blue Clerk holds a record of the remainder, of the repressions, of writing; saying only that which goes unsaid: "What is withheld is on the left-hand page. Nine left-hand pages have already written their own left-hand pages, as you will see. I have withheld more than I have written."[2] These collected versos are not drafts but traces, ulterior contexts for the topmost, attributable layer of language. Multiple registers of apprehension diverge in the clerk and the author and their respective collections, where the verso is historical and the poem is occasional: "the clerk lives in time like this, several and simultaneous. The author lives in place and not time. Weighted ... We negate each other."[3]

Then we are reading something other than the writing; a writing of the writing, a record of the record of a view upon an event. This writing, on presentation, implies a further record of the facing page, ad nauseum. On the face of it, this conceit appears to literalize Derridean différance—supposing a work that proceeds entirely on the side of the recursive trace, which Derrida himself had sometimes figured as a sheaf. In a poetic gambit verging on magical realism, the clerk exists in an archival present; in a syntactical city at a synchronic junction, minding the store, as it were. This present is the product of indefinite deferral; and the author as a finite body always works "a short step away from the present ... living that little fissure between scenes of the real."[4] Here again the clerk stands for the presence of the present, and the historicity of history. As traces of the poet's experience threaten to overwhelm the wharf, the Clerk of the Versos presides over the spatialization of time, as a positive record of the subject's essentially negative bearing in the world.

The Blue Clerk is a kind of tidalectic herald to the poem as well as an authorizing presence; an historical counterweight to the imaginary arts, and an imaginary complement to the author's occasions, conveying isolated instances to an overarching context and vocation. In this, the Blue Clerk is a formal postulate of poetry; corresponding to a full record, existing somewhere of necessity, of those subtending conditions that the poem as a made thing must omit. Sitcoms, cities,

2 Ibid, 3.
3 Ibid, 135.
4 Ibid, 92, 93.

ancestries, foreign policies, all manner of involuntary associations that elude the text and structure its reception are named as such in this agglomeration of forgotten substance, from which material "the grim list of the clerk begins."[5]

In this capacity, the clerk is both a political unconscious and an Angel of History, whose retrospection cradles actuality. This calling follows upon many precedents from theory and literature, narrators whose perspective appears to straddle the seam of the text whence it originates and the world in which this text must circulate. To speak of angels—Verso 13.1 cites poet Kamau Brathwaite's permutatory tale of the Black Angel as both a template and totality: "It is here in the Black Angel that everything is said already, everything that can be said," she admits, only extending a generative text.[6] In Brathwaite's story of the same name, the Black Angel denotes a leather bomber jacket that confers grace and impunity to its wearer within the irrepressible sociality of an otherwise dystopian factory setting. Like the Blue Clerk, the Black Angel is a figure of transcendence, a "pillowy amnesty" swaddling its worker-owner amid hostile environs.[7] Accordingly, the wearer becomes an "agent, *incarnation*" of the Black Angel—"a living form that was something other than itself."[8]

There are noteworthy similarities between the Blue Clerk's wharf and the Black Angel's factory; fantasy settings nonetheless derived from a too-real industrial scenery. In each case, a nearly Virgilian narrator speaks from and for a hidden abode, of circulation or production—"*the warped fantastic environment of our lives*," Brathwaite writes and Brand quotes, contrasting blue and Black arrivals.[9]

Why is the Blue Clerk blue? Blue indexes this world's interrelations: "Blue tremors, blue position, blue suppuration. The clerk is considering blue havoc, blue thousands, blue shoulder, where these arrive from, blue expenses."[10] This fixed-base incantation recurs, alongside complementary inventories of violet and lemon, implying as many currencies as

5 Ibid, 67.
6 Ibid, 73.
7 Kamau Brathwaite, *DS (2): Dreamstories, Volume 2* (New York: New Directions, 1989), 21.
8 Ibid, 22, 40.
9 Quoted in Brand, *The Blue Clerk*, 73.
10 Ibid, 72.

there are colours: "Blue the clerk has collected from exhaustion: blue maximums, blue wine, blue safety, blue descent … blue sprinkle, blue expenses, blue opportunities, blue discriminations, blue disciplines, blue suppurations, blue ants, blue proceedings," and so on, seemingly without end.[11]

Tracking flights of synaesthesia, blue is both signatory and auratic here; an incidental or imputed feature of a thing by which a fleeting essence may nevertheless be revealed. The clerk's blues, as distinct from many a scrivener's doldrums, see to the provisional or poetic identity of things under a general sign. This unexpected revelation is, to be sure, an effect of poetic language. But are these variously hued blues—in and in spite of their plurality—*the* blues?

What is the Blue Clerk? (Blues-Form and Value-Form)

For poet Amiri Baraka, "blues" names an impulse rather than a musical idiom; not only that, but an historically cultured impulse that operates uniquely on behalf of those ancestrally displaced by the transatlantic slave trade rather than a particular musical idiom—"even descriptive of a plane of evolution, a direction … coming and going … through whatever worlds."[12] This lacing effect of blues-as-direction clearly defies genre, describing a highly adaptive yet resilient form, which Baraka famously terms The Changing Same.

The Blue Clerk, too, describes her lifelong attempt upon Charles Mingus' 1956 recording *Pithecanthropus Erectus* in amenable terms; the suite, she says, stands as a work of instrumental political philosophy, of which her listening attempts translation. "I've only been able to make out the first two minutes of it like the first two chapters of *Capital* you are constantly going over," she admits to the author.[13] But "once you attempt to translate it into the sense of a language with vowels and consonants say, that is the sort of language that directs sound in a particular direction as opposed to another—let us say in the direction of known conventional languages that we use to 'communicate' with,

11 Ibid, 106.
12 Amiri Baraka, *Black Music* (New York: Da Capo Press, 1998), 184.
13 Brand, *The Blue Clerk*, 101.

then you are lost."[14] This system of registration or legibility arrests the music in a static form, limiting encounter with its sensuous materiality.

Suggestively, poet Tyrone Williams pursues an analogy between the Changing Same and the convoluted vehicularization of value in Marx, shored in so many changing figures. Value is multiform from its earliest appearance in Marx's mature project, where it appears both as salutary usage and as social efflorescence; as utility and exchange. Marx himself ambiguates this bipartite demonstration, for something can have a use-value without having a value; the beneficence of the sun, for example, which isn't mediated by labour; just as a thing can be useful, and a product of labour, without being a commodity; a poem or a piece of music, perhaps. The merely dual character of value is itself a posit of capitalism, where the value-form of abstract labour commends itself to monetary representation.

For the purposes of speculation, Williams adapts geographer George Henderson's argument that there is no single consistent definition of value across Marx's work, such that we can imagine a range of "ulterior constructive content" for value that exceeds, and precedes, the capitalist mode of production.[15] This alternative font of value, implied at the outset of *Capital*, has a strictly differential relationship to the processes of evaluation that Marx describes as belonging to the capitalist epoch—if anything, these alternative determinations of value, beyond one-sided utility, would reside among those prior and persistent cultures which capital incessantly represses and invades. With this suggestion in mind, Williams argues that Baraka's Changing Same— an impulse without essence, moving through a variety of historical figures in its application—offers a compelling instance of this non-capitalist value form:

> As a concept irreducible to any manifestation it makes possible, value might be understood as a synonym for what Baraka sometimes called the blues impulse, inasmuch as the latter functions as the apex of a dialectic. Thus, my reading of Baraka's blues impulse corresponds to Henderson's reading of Marx's value,

14 Ibid, 165.
15 George Henderson, *Value in Marx: The Persistence of Value in a More-Than-Capitalist World* (Minneapolis: University of Minnesota Press, 2013).

insofar as both appear within capitalism with one face (one facet)—for Henderson, as the condition and effect of capital; for Baraka, as commercialized music and imitative literature—and appear only "after" capitalism with another face—for Henderson, freedom; for Baraka, art … Insofar as value (as Henderson reads it) and the blues impulse (as Baraka understands it) unfold both during and "after" the epoch of capital, the contradictions and contraries foundational for dialectical thinking cannot be avoided.[16]

Williams's description of a multi-faceted preserve, in which different temporalities or destinations of a thing are held together by a momentary form, could as soon encompass the diaphoric system of interpretation set forth by Derrida, as well as the schemata of Marx and Baraka; for after such point as value has been pluralized so as to designate both an equivalential operation *as well as* that which resists equivalence—an extra-systemic difference, if not an essence—we can see it everywhere, wherever something enters into contradiction, or contradistinction, to an instance of itself. In an elegiac mood, Derrida himself says as much of the duplication of sensuous use-values by the "ghostly schema" of the value-form—which "displaces itself like an anonymous silhouette or the figure of an extra who might be the principal or capital character."[17]

The Blue Clerk may be seen as such a capital character, and the Black Angel, too; only in the dual sense anticipated by Baraka and Williams, outstripping the historical confines of the commodity form in which an ulterior value or material basis is negated. Williams seeks a precedent for this open sense of value in Baraka's own perambulatory verse—hoping that poetry might further Henderson's proposal to "inject a stream of value thinking to a different purpose: the search for disjunction, for the out of joint, for the principle of destabilization of meaning."[18] This sounds a properly poetic project on the face of it;

16　Tyrone Williams, "'The Changing Same': Value in Marx and Amiri Baraka," in *Communism and Poetry*, eds. Ruth Jennison and Julian Murphet (Cham: Palgrave Macmillan, 2019), 77.

17　Jacques Derrida, *Spectres of Marx*, trans. Peggy Kamuf (New York: Routledge, 2006), 189.

18　Henderson, *Value in Marx*, xxiv–xxv.

and the essentially spectral calling of the Blue Clerk evokes not only the phantasmagoria unfurled by the commodity form but the endless deferral and suspense characteristic of literary deconstruction. As a name for an archival drive commensurate with experience, the Blue Clerk stands for a principle operating quite apart from the equivalential registration of bourgeois life. This alternative valuation is non-autonomous, however, of the capitalist ledger of values that presides over so many transmutable essences, under the sign of exchange.

This alternative conception of value specifically accommodates, if not accounts for, those cultures that have been captured by capital accumulation from its earliest developments. The Changing Same is a fascinating analogue to value form; but one needn't reach quite so far to find a precedent for this alternative, positive valuation in Baraka's thought. In 1969, Baraka—as Imamu Ameer Baraka (LeRoi Jones)— published "A Black Value System," a sevenfold proposal for the national sovereignty of Black people in the United States. In this manifesto, Baraka lists Ujamaa, or cooperative economics, which accords with an orthodox socialist proposal of correct evaluation by associated producers, alongside spiritual and cultural values like Nia (Purpose) and Kuumba (Creativity), suggestively blurring a range of evaluations typically held at conceptual distance from each other in capitalist society. This composite clearly affirms a set of ulterior, constructive values that exceed the analytic categories of capital, and of *Capital*. As Baraka says:

> Ujamaa … is an economic attitude older than Europe, and certainly older than the term Socialism. Which finally is another thing, coming from the European definition, since the European definition is a state that will exist "after the decay of capitalism." Ujamaa has always been the African attitude towards the distribution of wealth.[19]

It's clear from this example that value, as a social relation, has assumed many forms outside of capitalist exchange, each with its own representation, irreducible to either the catchall positivity of "matter" and "utility," or the falsity of commodity fetishism. Where this terminology is concerned, anthropologist J. Lorand Matory has

19 Imamu Ameer Baraka, "A Black Value System," in *The Culture of Revolution: The Black Scholar* 1, no.1 (November 1969): 56.

described the Afro-Atlantic religious precedent for the status of the "fetish" in Marx as well as Freud, accusing both thinkers of securing their own contestable Europeanness by condescending to a further other in their figurative language. Despite his slim engagement with the terms of their respective projects, Matory vividly demonstrates how the European anthropologists whose terms Marx and Freud adapt failed to perceive the "fetish" as a living system of relation, immanently social and constantly evolving in subsequent contexts—which is to say, a form of value.

Marx's description of the commodity fetish borrows plausibility from this term by which European commentators addressed the "materialized gods" of native religion; but "fetishes are fulcrums of all social organization and self making, including historical materialism and psychoanalysis themselves," Matory argues: "fetishes are things that both animate contrary social roles and are animated by contrary value codes. In ritual and social use, they both clarify subjectivities and facilitate their interpenetration."[20]

Without eliding differences within a variety of African and Caribbean religious systems, we should note that Brathwaite's Black Angel—"a living form that was something other than itself"—is a fetish in a dual sense. As a jacket, manufactured by human labour and assigned a money-form, the Black Angel is a commodity in which the sociality of said labour is obscured. In Brathwaite's story, however, the Black Angel is also a personal talisman and avatar of the priestess Ta Mega, offering protection. In this sense, the so-called "use value" of the jacket isn't only to keep its owner warm, but also coincides with the ulterior and cultural font of value that Williams, by way of Henderson and Baraka, proposes to operate within—which is to say, before and after—capitalism. Where this cultural production is concerned, there are only relative degrees of subsumption.

Where is the Blue Clerk?

Whether construed as the unfolding of difference, a ritual means, or a planar series of creative transformations, value necessarily takes a form

20 J. Lorand Matory, *The Fetish Revisited: Marx, Freud, and the Gods Black People Make* (Durham: Duke University Press, 2018), 2.

other than whatever else it is. Thus the "capital character" of the Blue Clerk, whose spectral presence oversees a process of which it is apex and posit, differentiates itself from the author despite their ultimate identity. Something more than a conceit holds these roles apart; rather, this parallax—of value and evaluation, content and form—describes the phenomenology of capitalism at a preliminary level, which the clerk seems both to summarize and evade.

Capitalist actuality furnishes *The Blue Clerk* its content and keynote. War roars beyond the page—"a war, indefinite article, warns the clerk"—as the macroaggressions of intercontinental white supremacy condition its grammar and legibility.[21] And yet the clerk, as a principle of poetry itself, quotes and refutes these pages of imperial record in an evaluative or diacritical mode; meaning, prime: "Poetry's diacritic force (like Coltrane's Venus, or Charlie Parker's Ornithology) allows, breaks open, explodes the language of race power, registering the sounds of our living in the diaspora, the sounds of the always possible world-space one lives."[22]

In this revealing "stipule," Brand harmonizes Baraka's conception of the Changing Same: "different expressions (of a whole). A whole people ... a nation, in captivity."[23] This musical accompaniment to the coloniality of power isn't a soundtrack or interpretation, but an ulterior force, "characteristic of revelation through the creative."[24] As a diacritical marking of a master text, notating a surfeit of social being, this creative force not only enacts prosodical cross-rhythms to a colonial tongue, but negates the sense of the description.

In a dialectical extrapolation of the Changing Same, the clerk and author, debating amongst themselves, read Brand's 2010 work, *Ossuaries*, through the dialogic scaffold of John Coltrane and Rashied Ali's 1967 recording "Venus," from the album *Interstellar Space*. "In 'Venus' there are two basic elements, the author paces, the horn and the drums. They are working with doubleness, they are working with time."[25] The piece begins with a rustle of percussion, before the melody

21 Brand, *The Blue Clerk*, 61.
22 Dionne Brand, "An *Ars Poetica* from the Blue Clerk," in *The Black Scholar: Journal of Black Studies and Research* 47, no.1 (2017): 58–77, 64.
23 Baraka, *Black Music*, 185.
24 Baraka, "A Black Value System," 54.
25 Brand, *The Blue Clerk*, 75.

alights upon a cymbal patter, brushwork counterpointing scalar fidgets. "The drum serves as pacing for the horn, but it has its own investment in this state of things," the author notes, as a formal analogy to the clerk's placement alongside her metered progress: "It holds underneath, but its own project is to also find deconstructions."[26]

The first phrase is speculative, the clerk insists; invested over the course of its elaboration, commencing an intricate web. As the theme develops, the author continues, urged forward and to greater clarity by the clerk, "the music is fully realized as separate and sentient on its own."[27] The permutations of melody, the howling flourishes of derivative phrases and figures, continue until such point as "the state, the register itself is now indescribable without its fragmentations. It rejects its former self, as well as it accepts that somehow that self like a shadow is embedded in it, in him."[28] Beneath this spectralization of the melody, "the drum sustains," much as the author's tercets, "sheltering, pushing," keep time beneath the argument.[29] "Venus" is the juncture of poem and history, author and clerk, substance and value, or spirit; its pulse a metric of accountancy beneath a vertical accumulation.

Where the strange phenomenology of this text is concerned, the clerk reminds us of its substance. "Poetry has no obligation to the present," she says. "It *is* time."[30] This aphorism, of course, concerns not only the material stuff of poetry, as experience accrued and as craft, but names the occult substance of value in any Marxist account, to be reinvested in a post-capitalist value regime such as the poem protects. In the Blue Clerk's apprehension, all time is eternally present; ancestral lineations and addresses, cancelled itineraries and wistful contingencies, all coexist in a bale of impressions: "the veined blue book of her thoughts."[31]

This organic figuration suits the larger fantasy of an integral record, like the back of a hand. On the wharf, however, the author's experience has evidently burst its local bonds, as traces and pages overwhelm the present as if imported from outside the subject: "the global violence,

26 Ibid.
27 Ibid, 76.
28 Ibid.
29 Ibid.
30 Ibid, 112.
31 Ibid, 186.

one's own violence, the recognitions of one's own violence, the tercet anchors. Anchors, anchors, anchors, the tercet anchors. What colour is an anchor?"[32] The Blue Clerk sees to the completed ledger of experience—its preconditions and connections, and its verbal exchanges: "one hundred and seventy thousand odd nouns after the colour blue or violet ... Violet metres, violet scissors ..."—only awaiting further freight.[33]

Here especially, the litany as form convokes totality in its discontinuity; agrammatical and additive, its conjuring of names betokens bottomless multiplicity, a lexical post-scarcity to match any intended meaning or description. But this quantitative, bad infinity is also uninhabitable; unfurling the empty time of capitalist exchange. The Blue Clerk tells us as much: in the present order, "all information is available, all history is available, all thought is available. Consuming is the obvious answer to life. This availability exists, the clerk says, but it really exists in the brain; it doesn't exist in the mind. One is rushing over it, or one has a landscape, but it isn't a lived landscape, all the details aren't lived."[34]

These details are elusive in their substance and particularity, and to compile them wouldn't make a place or person, yet. Such feats of maintenance require the retrospection and repair of an impending presence, a double of which persists amid the shapeless progress of exchange, angel of memory and inter-worldly melody: "as if living in an area just adjacent to air, a film of air which carries time ... several but simultaneous."[35] As a capital character, tarrying deeply with the disfigural implications of the commodity form and its ceaseless exchanges for experience, Brand's Blue Clerk stands for such reintegration of experience into the dispossessing landscape of capitalism, that one day it too may wither in the mist of recollection.

32 Ibid, 77.
33 Ibid, 184.
34 Ibid, 110, 111.
35 Ibid, 135.

Mixed Connections

On Gail Scott's *The Obituary*

Experience is thick with history. The rooms we sleep in, the streets we cross, the names by which we navigate an oceanic everyday, the bundled fibres of our very thought—these nodes are artefacts of a lengthy process, summarized by the present moment. This antecedence is both sedimented and unsettled, where a shift in perspective can change the order of events—significantly if not chronologically—and politically convicted writing greets the world it would reorganize with a keen sense of all that a record omits. As novelist Gail Scott writes, "the white noise of the past, and the multi-linguistic onomatopoeia of the present, are written over particular urban sites," and Scott's 2010 novel *The Obituary* sifts these sonic and historical layers with an ear to their silences, too.[1]

The Obituary is a multi-level excavation of Montréal's Mile End neighbourhood, perceived through the movement of R, Rosine or Rosie, a grammatically dispersed narrator; an unnamed historian, relegated to the footnotes; and an otherwise uncertain host of voices and perspectives on a shifting scenery, centered upon a century-old triplex apartment on the fictional rue Settler-Nun. These figures keep their own narrative time alongside and separate of R's motivating crisis, illuminating mists of expressivist prose with rays of historical apprehension. Scott's version of a city is a shifting entity, sifting contents,

1 Gail Scott, "The Sutured Subject," in *The Review of Contemporary Fiction* 28, no. 3 (September 2008): 62–72.

including inhabitants, by weight of association. Sound and scent preside, as subconceptual conductors of attention, but this resolutely contemporaneous haze of impressions—"jazzy, ephemeral, like all things of beauty"—is not simply mimetic of durée.[2] *The Obituary* is a densely symptomatic, descended, and cross-referenced collection of material impressions—polyphony derived from active passage: "Reader, the past carries a secret index. Little by little revealing why one meandering in speaking, as disparate in our associations as a voyageur looking from a train."[3]

In an early description of the technique of free association, Freud recommends that the analysand proceed as if describing scenes outside the window of a carriage, and such a multi-dimensional distance supports R's personal impressions. As she rides the bus through the city—the #55 North, "wheezing up boul Saint. Passing, on occasion, buildings on fire"—the outdoors and its petty dioramas, public arts, and pat emergencies blend into a free association.[4] Scott glosses this calling of the subject, as an inner-outer filter, and the pangs of non-belonging affected thereby: "At that very moment th' overconnectedness of experience fundamental to th' paranoia any citizen by definition usually trying to deflect."[5]

Scott's map of Montreal, established across decades of writing, is composed of so many layered rubbings; a socialist impression, a nationalist impression, a lesbian impression, and so on. To place any two of these in overlay establishes a correspondence between subjects, by way of a terrain of which each is tributary. Eventually the city is nothing else but this: a registry of traversals, frequently mistaken for transactions. The uncertain grammar of *The Obituary* enacts a corresponding parallax of subject and object: "I/R" relates the action, leaving to a reader's discretion whether to follow the first- or third-person perspective. Moreover, one might choose to read this narrator's name as a formal writing of the subject—an "I" divided against itself, self-identity split by the factical perseverance of the historical individual.

Throughout *The Obituary*, Scott insists on the essential continuity of public experience and private impression, "overconnected" in

2 Gail Scott, *The Obituary* (Toronto: Coach House, 2010), 38.
3 Ibid, 39.
4 Ibid, 67.
5 Ibid, 70.

the sense that mere phenomena nonetheless come to exert their own semi-autonomous effects on the whole to which they belong. This occult connectedness mediates the falsity or partiality of the fragment, a device upon which Scott's fiction only apparently depends. In *The Obituary*, the "~~Basement~~ Bottom Historian" stands for totality: operating in the margins, her calling is to enumerate those matters of historical contingency that elude sense even as they structure experience at a distance:

> We materialists [like paranoids] know the facts speak for themselves. *Fact*: Explorers early seeking Northwest passage to la Chine find waters permanently frozen. *Fact*: The town, mockingly named Lachine after explorer now seeking *inland* China passage, becoming main site of embarkation for fur-company voyageurs ever paddling toward lustre sun to the west. *Fact*: Business is booming.[6]

As the Bottom Historian keeps a ledger of colonial crimes, narrating the capture of land and labour by the capitalist state, Rosine is haunted by the past—by the Shale Pit Workers, her forebears among them, quarriers whose labour "ca. 1900" formed the stone facades of the city; and by visions of her mother, Veeera, whose family continue to painfully evade their Indigenous ancestry. As footnotes furnish the historical coordinates of "post-resistance" Métis identity, Rosine interrogates her family history in an ongoing and irresolvable soliloquy, intersecting the mutating city and living relatives alike:

> Grandpa: on the subject of genealogy. Was your paternal grandma Maria's lack of family name meaning she, like your Mother, Indigenous? Was the Canuck Maria marrying somewhere au nord du Québec mixed? Or pure laine? Was your father, the Saint-Jean-Baptiste Shale Pit Worker! fleeing smallpox epidemy, West, really marrying an Ojibwa wife somewhere in Ontario? Whose offspring [you, Grandpa] marrying [but why only saying after she dying?] a *Métis*, Priscilla Beaulieu.[7]

6 Ibid, 66.
7 Ibid, 158.

Dial M

The Obituary is a murder mystery, or so the reader is informed: the triplex of Rosine's sequester "silent + awkward as the apartment in *Dial M for Murder*," a play by Frederick Knott adapted for the screen by Alfred Hitchcock in 1954.[8] While the victim's identity remains uncertain throughout, there are plenty of bodies concealed from this text: in *The Book of Genocides*, passing between characters; in the ghostly procession of Shale Pit Workers, a sacrifice to the city; and in R's own surrogate body, supine upon a mattress on rue Settler-Nun, observed by an all-seeing and lascivious housefly.

In "Dial M[ontréal] for Murder," Scott marshals a range of texts and allusions to imply, rather than produce, a promised dénouement, from Edgar Allen Poe's allegorical tale *Ligeia* to the incident of Knott and Hitchcock's claustrophobic thriller: "Sadly, given history has two classes: the amassees + the masses. The amassee—instead of herself becoming dead on dining-room floor, killing her attacker with a lady's sewing scissors."[9] In this somewhat perplexing re-staging, the thwarted, and reversed, murder at the center of *Dial M* becomes an allegory of class domination. Scott frames this vision with a sonically pleasing, pseudo-Marxist aphorism; a formula that elsewhere designates both colonizer and colonized; landlord and tenant.[10] Sexual jealousy and class antagonism comingle in the desires of Rosine's petite bourgeois landlady, Jo, whose obsession with Rosine veers from fascination to harassment; and in the unreliable narration of their psychoanalyst, MacBeth, who tracks Rosine's disappearance in missed appointments: "Missing Rosie. With her it's not work."[11]

Suspects proliferate without a clear view of the crime in which they may or may not be implicated. At the outset of *The Obituary's* final section, entitled "A Clou in R Case," The Bottom Historian leaves the footnotes and assumes the role of narrator herself, offering a clue as to the consistency of our, or R's, account; fastening signifier to signified and past to present, as the bilingual pun suggests; or perhaps driving a nail into a coffin: "May we offer a clou in R case. A solid griffe or

8 Scott, 54.
9 Scott, 128, 129. Punctuation and emphasis original to quoted text.
10 Scott, 141.
11 Scott, 132.

claw from 'the past.' Which time-worn device [analepsis]. Deployed in wider noir genre. By way of photo inset. Or scintilla."[12] These slivers of foregone incident only remind the reader-viewer that the body or content of the present is precisely that which is past: "Do not skyscrapers bear, deep within, straw huts? The person, her ancestors?"[13]

The Historian's intervention animates scenes from Veeera's life, tableaux of Mile End in the nineteen-twenties, alongside R's traversal of the city's interiors; a dense contemporaneity of perspectives, collated by the enduring coordinates of their perception. Clues abound, but the mystery resists any straightforward solution where the distributed moments of its telling defy order. Here too, the time of the mystery story tends normatively toward revelation; a future in which past events are explicated, and certainty is established in retrospect. But just as Rosine's ancestry eludes the closure affected by posthumous renarrativization, the crime that is alleged to have transpired cannot even be committed, let alone attributed, within the present of its telling. The misattribution of mortality to an absent body is a prominent motif in the "wider noir genre" as well, where someone commonly thought dead miraculously reappears at a critical moment in the plot, rebooting the intrigue. Sure enough, no sooner than one has formed a picture of R as the possible victim, we follow her outdoors on various errands. Is this a noir flashback upon a victim's former routine, or are we faced with a more curious scenario, in which R's various avatars continue to attend the scene of the crime that her body secures? Here the lost object motivating the text is a missing body, too, and this uncertainty impedes the work of mourning.

Mourning and Melancholia

Mourning, in Freud's description, is a test of reality, over the course of which one gradually confirms the absence of a loved object to oneself. Freudian mourning is preservative and comparative, as a libidinal attachment is withdrawn from its former object-position. This project provokes strong opposition at first: often, the subject turns from reality, "clinging to the object through the medium of hallucinatory wishful

12 Scott, 118.
13 Scott, 117.

psychosis."[14] In the essentially progressive time of mourning, this evasive haze gradually gives way as "each single one of the memories and expectations in which the libido is bound to the object is brought up and hypercathected, and detachment of the libido is accomplished in respect of it."[15]

In melancholia, any attempt at detachment or working through is already thwarted, insofar as the object-loss is withdrawn from consciousness. Perhaps it isn't clear who or what has been lost; or, more correctly, perhaps one "knows *whom* he has lost but not *what* he has lost in him."[16] In cases of melancholia, Freud explains, an object-loss is transformed into an ego-loss, where one's over-identification with an abandoned object impedes letting go, turning that agony upon oneself.

In a vivid description of this rerouting process, psychoanalysts Nicolas Abraham and Maria Torok remap the derivative relationship between mourning and melancholia as a process of either introjection or incorporation. Incorporation, Abraham and Torok explain, is a fantasy by which one introduces "all or part of a love object or a thing into one's own body, possessing, expelling or alternately acquiring, keeping, losing it"; "in order not to have to 'swallow' a loss, we fantasize swallowing (or having swallowed) that which has been lost, as if it were some kind of thing."[17] Incorporative practices, following Freud, constitute a refusal to mourn.

Introjection is a process of broadening the ego, initially modelled by the assumption of words in place of the breast. This "mouth-work" is directly social, where language supplements and consoles absence as representation; one weans on signifiers that consist collectively, altogether outside oneself. Were they not so, this gesture of casting inside would have very little imaginary traction. In the case of a subjectively constructive introjection, one's mouth, as it were, is quite literally filled: "this means of course that every incorporation has introjection as its nostalgic vocation."[18]

14 Sigmund Freud, *The Standard Edition of the Complete Psychological Works of Sigmund Freud Volume XIV*, trans. James Strachey (London: The Hogarth Press, 1957), 245.
15 Ibid.
16 Ibid.
17 Nicolas Abraham and Maria Torok, *The Shell and the Kernel: Renewals of Psychoanalysis Volume I*, trans. Nicholas T. Rand (Chicago and London; University of Chicago Press, 1994), 126.
18 Ibid, 129.

Incorporation, Abraham and Torok explain, is not only the result of a denied introjection, but results from unacknowledged loss: "Inexpressible mourning erects a secret tomb inside the subject. Reconstituted from the memories of words, scenes, and affects, the objectal correlative of the loss is buried alive in the crypt as a full-fledged person, complete with its own topography. The crypt also includes the actual or supposed traumas that made introjection impracticable."[19] This inner crypt, inaccessible to the constructive effects of representation, stages a sort of mystery of its own: "No crypt arises without a shared secret's having already split the subject's topography. In the realm of shame and secrecy, however, we need to determine *who* it is that ought to blush, *who* is to hide. Is it the subject for having been guilty of crimes, of shameful or unseemly acts?"[20] As Abraham and Torok describe, one constructs an inner crypt to conceal the shame of the love object as ego-ideal; always on behalf of another, interred within the subject to obviate the chance of loss.

New Ghosts

This well describes the multi-generational mystery of *The Obituary*, from the conspicuous splitting of the narrator's subject to the proliferation of perspectives on intrafamilial and national-historical trauma. But if "old soul" Veeera is walled in by Rosine's melancholic recollections, it isn't only owing to a subjective failure or resistance on Rosine's part: rather, this incorporation of a fantasized parent comes about because of an objective and historical impediment to mourning; an inter-generational conspiracy of silence around Veeera's Indigeneity.

More recently, psychoanalysts David Eng and Shinhee Han have extended the Freudian literature on loss in their investigation of "racial melancholia"—an indefinite and irresolute processing of cultural assimilation and its unacknowledged effects. As they explain, "Freud's theory of melancholia provides a provocative model to consider how processes of assimilation work," where assimilation into dominant North American culture for people of colour requires identification

19 Ibid, 130.
20 Ibid, 131.

with a hegemonic whiteness: "The exclusion from these norms—the reiterated loss of whiteness as an ideal, notably—establishes a melancholic framework for assimilation and racialization processes in the United States precisely as a series of failed and unresolved integrations."[21] With appreciation for the specificity of this study, focusing on the experiences of Asian Americans in the United States, Eng and Han's proposal of a non-pathological and objective basis for a melancholic prolongation of mourning, based in the repressive agenda of a white supremacist society, bears powerfully upon the assimilationist demands placed upon the colonized. "From a slightly different perspective, we might say that ambivalence is precisely the result of the transformation of an intersubjective conflict into an intrasubjective loss, as the melancholic makes every conceivable effort to retain the absent object or ideal, to keep it alive in the shelter of the ego … In identifying with the lost object, the melancholic is able to preserve it but only as a type of haunted, ghostly identification."[22]

This insight might as well caption *The Obituary*, in which Rosine's attempts to mourn her mother are impeded by Veeera's barely shared and wide-open secrets; by the alternate likeness raised in her place by dissimulating relations. As a child is ultimately their parent's symptom, Veeera's melancholic attachment to an ultimately fickle whiteness—procured over the course of migration from the Métis Homeland in the Northwest to the densely multicultural enclave of Mile End—becomes Rosine's irresolvable affliction.

> – *Was Veeera*, I asking Reef, over-loudly at reception [heart beating madly]. *Ever saying she Indigenous?* Silence a minute. His curly lashes dropping over spotted Celtic eyes, Reeef half-bowing in way of gentleman [but not quite officer] soldier: —*I don't think she knew.*[23]

Not-knowing prolongs mourning, as above; for how is one to mourn what one cannot name or locate? *"Is not the hybrid a melancholic? On a*

21 David L. Eng and Shinhee Han, *Racial Melancholia, Racial Dissociation: On the Social and Psychic Life of Asian Americans* (Durham and London: Duke University Press, 2019), 35.

22 Ibid, 37.

23 Scott, *The Obituary*, 154.

line between appearing + disappearing?"[24] asks the Fly, in a voyeur's survey of the "contemporaneous neighbourin' citizen dialectic" of the faux-Gothic triplex on rue Settler-Nun. In this respect, the building itself stands as an outer crypt; an intergenerationally constructed and literal shell for the agonized subject within. *"This place's fulla ghosts,"* reports one tenant; meanwhile ghosts, as past occasions of a place, are full of people.[25]

It's notable that Rosine's crypt is constructed in commemoration and pursuit of Veeera, as throughout Freudian literature, the body of the mother normatively models introjection. But the positive content of this mouth-work is formed by absence, too: "Children take words from the air, ventriloquizing omissions passed down generations."[26] As an emblem of this insurmountable dependency, Veeera is represented in a single image from childhood; the absent mother appears arrested in time as an infant. Rosine even considers carrying the photograph as if a piece of cultural identification: "Therefore regretting not carrying in wallet the photo of Veeera. Sad ancient eyes. Rez-school-style bowl haircut. Bare four-year-old shoulders."[27] In an Historian's footnote, the legibility of Veeera's heritage appears negatively as well, in a cosmetic sign of repression: "Consider the genealogy of the lie - + the lie of genealogy. Say, that bowl haircut on little Veeera's photo recalling, for some of Rosie's generation—suddenly interested in 'remembering'— the shorn braids of residential school-children."[28]

This image, and the legibility of its conventions, becomes an emblem of the crypt and all the personal pre-history that it is made to contain: "But where in this picture are the other Others? Take [memento mori] the Scots fur traders + their Indigenous wives from the long-gone Métis Presbyterian Church. Do we care how their offspring were treated? Differentiated? Indifferently assimilated? Or enjoying a great fluidity of situation?"[29] Here too one notes innumerable factual impediments to mourning, placed before the subject by the colonial state; among them, the unspoken proscriptions of official multiculturalism, which

24 Ibid, 57.
25 Ibid, 30.
26 Ibid, 48.
27 Ibid, 156.
28 Ibid, 156.
29 Ibid, 31.

ideology taunts from the radio ("In this land everyone an immigrant") as the Historian seethes in the bottom margin.[30]

As Abraham and Torok speak of incorporation as thwarted introjection—a tormented imaginary cordoned from a common symbolism—Eng and Han observe the transformation of an intersubjective conflict into an intrasubjective loss. In this case, an outer obstacle is experienced as a personal deficiency. Throughout *The Obituary*, the intersubjective difficulty staged by colonization—resulting in an asymmetrical impasse of cultural recognition, as described by Frantz Fanon and Glen Coulthard respectively—is itself displaced onto the colonized subject, who ceases to recognize themselves. Thus the "fluidity of situation" to which the Historian alludes encompasses many moments of a complex psychological, and political, negotiation between objectively irreconcilable standpoints, one being the logical negation of the other.

National Questions

One ingenuitive and influential solution to this difficulty arrives in the form of hybridity, a program of assimilation that displaces culture and nation with pedigree. In a colonial situation, this would ameliorate the real contradiction between a national oppressed and its oppressor by a twofold movement: racializing political and cultural difference, only to void the national identities encompassed thereby by falsifying the category of race as such. As Rosine contends with a melancholy of the hybrid, having to do with her conflicted parentage, the Bottom Historian maintains a record of Métis national struggles, as an undercurrent to the ambivalent text.

Actor and writer Myriam Tadessé describes her experience as a biracial woman in France, where Ethiopian and French ancestry renders her "métis" to unmarked, so presumed unmixed, neighbours. The prejudice of neighbours is a major problem in Tadessé's memoir, and in the haunted triplex of *The Obituary*, too; but Tadessé refracts their attention, crediting her double being with a "twofold gaze" upon the world; being from here and there at once, inhabiting multiple time frames, she claims the ability to perceive conflictedness and

30 Ibid, 86.

ambivalence in others, too.[31] Ultimately, this bears on the structure of racial melancholia described by Eng and Han, which pervades *The Obituary* as an unacknowledged inheritance.

Naturally, one acts out that which goes unacknowledged. "Something, however, is seeking to be said," Tadessé writes: "Something lurking between the lines of books, of official history, always on the margins, vanishing as soon as we try to look directly at it. Something related to *métissage* and that, rather than designating it, concerns us all."[32] For Tadessé, *métissage* denotes not only mixed parentage, but a multiplicity of perceptions that inherently exceeds a given text, subject, or situation. This is in keeping with Scott's postmodern stylistics, and very nearly doubles as a description of *The Obituary*'s formal conceit, where a repressed historical and family register appears in the margins. But Métis, particularly as it figures in Rosine's family history, is not an adjective nor a style, much less a synonym for hybridity. In Canada, Métis denotes the full integrity of a national identity—that is, a definite community of people born of concrete struggles, sharing a common language, landbase, and economy, not to mention consciousness of the above.

As Métis scholar Chris Anderson notes, postcolonial theory has largely "extolled the virtues of hybridity ... which is thought to disturb the otherwise monological waters of colonial claims to authority and classificatory power."[33] However, Anderson writes, "for Métis especially ... the discourse of hybridity does not provide a transgressive 'third space of enunciation.' Instead, it represents the space into which we have been shoehorned as part of the Canadian state's growing racial imaginary. Métis are classified as hybrid—with all the denigrating connotations of the term—in ways that deny what we seek most, an acknowledgement of our political legitimacy and authenticity as an Indigenous *people*."[34]

As Anderson notes, the Canadian state's inability to discern folk definitions of métis as an admixture of racial essences from the sense

31 Myriam Tadessé, *Blind Spot*, trans. Gila Walker (London, New York and Calcutta: Seagull Books, 2021), 29.

32 Ibid, 2.

33 Chris Anderson, *"Métis": Race, Recognition, and the Struggle for Indigenous Peoplehood* (Vancouver: University of British Columbia Press, 2014), 37.

34 Ibid, 38.

of Métis as a national, and Indigenous, constituency actually "reproduces the legitimacy and apparent logic of the former at the expense of the latter."[35] As Dakota scholar Kim TallBear notes, this racializing logic is incoherent at its basis, given that "mixing is predicated on the notion of purity."[36] Karen and Barbara Fields describe this fallacy as "the move, by definition, from the concept 'mixture' to the false inference that unmixed components exist, which cannot be disproved by observation and experience because it does not arise from them."[37] Thus the idea of métis-as-mixed postulates two racial essences, incomplete in themselves, retained at all times in some difficult cultural ratio. This logical extrapolation of an incomplete and asocial whiteness from the ideology of mixing or hybridity opens onto a complex spate of mutually reinforcing misrecognitions. This is a discursive structure of racial melancholia, insofar as social categories describing an intersubjective conflict are incorporated as contradictions within the individual themselves.

The sense in which Scott, and Rosine, uses the word Métis is ambiguous and varies over the course of the text, sometimes denoting Red River Métis ancestry and sometimes denoting a formula of belonging by degrees, upon which the state ultimately rules. This ambiguity is no doubt intentional, as the materiality of this distinction is far greater than discursive, issuing from the vicissitudes of historical nationcraft on one hand and colonial dispossession on the other.[38] Rosine's angst isn't only familial, and Veeera's denial of identity isn't simply evasive. The thwarted recognition characteristic of colonial dispossession is not only racializing but melancholizing at the individual level, where the very basis for identification with an oppressed culture is withheld the colonized subject.

35 Ibid, 60.

36 Kim TallBear, *Native American DNA: Tribal Belonging and the False Promise of Genetic Science* (Minneapolis: University of Minnesota Press, 2013), 5.

37 Karen Fields and Barbara Fields, *Racecraft: The Soul of Inequality in American Life* (New York and London: Verso Books, 2012), 4.

38 Scott's materially attentive genealogies contrast many recent attempts at "self-Indigenization" by white, French-descended people today, whose fraudulent claims to Indigenous and specifically Métis identity on the basis of a single distant ancestor actually interpolate and exploit the cultural and historical lacunae that Scott describes, as well as the sociolinguistic ambiguity that has historically attended the term Métis. See Darryl Leroux, *Distorted Descent: White Claims to Indigenous Identity* (Winnipeg: University of Manitoba Press, 2019).

Beyond the orthographic differentiation of métis-as-mixed and Métis-as-nation, there are only so many individual standpoints, each summarizing the complex historical and ancestral information of which they are concentric. As Tadessé writes, "'one' cannot speak of *the* métis: there are as many *métis* as there are people and spaces. Only 'I' can do so."[39] But each individual history is immanently social, and every "I" is an historical contract. In Canada, where official multiculturalism has repressed Indigenous nationhood, liberal ideologists routinely attempt to universalize "métis" as a generically syncretic term denoting nothing but the cultural metabolism of an inclusive society across generations. But as Tadessé and Scott note separately, the "I" concentric of this historical information is at every moment whole; only divided by language.

Scott draws this parallax, where Rosine speaks as "I/R, daughter of Veeera": subject and object, author and offspring, seer and seen.[40] Glossing Rosine in the third-person-paranoid as "R"—or our—permits a further writing of this immanently social standpoint: "Polished as mirror. To catch R collective pathos."[41] The ear grammatically corrects this sonically ambiguous statement from third- to first-person, staging a number of suggestive questions. Where Rosine may be heard to describe "our collective pathos," who does she gather or address? Veeera, perhaps, or the disavowed identity that unites them as a people? The mirror-as-divisor, elsewhere transcribed as a forward slash, reflecting one's image back to oneself as an object of identification, stages a confrontation: *"Halfway between melancholia + paranoia,"* writes MacBeth of Rosie: *"Not being authorized to mourn, leaning increasingly toward latter. She thinks she's being watched, when being watched she—"*[42]

Melancholia transpires where access to an object of mourning is impeded—and in racial melancholia, the object in question is an identity. Thus the racialization of Indigeneity, otherwise a term of geopolitical relation, is objectively melancholizing, as it seeks to redefine the land-based and multi-generational relations constituting Indigeneity out of meaningful existence. At base, Indigenous identity is not something that can be sourced by blood, but has essentially

39 Tadessé, *Blind Spot*, 1.
40 Scott, *The Obituary*, 21.
41 Ibid, 145.
42 Ibid, 134.

to do with land and one's relation to place. The intricate political geography of *The Obituary* and its interiors, placed atop a densely sedimented record of both conquest and cohabitation, spatializes this matter of generational succession: "There being no redemption in ~~origins~~ extinct matter. Remembrance concerns not the dead. But what is alive + speaking within us. *Do not skyscrapers bear, deep within, straw huts? The person, her ancestors?*"[43]

Chez Moi

What kind of structure is an individual? The intertextual conflict posited by Tadessé and Scott alike, where a Métis speaks from the margins of a colonizing master text, bears uniquely on the home. Tadessé writes:

> *Chez moi.* At home. What an odd expression when you think about it! *Chez Moi*, where? And me, who, or rather which me? Since there's necessarily one on the outside to say this, one who observes the other go in. One who has a general view of the inside and the outside, one who can only refer to herself as such in relationship to the other. Does this mean that one stays outside while the other thinks she's *chez elle*? Wouldn't that indicate something of a hiatus right from the start between two me's, two spaces, one that would correspond to the self as a being outside space-time and a me that would espouse this space-time entirely?[44]

The interval between the moi and chez is a site of identity in displacement, Tadessé suggests. Throughout *The Obituary*, the triplex on rue Settler-Nun is such an in-between place, traversed by ghosts and visitors; a social and historical node of comings-and-goings. These transpire by way of prior residents, the small intruders one cannot control for nor uninvite; the lecherous, all-seeing fly; detectives crouching in the stairwell; the cipheral lover-interlocutor designated only by the letter X. Most saliently, the building is a private property leased to Rosine, hounded by a sexually obsessed landlady. This strange picture of a home, which one must have departed from in order to reenter,

43 Ibid, 117.
44 Tadessé, *Blind Spot*, 40.

reproduces the cloven identity that Scott transcribes as "I/R"—an inside-outside perspective spanning narrative designs upon reality. In this spirit, Tadessé assigns herself the status of hiatus, a divisor of phenomenal space; but this hiatus expresses an exterior temporality, too, where time splits the subject such that she may pass from place to place, from here to there, in a self-perceived arc of intention.

Crossing the threshold of the chez moi, one splits oneself again; and the vexed, reversible temporality of *The Obituary* permits Rosine's body to traverse the city even as it lies in wait for an indefinitely forestalled moment of self-discovery. Relatedly, in Slavoj Žižek's reading of *Dial M for Murder*, the murderer's identity is revealed by a display of surplus knowledge—the would-be uxoricidal jock Wendice, having designed the apartment murder scenario in every detail, is caught out by his own deductive reasoning as to the whereabouts of Margot's latchkey. Had he failed to deduce the whereabouts of the key, the incriminating reflex that seals his fate would never have been observed by the police.[45] Here again, the murderer must have been chez soi.

This sense of having-been-seen is not just a paranoid structure, as named above, but a prerequisite feature of the chez soi as described by Tadessé. In her account, to be at-home is not to be hidden from sight, but to be situated in an imaginary space corresponding to another's view—home is at the junction of "material horizontality and immaterial verticality."[46] Here the subject is a transcendental guarantor of historical sequentiality; requisite to the twofold gaze described above. But this personal consistency, down to one's DNA, is an historical effect; a columnar contemporaneity of information and (other) experience. From the margins of *The Obituary*, in a parallel time, the Bottom Historian harmonizes poet Stéphane Mallarmé: "If material conditions truly impact the 'spirit,' we may empirically declare the *Triplex* a place where what happens is chiefly the place."[47]

In *My Paris*, a pivotal 2003 work that anticipates the style of *The Obituary*, Scott adopts the standpoint of flâneuse, assuming a "total

45 Slavoj Žižek, *Looking Awry: An Introduction to Jacques Lacan Through Popular Culture* (Cambridge: The MIT Press, 1991), 179.

46 Tadessé, *Blind Spot*, 40.

47 Scott, *The Obituary*, 21.

posture of receptivity" to novel surroundings.[48] The work is almost entirely constructed of short descriptive sentence fragments that hew to an absolute present, an order of perception which nevertheless archives the Paris of Benjamin and the Surrealists; of Hausmann's demolitionist renovation; and any number of unfinished revolutions, artistic and political. In this sense, an historical depth of experience is doubled as a spatial predicament, where "the past and future of time are space," says G.W.F. Hegel, "for space is negated time."[49] In Hegel's account, the past and future do not occur in nature, where "time is *now* as separately subsistent differences"; rather, they are a feature of representation.[50] In his vivid evocation of the Passage de l'Opera, for example, Louis Aragon confesses that the demolition of this favoured corridor enacts a precondition of his own descriptive writing, permitting his impressions to stand without factual comparison. Only thereby can the passage become a wholly literary portal, a subjective reconstruction of a social process. As the Bottom Historian advises, "on quitting autobiographical space, more ~~profane~~ material illuminations will impel our intrigue."[51] Likewise, the externalized and urbanistic time of *The Obituary* encompasses numerous mutually exclusive representations of a colonial past, nonetheless accountable to a present occupation and its objective incongruencies.

The Tragedy of This Place

Rosine's conscience refracts the matter of national ontology in a colony. Moreover, national consciousness, or the subjective sense of belonging to a nation, emanates from multiple objective criteria—land, language, economy—that are objectively withheld a colonized people. Of course, this doesn't mean that dispossession of these criteria dispenses with nation, or that oppression of the separate terms of nationhood negates the historical objectivity of a nation at once. Rather, in instances of national oppression, a collective consciousness persists in spite of having been deprived of its material basis, in whole or in part. (For

48 Gail Scott, *My Paris* (Funks Grove: Dalkey Archive, 2003), 34.
49 G.W.F. Hegel, ed. by M.J. Petry, *Philosophy of Nature Volume I*, (Abingdon: Routledge, 2002), 226.
50 Ibid.
51 Scott, *The Obituary*, 14.

related reasons, psychoanalyst and FLN militant Frantz Fanon char-
acterizes an initial phase of national liberationist consciousness as "an
empty shell," assuming an apolitical, racial form.)

As seen above, the categorical requirements of nationhood have
spatial and temporal axes, such that colonial oppression entails not
only the spatial dispossession of Indigenous peoples, but the subject-
ive isolation of the colonized from their conditions of life ongoingly
and intergenerationally. As Scott's postmodern stylistics disclose
the cyclonic contemporaneity of moments and their subjects in an
expressivist "mythology of motion," *The Obituary* demonstrates how
the categories of experience—of oneself as time and countervailing
space—are intricately commensurate, such that traversing a city initi-
ates a roll call of its ghosts. Scott presents this haunted tenancy as
an historical crypt; an incorporation of collective memories by the
modified environment, inaccessible as such and yet actively consti-
tuting the parameters of one's world and experience. This traumatic
data is collected, but not recollected; such that the subject of the
city is herself a structural hiatus, "stuck in pleasant dislocating space
of dreams."[52]

This hiatus doesn't simply correspond to the minimal gap between
subject and object, but to a topographical split within the subject
herself, as Abraham and Torok describe in gothic detail, furnishing
Scott's novel its epigram: "What haunts are not the dead but the gaps
left within us by the secrets of others."[53] But the metapsychological
ghost story that Scott unfurls doesn't only play out within the indi-
vidual. In a colonial situation, as "R collective pathos" demonstrates,
this split within a subject's personal topography follows a literal rift in
the landscape, between its masses and amassees; or, those dispossessed
of everything, including their claim to dispossession, and a lost object
that must be comprehended as such in order to be claimed.

Over the course of *The Obituary*, the surrealist ideal of a "laby-
rinthine" individual is socialized with reference to the historical thread
of which it is a knot or subplot; and yet this figure persists in the
midst of history, not only as negativity or trauma, but as a psychogeo-
graphical anthology of generations. Thus R declares, within earshot of

52 Ibid, 34.
53 Ibid, 6.

surveillance, *"the tragedy of this place, so carefully chosen because it has all the veins running through it running through myself. Is that I must leave."*[54] At novel's end, one departs the scenery of an uncertain crime with many clues and no case; a suspected corpse with more identities than there are witnesses; and a real doubt as to whether anything has taken place except the place itself. This is surely to the point; in the social detective story of *The Obituary*, the clearest crimes transpire intergenerationally, concerning the partial murder of assimilation, and to resolve them in a common timeline would require an honest accounting for once. As Freud's melancholic comes to mourning, and Fanon's to action, the genres of obituary and autobiography eventually converge upon a history of the present. Until that time, to follow Scott, the single life remains a mystery, in search of dénouement.

54 Ibid, 103.

Station
to Station

Remapping Renata Adler

In writing as in navigating cities, the major difficulty is in getting from one place to another. Any point of departure offers innumerable paths, whether designated or experimental, leisurely or direct, and one's trajectory between points drafts a space of potential action, or plot. Sentences impel direction, then; and two or more are an itinerary. In *How to Write*, our alma mater Gertrude Stein—whose own writing is more or less entirely lacking in incident—cautions against works of arrested motion. "A Sentence is not emotional," writes Stein, but "a paragraph is," as a higher unity capable of sustaining contradiction and comparison.[1]

"So many rhythms collide"

A related intuition drives the solitary novels of Renata Adler, whose trademark paragraph, biting and smitten and stoic and spiteful, is widely praised for its accrued, and then controlled, emotionality. A prize wit and winner of arguments, Adler's force of personality underscores each of her two novels, both of whose narrators share her journalistic vocation. Both novels are built of abutting, but utterly separate, paragraphs, each corresponding to a flash of insight or incident.

1 Gertrude Stein, *How To Write* (Mineola: Dover Publications, 1975), 23. This
 aphorism also figures prominently in poet Ron Silliman's theory of the New Sentence
 as the characteristic form of Language poetry.

These bursts of personal reportage appear excerpted from a Heraclitean traffic of raw experience, in contrast to those torrential literatures that attempt to disclose the world as an unremitting intensity, only to find a limit of the sentence by sheer quantitative overload. In this, Adler's writing tends to pith and depth at once, embracing the paragraph as a unitary means of staging irony and contradiction, which can only transpire over the course of consecutive sentences. Where the content of these books is, in a word, ambivalence, Adler's paragraph is precisely weighted so as to disclose this vacillating feeling.

In the opening paragraph of *Speedboat*, Adler's avatar, Jen Fain, describes a practice of apprenticeship in sleep, during which one may revise all that roared by in the light of consciousness. "So many rhythms collide," Fain asserts of this creative nocturama, which would as soon describe the multiple digressions of its author's paragraph.[2] Pages later, Brooklyn's Broadway Junction looms to symbolize this principle: "It seems to me one of the world's true wonders: nine criss-crossing, overlapping elevated tracks, high in the air, with subway cars screeching, despite uncanny slowness, over thick rusted girders, to distant, sordid places."[3]

This vertical arrangement of platforms, meeting obliquely over the neighbourhood of Bedford–Stuyvesant, presents a commuter-reader with a spatial model of the mutual indifference upon which city life depends. This bustle is the proper backdrop of urbanity, otherwise Adler's cause. Everyone is going somewhere, and the station itself is a living index or towering node of an incessant to-and-fro in which so many separate lives are braided. The principle here is neither coming, nor going, but *transfer*, and the modular emotionality of Adler's paragraphs enacts this motion as a cognitive deduction. One plots a route between dream-like vignettes.

This writerly solipsism requires a counterforce, however, for the city isn't any one denizen's dream. For Adler's onlooker, the corroded monolith of Broadway's concept-junction is already beholden to the blind spots that comprise any single-minded design. "It might have been created by an architect with an Erector Set and recurrent amnesia,"

2 Renata Adler, *Speedboat* (New York: New York Review of Books, 2013), 7.
3 Ibid, 14.

Fain accuses.[4] What then is the city designer, or designer city, given to forget? In Adler's vignette as in actuality, the derelict housing developments of Brownsville, icons of poverty and urban segregation, loom beyond the platform. This is an important key to our narrator's dream of the city, even as she conducts her fieldwork upon the fickle ground of a decidedly elite strata. Much as the view from Broadway Junction canvases the unevenness of East New York, belying the territorial suture of any infrastructure promising "access," Adler's resolutely episodic book baffles narrative omniscience by marking its limit: a constitutive, or recurrent, amnesia.

These intimations of complexity manifest a different kind of novel, wherein a dishy diarism alternates wry anecdotes of other people's intrigue. In this assessment of Adler's style, two vocational poles—journalist and novelist respectively—correspond one-sidedly to suspicious objectivity on one hand, and untested subjectivity on the other. This simple polarity produces a public tension, and these are insistently pro-social novels—comedies of manners in which linguistic currency is all: "Late sleeping Utopians, especially, persist like mercury. I am a fanatic myself, although not a woman of temperament. I get nervous at scenes."[5] Then, the bon mot is a prize possession of the person who lacks nothing else. The less articulate are doomed to circulate without fixation.

"This matter of the paragraphs"

This bluffing approach inhibits understanding of the larger conditions that conduct one sociological set piece to another. Here one may diagnose a distinctly journalistic empiricism: the flashes of consciousness by which Adler discloses her reality appear less discrete than discretionary, culminating at one limit in a caricatural writing. From the back of taxis, in a fully staffed resort, or visiting a nation's embassy—wherever two encounter in a mercantile agreement, a typology is re-established, arbitrary and absolute. These trademark snap assessments, a hallmark of literary reportage, produce numerically more and emotionally fewer characters than populate the standard

4 Ibid.
5 Ibid, 12.

bourgeois novel, which grand genealogical scaffold authorizes variety in spite of almost total circumscription.

In Adler's cosmopolitan reply to this storied form, the social scale is enlarged beyond apprehension, in order to mock at any single display of influence or opulence. Fain finds herself in the company of innumerable moguls, politicos, and career egotists, none of whom possess any universal sway whatsoever. The totality of which the novel treats is gallantly belied at every turn by Fain's pace of travel—worldliness negating world—and a formal arrangement that conveys as much at the level of the text. ("I have lost my sense of the whole," Fain confesses: "I wait for events to take form.")[6]

In the absence of the social gravity presumed by the 'landed' novel form, Fain flits and floats, on assignment and for reasons more obscure. In this sense, Adler's hyper-episodic manner of assembly hews to the discontinuous texture of travel, itinerary withheld. In the first pages of *Speedboat* alone, the setting shifts from New York to Cairo with minimal signposting; the narrator is afloat on the Mediterranean Sea, aboard a Boeing 707 from Zurich to an undisclosed location, reporting on a story from the American south; it's difficult to keep track. A readerly vertigo sets in, to which one must simply assent, for the shuffled deck of Adler's text declines any ulterior re-ordering.

Journalistic vocation naturalizes the formal effect of each vignette, which assume an interloper's optic. Either of Adler's fictionalized counterparts—the stoically insinuating Jen Fain of *Speedboat*, or Kate Ennis, whose anti-romantic antics comprise the action of its tonal sequel, *Pitch Dark*—would surely affirm as much if made to give a statement of belonging. Both novels are resolutely jet-set, written with a wariness, and a weariness, attending constant travel. "It began at the airline ticket counter," Ennis recounts at a non-climactic moment of *Pitch Dark*, before reconsidering her story's point of origin several times over: "No, it began with another lorry driver, three days earlier, at midday, in a small town, on the road from Shannon. No, with the fact that we were brought up to be honest, or the fact that my parents fled."[7] The text presents only so many qualifications, corresponding to multiple points of departure. These stalling clauses and backtracking

6 Ibid, 10.
7 Renata Adler, *Pitch Dark* (New York: New York Review of Books, 2013), 49.

sentences, each enacting a gradually less exacting frame, demonstrate the impossibility of making a clean start; and Ennis will address this mechanism elsewhere in a halting monologue: "And this matter of the commas. And this matter of the paragraphs. The true comma. The pause comma. The afterthought comma. The hesitation comma. The rhythm comma. The blues."[8]

Stein abjured the comma as a sentimental means, and Adler appears to endorse it for this very reason: the comma is a wink, a nod, a flower, an embellishment; a dotted note by way of emotional instruction, or placeholder for a space of interjection, less prosodical than interpretive. For Stein, the emotionality of paragraphs concerns their integrative capacity, after which logic one might suggest that the comma, as a subdivisory scoring of the text, makes paragraphs of sentences. Stein's contemporary Laura Riding took a differently amenable view of commas in an Adler-esque short story, "Commas and Others," published in 1930, one year before Stein's *How To Write* appeared. At a punctuation function, the narrator and an imperious friend, Miss Spot, regard a roomful of commas with polite exasperation:

> The room happened to be full of Commas. My conversation with them alternated between hauteur and ingratiation. It was very disgusting—until Miss Spot arrived. Miss Spot and I had a bond. Her whole social life was with Commas, but she had a reputation for being sharp. She was not so much sharp as restive. She was restive because she realized that the Commas were inadequate as conclusive punctuation. Yet she did not seek the society of the more classically disposed stops, preferring to experience chagrin rather than false resignation. And the society of the Commas gave full scope to her chagrin; not experiencing anything in particular themselves, they imposed no emotional formula on her.[9]

Like Miss Spot, Adler's narrators settle for ennui and irritation, distraction and bad company, rather than insist on the narrative cinch of an ending. This comes at cost of superficiality, of course, for social intercourse becomes a grammatical quarrel when there's nothing to

8 Ibid, 78.
9 Laura Riding, *Experts Are Puzzled* (Brooklyn: Ugly Duckling Presse, 2018), 137.

concern oneself with any longer except style. Adler's cultivated chagrin may forestall the difficulty, or dishonesty, of a prefabricated literary ending; but it also raises certain questions concerning the ethics of observation, and the plausibility of disinterest in the first place.

Island Hopping

Speedboat stages these difficulties most clearly in a chapter entitled "Islands," in which Adler more or less writes the obverse essay to Jamaica Kincaid's 1988 polemic, *A Small Place*. While Kincaid's book offers a detourned tourist guide to postcolonial Antigua, addressing itself to the would-be visitor on behalf of a subaltern service industry, Adler's interlude is written for, and by, the queasy tourist herself. Fain seeks solitude amid uncommunicative strangers; elsewhere, she arrives in tow of an adaptively dissociative company. In either case, archipelagic paragraphs enact a series of separate adventures in unclear locales.

The first island, unnamed but apparently Mediterranean, has no trees; it has one taxi, captained by an eager-to-please ventriloquist whose party trick, of hailing himself from the roadside, wears immediately thin; electricity is a luxury. Fain writes suspiciously of the "islanders," some of whom have benefited from the sale of beaches to investors and their architects, many of whom work in service of the same. "Hotels were going up. The island sons and daughters now took jobs in the tourist hotels. Bandits remained active in the interior. On the coast, in the houses of the outriders, a Communist party formed. The party swept through the staff of the hotels, too, of course."[10]

Fain's matter-of-fact assessment of the disparity in which she participates is neither self-effacing nor solidaristic; rather, her synopsis appears stoical, selectively observed. On another island, "this one in the Caribbean," Fain's debauched company includes a serially violent Englishman, who flashes the Queen during her royal visit.[11] Fain remains as remote from his hooligan cause as from the monarchy he would offend, let alone the Communists whose plight we have just recited. All displays of conviction appear equivalently futile to the mercenary interloper, whose determination to find all things equal typifies petty bourgeois prejudice.

10 Adler, *Speedboat*, 92.
11 Ibid, 109.

In overview of this bemusement, one might observe that many of *Speedboat*'s most important cameos are not separate characters but thwarted collectivities. "There is a difference," Fain affirms, "between real sentiment and the trash of shared experience."[12] The reader is treated to typological digressions upon the National Guard and the rigors of service; of stays in extremist spas where each registered guest must endure therapeutic privation. Similar accounts, of stifled association and unpleasant company, thread the entire book. The antics of the indifferently rich contrast school-age anecdotes of phoney camaraderie, as Fain dwells at length upon the sitcom of her youthful grooming at a boarding school earnestly run by Communists: "We voted constantly on everything—issues and offices of every kind. We were expected at every age to have an opinion on all matters, political matters in particular."[13] Adler thwarts this injunction, to opine politically, at every socially decisive turn; though this personal rebellion soon resembles noble indignation.

The Radical Middle

As one might guess, these separately pleasing refusals eventually collide the limit of a glib liberalism. Noticing a lucky clover nested in a thatch of poison ivy, Adler's fictional counterpart remarks: "It was by no means a parable about capitalism and making money. I believe in both, and would not think of dreaming against either. Anyway, I do not dream in parables."[14] A higher-order realism, derived from the amoral purity of dream-life, apparently corroborates this curt non-sequitur, more telling of the narrator's desire where unsolicited. On this point, nothing of Adler's work updates so badly as her 1970 semi-polemic for a "radical middle"; though by her own later account the title originated as an inside joke. Even so, this staunch centrism offers a key to the novels as well, in which so much randomized action orbits an absolute individual, aloof and unaltered by experience.

To quote a declarative paragraph of *Speedboat* in its brief entirety: "The radical intelligence in the moderate position is the only place

12 Ibid, 97.
13 Ibid, 17.
14 Ibid, 37.

where the center holds. Or so it seems."[15] At a glance, this aphorism is tautological: the center is where the center holds. And yet, Yeatsian foreboding observed, this mandate—that an eccentric conscience ought nonetheless to reconcile itself to a conservative median—feels oddly prudish. Moderation in the wrong society is an insidious zen, and actuality is never exhausted by the status quo. But Adler's anti-holistic worldview frequently declines synthetic understanding, too: "I do not, certainly, believe in evolution ... I have never seen a word derive. It seems to me that there are given things, all strewn and simultaneous."[16]

This willful, even playful, ignorance could be read satirically, as a jest at the jet-set empiricist and her brilliant refusal to connect the dots of superficially isolated experiences. Adler formalizes this refusal, skirting the circumstances of her character's mobility. This self-protective discretion, however, repeatedly appears as a kind of bad faith. "Tipping is still my option," Fain consoles herself after a taxi driver in New York pauses at each light to peruse pornography, and she declines the custom. This punitive decision then occasions guilt: "Racism and prudishness, I thought, and reading over other people's shoulders."[17]

In a world of options—of transactional acquaintanceship and floating gossip, where every person is an island—problems of consciousness appear as matters of conscience. "Contrary to the lore of restaurants and hotel schools," Fain later offers, "I find the women I know do tip reasonably and drink a lot."[18] Many of the incidental themes of Adler's books concern this ambiguity between public and private, where the former demand appears tyrannical and the latter unreliable. Where this tension is concerned, Adler writes an ambivalent elegy to chivalry; an order in which these spheres and their distinction were tenuously preserved. "There used to be so many categories of the wallflower," Fain laments, watching a bookish stranger clumsily repudiate a pass.[19]

15 Ibid, 41.
16 Ibid, 42.
17 Ibid, 55.
18 Ibid, 131.
19 Ibid, 151.

Leaving House

But Adler's vertiginous masterpieces do not herald the utopian aban-
donment of plot that their popular appraisal would suggest. Rather,
their plotlessness is symptomatic, even disappointed: "There are only
so many plots. There are insights, prose flights, rhythms, felicities. But
only so many plots. At a slower pace, in a statelier world, the equations
are statelier."[20] Here Fain gives a statement of post-narrative purpose,
summarizing the ambition of the novel that contains her, only to qual-
ify its texture and velocity with reference to a "statelier" consistency, a
bygone golden age of linearity.

Even so, a sheen of confidence gives *Speedboat* its urbane allure. But
if this is a novel of incessant re-arrival, *Pitch Dark* would be a book of
departures, emotional and otherwise, by comparison. How does Adler's
ongoing dispersal of the novel form fare in this melancholy version?
The scenes of *Pitch Dark* are longer and more frequently enjambed—a
raccoon euthanasia spans several pages with a rural patience—and
when a sequence of paragraphs does follow a linear narrative, the dis-
sociative expectation of the preceding text carries over, ambiguating
the plot and loosening an illusory through-line.

Pitch Dark, for all its fragmentary airs, is less a professional com-
panion to *Speedboat* than a neo-Gothic novel of domestic crisis, in
which the postmodern inconsistency assailing novelistic form would
seem to have inhibited the home scene, too. In a pivotal sequence, a
low-tech sojourn at an Irish country house proves unbearable: "As I
walk downstairs, and I see that the car is already at the far end of the
driveway, I think, I am going to leave this country and this house."[21]
But the speaker is waylaid by inner monologue, already bored of its
digressions:

> And there are just these episodes, anecdotes, places, pauses,
> hailings of cabs, overcomings of obstacles, or instances of being
> overcome by them, illnesses, accidents, recoveries, wars, desires,
> welcomings, rebuffs, baskings (rare, not so long), pinings
> (more frequent, perhaps, and longer), actions, failures to act,

20 Ibid, 162.
21 Adler, *Pitch Dark*, 71.

hesitations, proliferations, endings of the line until there is death. Well, no.[22]

This litany of abstract plot points, flattening the distance between war and leisure, performs a certain weariness with literary repetition; and Ennis reiterates in strict self-quotation several pages later that the car is waiting at the far end of the driveway, that she is going to leave this country and this house; a conviction less credible the second time around.

A Novel Sentence

Ennis's elongating registry of would-be dramas, minor tragedies, alternative realities, and so on, finishes with death. Well, no. The comma, as observed above, would be precisely that emotive vice, holding a sentence open for development indefinitely. What does this "matter of the paragraphs" offer us by way of insight into Adler's fiction?

Perhaps the sentence does await the paragraph, or else becomes one to elude its fate. As an emotional module, the paragraph includes and surpasses many starts and finishes—like an enormous transit station, looming in hallucinated night. A writing of the paragraph presumes different itineraries, and unassumingly builds to multi-rhythmic integration. And yet, Adler's suspicion of totality, allegorically posted at the outset in the urtext of a dream, inhibits any but the most frightfully individuated angles on novelistic design.

Fain's wisecracking quietism and Ennis's melancholy are two functional conceits by which to catalogue and sentimentalize contingency. In this respect, the reader can't help but desire something in common with these characters, that the novel as a bound thing nonetheless affords—a better-than-suggestive finish, and a series of arrivals from which to depart. Then it seems fitting to conclude with Adler's words, anticipating punctuality: "It could be that the sort of sentence one wants right here is the kind that runs, and laughs, and slides, and stops right on a dime."[23] The sort of sentence one might call emotional, mysterious, or multiple; a novel sentence, pending many others.

22 Ibid, 72.
23 Adler, *Speedboat*, 170.

Writing Drawing/
Drawing Writing

Any materialist theory of writing must accept a certain order of things—for writing is depicted thought; thought is a represented world; and this world is prior to concept and portrait alike. Such preliminaries, however, furnish us a capacious definition of writing, one that immediately exceeds not only the page but language itself. Is writing a drawing of the world? Is drawing writing?

Much thinking around this relation tends to simple dualism, placing a romanticized handwriting before meaningful reference. In this account, an iconic or self-referential drawing precedes the advent of writing as a differential system. But this order of operations only entrenches an opposition between body and spirit, letter and intent, that would cleave writing and world completely. As a practice of delineation, writing draws from something other than itself. And wherever one refuses the rumour of a primary repletion—a positivity that wants for nothing, standing only for its own—one discovers a minimal grammar. Beyond simple negativity, this is an important reminder of the differences comprising any world.

Rift-Design

Conversely, what might a generalized writing resemble but a kind of drawing? This description places drawing—the inscription of shapeliness—immediately on the side of voice, as a primary vehicle of meaning alienated in all subsequent content. Here an icon of presence, the hand, asserts itself in place of speech as a measure of proximity. These two

facets of outreach, apparently uniquely human, enjoy a sacred pact in Martin Heidegger's thought, converging upon the world in a constructive practice of "rift-design." *Riß*, by which Heidegger denotes a break between earth and world, representation and reality, refers both to a cleft and a literal sketching.

In a repetitious formula, fashioned after a remark by Albrecht Dürer, Heidegger implores us to wrest artistry from nature: to "draw out the rift and to draw the design with the drawing-pen on the drawing board."[1] Any "creative sketch" must first and foremost manifest a rift, or boundary, to be thematically remediated by design. This dialectic of fissure and figure is explained by Timothy Clark in the following example:

> Imagine a line traced across a background of mottled paper. Completed, it brings into being two distinct shapes on either side, one looking, say, a bit like a human profile with hints of other features in the mottling, the other perhaps like the silhouette of a jug with a rough surface. The picture as a whole now may seem merely to depict or represent these forms, as if they had already been there and had now simply been highlighted by a line traced along their edges.[2]

This gesture redrafts an opaque substratum of as-yet-unrealized forms, so as to comprise at least two elements. From this proliferative limit, one may extrapolate a world, quintessentially susceptible to aesthetic treatment. Drawing is a primary demarcation in this account, tied up in language from the start. Of course, Heidegger is fanatically selective of which ethnolinguistic equipment is apt to this task of unconcealment, such that the fantasy of drawing reproduced above depends not just upon an individual's sovereign operation, romantic and exclusive, but the cultural bearings of that operation more generally. This ante-, or anti-, foundational gesture is simply too exclusive to uncritically repeat.

One might commence from Juliet Fleming's Derridean programme of cultural graphology instead, and her paraphrase that "differences

1 Martin Heidegger, *Basic Writings* (London: Harper Collins, 2008), 195.
2 Timothy Clark, *Martin Heidegger* (Abingdon: Routledge, 2011), 53.

Fig. 10. Renee Gladman, *Prose Architectures 227* from *Prose Architectures*. Copyright 2017 by Renee Gladman. Reproduced with permission of the author and Wave Books.

are all that is required in order for there to be writing."[3] In its generality, at least, this minimal definition approaches our cause, the parsing of non-discursive inscription—a project which tempts phanopoetic or visual apprehension in its strangeness rather than its proximity to hand.

According to Fleming, Derrida's own illustrative dalliances with typography work on this principle; they too "appear to aspire to be the image of what they would express."[4] In this regard, she continues, Derrida's experimental writing is "scarcely philosophy, it is more like squinting, for it asks you to *look at* rather than abstract meaning from writing."[5] This impels a secondary question as to the status of reading in the equation of writing and drawing.

Writing, says Fleming, concerns "an experience of cognition best understood not as a *representation* of the world to the person who perceived it but rather as an ongoing bringing-forth of the world through a process of living in and through the dynamic organization of its

3 Juliet Fleming, *Cultural Graphology* (Chicago: University of Chicago Press, 2016), 8.
4 Ibid, 59.
5 Ibid.

spatial archives."[6] This description approaches the anti-foundational foundation of rift-inscription, without indulging the fantasy of a privileged writer, let alone the Greco-Germanic architecture of appropriate expression supposed by Heidegger.

As we approach both writing and drawing in the guise of their mutual limitation, we could consider the writing of the threshold as such. In a revealing chapter on early-modern bookworks, Fleming discusses the proliferation of ornamentation, such as arabesques and floral motifs, that developed alongside moveable type as an example of a non-discursive writing, in which the hand is obscured.

The frame, violently subtracted by and from artistic evaluation, manifests as more than a marker of incision. Here appears Derrida's *parergon*, the contiguous space that marks the interior of a work from its exterior conditions, and in so doing cooperates with both—with an outside from within and with an inside from without. This consideration of the frame as work, or of the page as non-arbitrary with respect to its inscription, establishes writing and drawing on a kind of continuum. As Fleming writes:

> ... to understand type ornament in this way is to be able to see the printed page not as site for information but as a visual field whose intricate black lines and white spaces provoke sensations of movement and light and whose vibrating surface combines regularity and recurrence with a commitment to systemic local variance ... you will begin to see leading figures in the script and in the letter forms: stairways to climb, paths and rivers down which to you can travel, shapes to lean against, spaces in which you might hide."[7]

This translation of line into meaning is revealing, insofar as the reader is a spatial organization, too. With this in mind, we may set ourselves to reading as a practice of cohabitation, extrapolating interiors from surfaces, measuring lines against a motile immutable, a living, live-in, frame.

6 Ibid, 62.
7 Ibid, 84.

Renee Gladman: *DRAWING BRIDGES*

Renee Gladman's writing already spans any ambiguous boundary between poetry and prose; and her *Prose Architectures* showcases a practice of lyric draughtsmanship that establishes both on a strictly visual continuum with surroundings. Gladman has been producing a writing of intense civic interest, mapping fictional cities in their unevenness and intrigue, over volumes and years; and her novels set in the unplaceable terrain of Ravicka, beginning with *The Event Factory*, explicitly pursue a co-theory between language and place, where to imagine one term is to presume, or project, the other. A similar set of concerns anticipate, or accompany, these drawings.

"How were houses like paragraphs?" Gladman asks in her introduction, setting out to discover as much.[8] This inquiry follows Gertrude Stein's assertion that paragraphs, unlike their constituent sentences, are emotional; much as houses, unlike their materials, are inhabitable, that associations may accrue. A similar expectation—that confluences of otherwise emotionally inert lines should produce depth, both pictorial and emotional—underwrites Gladman's project. "I drew out of the matter that was most central to my thinking and living, and that was *the city*," she explains, much as the fictional Ravickian poet Ana Patova attempts to manifest inhabitable structures line over line.

Something utopian transpires in these illustrations, for Gladman's "writing" does not translate back into a language from which it derives. "Language has an energy that eludes verbal expression," she writes, such that a dreamlike meaning emanates from behind, and between, contiguous glyphs. As though charting an arrhythmia, the pen makes signs of life upon the page, an active field. Gladman's hand is divisory of the negative space it presumes, and her carefully placed characters impel the projection of pictorial space. A panoramic backdrop to each figure, like the painterly wash of a canvas before scenic embellishment, is implicit in the page, or paper, as Gladman prefers to call it, foregrounding its material obtrusiveness. This is the space of which Mallarmé wrote in the 1897 preface to *Un coup de dés jamais n'abolira le hasard*, the paper that "intervenes each time as an image of itself," both a cause and an effect of the language it supports.[9]

8 Renee Gladman, *Prose Architectures* (Seattle: Wave Books, 2017).
9 Quoted in Fleming, *Cultural Graphology*, 58.

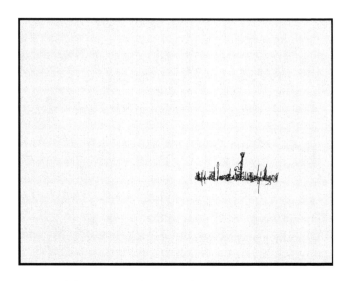

Fig. 11. Renee Gladman, *Prose Architectures 37* from *Prose Architectures*. Copyright 2017 by Renee Gladman. Reproduced with permission of the author and Wave Books.

After Fleming's suggestion, we could squint together in the direction of these works. In the image above, a provisional foreground unfurls from a legato skyline. Off-centre battlements imply a downtown on the water, a super-alphabetic spire towering above the illegible sentence of its reflection. In their mirage-like suggestiveness, Gladman's prose has less to do with the geometric abstraction of the architect's draft than with the lived abstraction of space itself, as an intuited relation of things. This is a writing of implied interiors. And when Gladman describes this writing as architecture, we should presume the prose itself the realized project, a structure fully coincident with its conceptualization.

Gladman's visual prose depends for its sense upon effects of spatialization, such that the minimal requirements of poetry, marking it apart from the prosaic, are already met. Without concern for jurisdiction, we could decide that poetry in general has something to do with "line" as a meaningful gesture: poetry is not a writing *in*, but rather *of*, lines. To adapt Stein's adage, sentences aren't emotional; but the lines in which they may occur are rife with feeling, as desirous vectors in themselves.

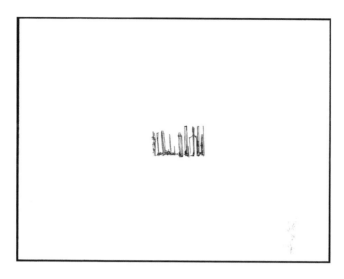

Fig. 12. Renee Gladman, *Prose Architectures 131* from *Prose Architectures*. Copyright 2017 by Renee Gladman. Reproduced with permission of the author and Wave Books.

The legibility of Gladman's hand doesn't rely upon the use of written symbols as a key, but consists over the course of an automatic, or iconic, music. This invites sight-reading, a transfer without expectation of semantic exchange. These non-alphabetic letters appear self-abiding at a glance: pistils, petals, gridwork, tracery, any and all possible analogues, unfurl in retrospect of expectation, making no distinction between ornamental flourish and its sturdier support. Each construction is a single ligature, a sentence-character exhaustively pronounced in the act of seeing.

To speak of sight-reading, many of these structures resemble musical staves; and here too, the abstraction of the orthographic score is mediated at the level of one's own readerly performance. Throughout these works, the draft is practically identical with the extemporized structure it would describe, such that Gladman's super-discursive freehand may be referred to a practice of improvisation where anticipation and experience are near-synchronous; or the necessary gap intervening between these temporal attunements is so minimal that one may identify the adaptive pivot of spontaneous decision with the crux of the composition as a whole. Throughout her work, Gladman proliferates themes as

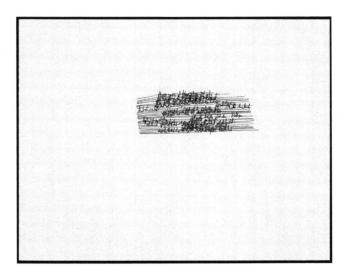

Fig. 13. Renee Gladman, *Prose Architectures 132* from *Prose Architectures*. Copyright 2017 by Renee Gladman. Reproduced with permission of the author and Wave Books.

a kind of baroque improvisation. This processual coincidence of signified and signifier is not simply self-referential; rather, it is self-revising.

For Heidegger, whose rustic mandate obliged him to fear the typewriter, the typographical regularization of writing threatened the hand as an utterly singular, expressive institution. By his account, the hand is the origin of the essence of the word, and the history of technological transcription is the history of its destruction. It doesn't seem to have occurred that the alphabet in general would be another such regularizing institution, and every bit as much a pre-requirement of writing-by-hand. Heidegger's mystical reverence for the word—otherwise a token of relation—is also symptomatic of the modernity he decries, over the course of a metaphysical project that comes to resemble a reactionary version of the critique of commodity fetishism.

Conversely, Gladman's architectures affirm that the modest expressionism of the hand already tends to verticality. Heidegger remains the self-appointed philosopher of sedentary domicility, and his poetic descriptions of language always tend in this direction—language is a "house of being" in which we dwell, and so on. Gladman changes the emphasis from private dwelling to planning, and it is striking that

Fig. 14. Renee Gladman, *Prose Architectures 206* from *Prose Architectures*. Copyright 2017 by Renee Gladman. Reproduced with permission of the author and Wave Books.

the prose comprising these illustrations is public in its very appearance. Where some might, after the fashion of asemic writing, attribute an agenda of deep privacy to the dense curlicues and un-voiceably (re)cursive figures of Gladman's series, the very naming of the writing as "architecture" is evocative of a peopled space.

The tiered paragraph above is most reminiscent of an architectural elevation, with spirals for stairwells and steep diagonals for railings. Perhaps the most startling addition is the square of deep blue above the structure, as though sky itself unfurls from the rooftop like a flag, a picturesque enlargement of a neighbour's laundry. This imaginative gloss offers but one possible reading, as we insist upon legibility as a requirement of line, and life as a requirement of space, rather than prize the authenticating hand as ineffable presence.

This preservation and embrace of space furnishes Gladman's architecture its depth and suggestiveness. As she explains, "the dream is often not the text you're reading but comes from some other part of the page, some part of the text that is not quite visible." In this respect, Gladman's drawing stands instructively alongside the very different prose architectures of artist José Vera Matos, whose illegibly small

Fig. 15. José Vera Matos, *Lenguaje Y Discriminación Social En América Latina*,
ink on bambu paper, 2016.

handwriting furnishes interlocking panels their variegated texture, inky
to the point of tactility. In *Reading Paths*, a drawing from 2016, tidy
aisles mark polygonal paragraphs apart from one another, whilst larger
letters and inscriptions float in the foreground, like strands of protein
adrift in one's field of vision.

Vera Matos explicitly models his vertiginous citadels on Incan
architecture, whilst drawing additional detail from a source text or
transcription. *Siete Ensayos de Interpretación de la Realidad Peruana* is
a re-writing of a work of the same name by Marxist philosopher José
Carlos Mariátegui, whose prose is organized into practically illegible
abutting blocks by the artist, outcroppings and cloisters of which cor-
respond to lines of argumentation. Space gathers around the bottom
of each paper-sized chapter, in silent or unwritten relief to the opaque
blocks of writing above. Where the page, or any frame implicated
therein, appears pre-allocated to the cause of writing, the script is
provisionally finished; an open-ended hypergraphia, when materially
cordoned, manifests as horror vacui.

Conversely, Gladman's civic inscriptions appear as "one elab-
orate question about the making of space." Her figures are neither

free-standing nor entirely self-referential, but ways of writing absence, or non-writing, by implication. Likewise, the abiding concern of her character Ana Patova is "to give language to the spaces she recognizes between buildings and bodies, between books and bodies, between one body and another." Tarrying with negativity, this marking of space transcends any narrow question of penmanship, issuing a challenge to perception that bears directly on the subject of politics.

Mirtha Dermisache: NO REPETITION

Argentinian artist-writer Mirtha Dermisache's work is often discussed with reference to her historical situation, and the military dictatorship during which she continued to create. Against this backdrop, Dermisache's difficult writing is framed as a practice of utopian negativity. The artist herself, however, eschewed any such interpretation, offering a formalist account instead: "I never wanted to give a political meaning to my work. What I did and continue to do is to develop graphic ideas with respect to writing, which in the end, I think, have little to do with political events but with structures and forms of language."[10]

The political purity of this writing, however, is not secured prior to engagement but derived from its conditions. Certainly it would be reductive to construe this writing as cipheral, or simply inscrutable before its would-be censors. But the aforesaid "forms of language" bear closely upon, and produce, political meaning, and Dermisache's wordless quotations of the newspaper form and its visual hierarchies presume as much. Content appears cognitively redacted, pointing up certain concrete interpretive cues that inhere in the medium, short-cutting interpretation at a glance. Her use of the tabloid format and its columnar organization models discursive clamour without content, where four or more provisional systems of writing share a page.

This implied comparison presumes an engaged readership, immediately refuting the one-sided reception of asemic writing that finds anti-social mysticism at each and every point of impasse. In their

10 Will Fenstermaker, "Mirtha Dermisache and the Limits of Language," *The Paris Review*, January, 2018, www.theparisreview.org/blog/2018/01/30/mirtha-dermisache-limits-language.

Fig. 16. Mirtha Dermisache, *Sin título (Texto)*, ink on paper, no date, c. 1970s, from
Mirtha Dermisache: Selected Writings, published by Siglio and Ugly Duckling Presse, 2018.
Image courtesy of the Mirtha Dermisache Archive.

formality, these texts enact neither visionary saintliness nor a state-
savvy evasion of surveillance, but a sustained engagement with the
material and historical situation of writing qua writing—a gradually,
if not initially, impossible ideal.

More than most hand-writing practices, Dermisache's work
addresses the conditions of what Benedict Anderson terms "print-cap-
italism": the consolidation of national consciousness by the mechanical
reproduction and distribution of vernacular writing.[11] Dermisache's
seismographic regularity of hand proliferates occasional systems,
that her attention to the objectal dimension of reception renders
inseparable from a medium of dissemination. While many of her ink-
on-paper works have found an afterlife in gallery settings, Dermisache

11 Benedict Anderson, *Imagined Communities* (London and New York: Verso, 1983), 18.

Fig. 17. Mirtha Dermisache, page from *Libro No. 1*, unique artist's book, ink on paper, 1972, from *Mirtha Dermisache: Selected Writings*, published by Siglio and Ugly Duckling Presse, 2018. Image courtesy of the Mirtha Dermisache Archive.

produced innumerable books, postcards, newspapers, and ephemera: portable formats that structure each encounter. These are public texts, anticipating a reader whose attention may fill the "tenuous structure of 'gaps'" that constitutes each system of writing, hereafter expanded to include the broader gaps comprising difficulties of access and distribution.[12]

Reading, then, may be as simple as looking at an object. In Dermisache's 1972 artist book, *Libro No. 1*, blocks of text appear as though a skyline. This silhouetted vista is reversible; a negative image of itself, calling attention to those spatial rifts comprising an orthographical system. This differential structure visualizes a provisional outdoors, a cityscape awaiting traffic in attention.

12 Mirtha Dermisache, *Selected Writings* (Los Angeles: Siglio; New York: Ugly Duckling Presse, 2018).

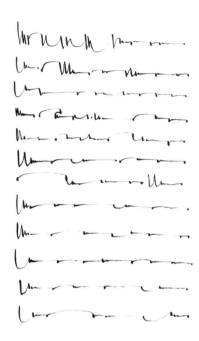

Fig. 18. Mirtha Dermisache, *Sin título (Texto),* ink on paper, no date, c. 1970s, from
Mirtha Dermisache: Selected Writings, published by Siglio and Ugly Duckling Presse, 2018.
Image courtesy of the Mirtha Dermisache Archive.

In other series, Dermisache's hand descends the page in lines of
approximately equivalent weight and length, as if recopying a sen-
tence, in a visual incantation. This marking of difference in regularity
recalls Stein's insistence that one never repeats oneself when writing.
Stein, of course, is a grammarian, in which guise she addresses herself
to syntactic permutation rather than a restricted spate of characters
per se. But her pith pertains: even birdsong varies its insistence, Stein
reminds her reader, and only a high degree of familiarity or an encom-
passing condition of strangeness will give the impression of repetition.

From coursing cursivities to abacus-like measurements of space,
Dermisache's systems are tightly controlled, and this minimal varia-
tion makes all the difference. At second glance, this writing is more
urbanistic than its hermetic reputation would suggest, insofar as it
too measures and decides upon space, rendering it visible as so many
enclosures—whorls and gaps to find oneself alongside and within.

This regularity marks Dermisache's work apart from many super-ficially related practices of asemic writing, often regarded as a method of secrecy or withdrawal, that attempt to circumvent the agony of representation more generally. Simply put, these idealized practices merely ironize language, for in each such case of "pure" writing, the alienation implicit in representation transpires without any hope of the conceptual recuperation presupposed by language, which tends to universality. As philosopher Hans-Georg Gadamer prudently states, "even the pure signs of an inscription can be seen properly and articu-lated correctly only if the text can be transferred back into language."[13]

Purity in writing is difficult to imagine, however, and the very notion of a self-contained or univocal sign opens onto all kinds of patholo-gizing discourses around the difficulty of an encounter otherwise occasioning translation. Consider psychologist Theodore Flournoy's infantilizing verdict on the inspired "Martian" and "Hindoo" writing of Hélène Smith, a Swiss medium and automatic writer: "momentary returns of inferior phases," betraying "an eminently puerile origin and the display of an hereditary linguistic aptitude."[14] This refusal of medi-ation, bodily or conceptual, remains untenable: when one speaks of sound, for example, as a basis for language that is not comprehended by language itself, it is without any hope of recovering non-signifying sonority as such.

John Keene and Christopher Stackhouse: *"NOTATABLE ARCHITEXTURES"*

In *Seismosis*, a book-length exchange with artist Christopher Stackhouse, John Keene sets out to write through the "notatable architextures" of his collaborator's hand, with attention to the extensive interpersonal merit of the line-on-paper.[15] Over the course of this exchange, the two pursue a highly demonstrative co-theory: Keene is writing drawing, whilst Stackhouse is drawing writing. These are two ways, or direc-tions, of touching a common object, which may or may not pre-exist artistic contact.

13 Hans-Georg Gadamer, *Truth and Method* (London and New York: Bloomsbury, 2013), 409.
14 Theodore Flournoy, *From India to the Planet Mars: A Case of Multiple Personality with Imaginary Languages* (Princeton: Princeton University Press, 2015), 267.
15 John Keene and Christopher Stackhouse, *Seismosis* (San Diego: 1913 Press, 2006), 72.

Fig. 19. Christopher Stackhouse and John Keene, from *Seismosis*. Copyright 2006 Christopher Stackhouse and John Keene. Reproduced with permission of the artists.

Keene defines drawing in a complementary relationship to language, as a practice of "deriving the called thing," and the consonant bookends of this formulation sound as though an elongation of a nearby acronym, "drwng."[16] In treating words abstractly, as melodies subject to embellishment, Keene greets language as permutatory, plastic, a practice of mapping in the absence of terrain. The pleasure of line may imply an eventual punctuation, but it proceeds immediately without a self-conserving limit. In a subtle rejoinder to Heidegger,

16 Ibid, 5.

perhaps, whose doctrine of handiness also underwrites and haunts these paragraphs, Keene's grammar suggests that the mystical pact between language and being is in fact one moment of a process: one *derives* the thing, *so-called*, rather than receiving, much less calling forth, its form.

The collaboration begins with a vertical frontispiece, densely layered and multi-signatory. On a facing page, Keene identifies the hand with an absolutely singular expression, multiplying figures of interiority. This personal touch must adapt to the more rigid requirements of experience: when Keene speaks of "the augured grid," against which drawing attains to depth, he situates this effort in excess of Cartesian space.[17] This is not to simplistically oppose figure and concept: Keene riffs repeatedly upon the ways in which one term originates in and returns upon the other, regarding "spirals darkening at angles where concept begins."[18]

As Keene reminds us, the concept is not only secondary to, but generative of, myriad figurations. Stackhouse's riverine line evades, exceeds, and implies a geometric overlay, while elsewhere Keene sorts keywords into parallel columns, four-quadrant charts, and ten-by-ten grids: agrammatical inventories that await attentive vectors. Each poem projects an ersatz-system or technique which proves itself by its result, and which result exalts technique.

The page has a categorical function in Stackhouse's drawings, as a generic vista from which the particular depiction unfurls; a parcelled sheaf the blankness of which pre-concerns uncertain figuration. For all those drawings that allude to an aerial vantage, and the sublime abstraction of a vast topography seen from a distance, there are many more in which the onlooker is one-sidedly embedded; where a vanishing point or implied horizon establishes a series of relations in space. Moreover, the page allows for an impossible overlay of viewpoints, such that multiple perspectives coincide as seen below, where a figure in outline appears to recline, gazing skyward in the midst of a visual din.

On a facing page, Keene queries these images, that they may bear reflectively on reader's subjectivity: "Raised to itself as global agent,

17 Ibid, 6.
18 Ibid, 69.

Fig. 20. Christopher Stackhouse and John Keene, from *Seismosis*. Copyright 2006
Christopher Stackhouse and John Keene. Reproduced with permission of the artist.

figure and ground impel representation."[19] The relationship between
self and other, local and global, here and there, is iterated as so many
points of contact within the lines of a "differentiable map"; config-
urations animated by "psychosexual momenta," or Freudian drive.[20]

Stackhouse's drawings greet the spontaneous gloss of understanding
halfway, frequently appearing to ascend from the page like plumes of
smoke, or to glance upon it like a certain slant of light; all the more
striking with reference to the aforesaid preservation of pictorial space.
Stackhouse allows the page to function as such, rather than ideally, as
a disappearing frame. Each facsimile preserves the tactile materiality

19 Ibid, 19.
20 Ibid.

of its source; the grain features prominently as a counter-texture, and square perforations along the top are frequently retained as ornament. This introduces an additional layer of framing, concerning the reproduction of paper on paper as an emblem of mediation. Keene writes in "(ANTI)KANTIAN": "how when I filter the frail margin/ record of ideal forms of something/so mundane and readymade/ moment ravels there."[21] So many concentric frames facilitate experience that any point of view has only virtual purchase on an object that is more properly a moment of perception. Keene and Stackhouse refute geometric regularity throughout this collaboration, constantly referring its preconditions back to a decisional substrate: "The design event begins in subjectivity."[22]

After this insight, Keene binds writing to drawing as a parallel pre-discursivity: "I've written since I was small, right after I uttered my first word or crayoned a scribble."[23] In this account, drawing is an auto-erotic placing of worlds on the page, a practice of "interiority exteriorized." As importantly, Keene calls attention to this movement of exteriorization, so as not to portray drawing as a kind of pre-conceptual *Stimmung* or acognitive simplicity. "Within toy, fusion, cognition," Keene writes, for play is a relationship that already tends toward conceptualization.[24]

Here appears an unlikely term of mediation between writing and drawing, namely *voice* as a primary expressive means. This movement may seem counterintuitive for abandoning the page altogether, and the visual as well, but Keene, Stackhouse, Dermisache, and Gladman each invite us to consider the act of drawing as a kind of creative outreach, rather than a pursuit of any representational outcome per se. While drawing and writing converge only naïvely in the hand, Keene's developmental insight enlarges our scale of inquiry, where voice preconfigures an external world-at-hand, as a self-touching mechanism which transmission intersects an ultimately responsive world. (The German *Stimmung*, for "attunement" to surroundings, carries the additional sense of musical tuning, and derives from the word *Stimme*, or voice.)

21 Ibid, 32.
22 Ibid, 38.
23 Ibid, 35.
24 Ibid, 73.

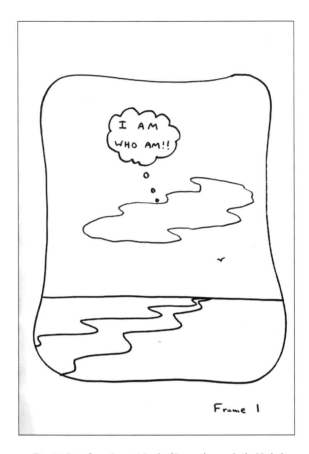

Fig. 21. Page from *Love: A Book of Remembrances* by bpNichol.
Copyright 2013. Image courtesy of Coach House Books.

bpNichol: LUNGSCAPES

At least superficially, poet bpNichol's work commences from the quint-
essentially modernist desire for a non-arbitrary written character, a
marking that would be somehow iconic of its bearing in the world. If
the concrete poetry of the mid-twentieth century aspired to such a goal
as well, it was comparatively shorn of idealism, its autonomy purchased
at expense of extra-compositional reference. Likewise, Nichol appears
at various points to be interested in the letter qua letter, treating each
alphabetic form as a recurrent character in a dual sense.

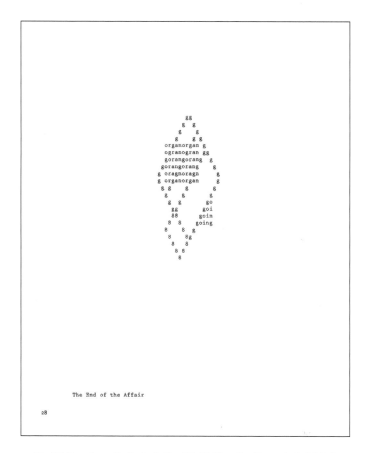

Fig. 22. Page from *KonfessIonS of an ElizAbeThan Fan Dancer* by bpNichol.
Copyright 2004. Image courtesy of Coach House Books.

The sculptural possibilities of moveable type were of formative
importance for Nichol, and his first published book, *KonfessIonS of an
ElizAbeThan Fan Dancer*, collects a variety of crystalline typewriter
concrete. But Nichol's kinetic interest in the page as a threshold
between poet-sculptor and reader-other would also impel him toward
more forthrightly sentimental means, such that one may trace a
movement toward the vocalization of the hand over the course of
his visual work. By 1973, ambivalence had crept into his relation-
ship with type as a regularizing technology. Nichol is starting to
write by hand:

> it feels like for me it's a more direct connection with the
> body—i'm actually shaping the individual letters with my
> hand—essentially when i'm typing each letter's the same as
> an experience with fingers—it's just a pressing down—when
> i'm writing it … the form is moving into my body—it's moving
> into my own musculature—it's like an intimate involvement
> with the architecture of the single letter.[25]

Coming from a less committed poet-typist, one might suspect banal technophobia ala Heidegger, for whom "the typewriter tears writing from the essential realm of the hand, i.e., the realm of the word."[26] But Nichol's typewriter poems subject the regularity of the medium to non-calligramatic pictorial elaboration. A densely repetitive, shapely text like "Early Morning: June 23," or the performance script "Not What the Siren Sang But What the Frag Meant," begins from and with recombinable vocables of bodily origination, contrasting a columnar alignment of letters with the many sounds and scenic associations that proceed from the shifting placement of alphabetic sets. In this regard, Nichol's transmutatory typistry directly rebuffs Heidegger's selective anxiety regarding technologies of the word.

Nichol's insistence on the bodily mediation of a written alphabet will impel him to "consider a serial development of a primary drawn text" on the model of his earliest literary obsession, comic books, and to a practice of "drawing as drawing - line as line," where line is conceived as a medium closely akin to breath.[27] For all its physical persuasiveness, however, this sophisticated naturalism actually elaborates upon the critique of phonocentrism implicit in earlier work. For Nichol, the letter is in many ways prior to the sounding voice, which is an instrument of its recovery. One trains upon it, in a kind of circular rediscovery of self. In a letter to Mary Ellen Solt, quoted above, Nichol describes an integration of breath line, or sound-based, poetry with his "literal obsession with the single letter & what it contains as an element of word as sound unit & in terms of its own history."[28]

25 bpNichol, *Meanwhile: The Critical Writings of bpNichol* (Vancouver: Talon Books, 2002), 120.
26 Martin Heidegger, *Parmenides*, trans. André Schuwer and Richard Rojcewicz (Bloomington and Indianapolis: Indiana University Press, 1998), 81.
27 Ibid, 115.
28 Ibid.

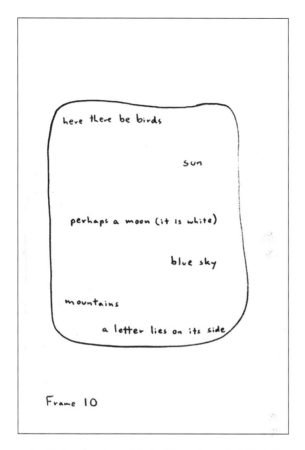

Fig. 23. Page from *Love: A Book of Remembrances* by bpNichol.
Copyright 2013. Image courtesy of Coach House Books.

Nichol's cartoon allegories are exemplary of this material re-evaluation of the alphabet. While Krazy Kat and Dick Tracy comics would spur Nichol to create recurrent heroes of his own, like Captain Poetry or Tommy the Turk, the far more important characterological associations within his enormous body of work concern the alphabet itself. Nichol writes and rewrites each letter as though it were a miniature poetic personality, with cameos across the written universe. Pursuing this childhood conceit, Nichol seizes upon the integral flatness of the comic-book page, where each hand-lettered speech bubble and its purveyor feature equally in space.

Fig. 24. Page from *Love: A Book of Remembrances* by bpNichol.
Copyright 2013. Image courtesy of Coach House Books.

The formal strictures of the comic book may have primed a school-age Nichol for his later experiments in concrete poetry, using the page as a framing device. But Nichol's Steinian deduction from comic narrativity eventually concerns the expectation of sequentiality. In *Love: A Book of Remembrances*, frames are radically contemporary of one another, and present as discrete containers, which may be provocatively recombined. The letter is an allotment of space, in which movement is implied.

In the numbered allegories, from which an amoebal frame is notably absent, each letter form appears as so many concentric and competing

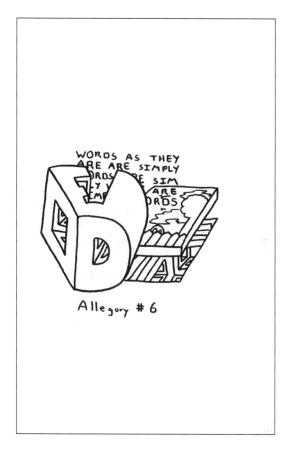

Fig. 25. Page from *Love: A Book of Remembrances* by bpNichol.
Copyright 2013. Image courtesy of Coach House Books.

containers in itself. The letter, spontaneously construed as the smallest integral unit of written language, appears both infinitely divisible itself, and contiguous in body with its sounding neighbours. Strange worlds gape from every crevice, pictures of private association. Letters are trapdoors, nesting dolls, collapsible vistas, inhabitable domiciles. In Nichol's words, "the language is the landscape of the poem," such that his drawing circumvents the idealism of Pound's calligraphic fetish altogether.[29] In Nichol's case, poems do not depict, but are depicted.

29 Ibid, 113.

Writing Drawing

On an immediate level, both Gladman and Nichol appear to attempt the recovery of interiority in representation, and to manifest a certain impasse of form and content, concept and figure. While the outcome of these drawing practices could hardly be more different—an intelligible illegible on one hand, and a cute inscrutable on the other—they are amenable, where each of the artists under discussion here have embarked upon a project of expanded field poetics more concerned with bodily conduction than with information exchange. This undertaking is immanently social, for as these works understand, self-expression is already mediated by the structures comprising our external reality, whether by cities or alphabets, categories or symbols.

As Keene reminds us, design begins in subjectivity, and it culminates in subjective appreciation, too. Drawing, then, may be an inter-objective conductor of subject to subject, desire to desire. To quote a foundational statement of Nichol's poetics, "if (the poet's) need is to touch you physically he creates a poem/object for you to touch and is not a sculptor for he is still moved by the language."[30] In what respect does drawing open onto a superior, or ulterior, poetics?

On one hand, we could define drawing as a practice of the body of writing, without the presumed universality of a given language. On the other hand, this utopian retreat from translation depends upon a spontaneous notion of drawing as auto-iconic, marking a retreat from the concept, too. Not only is writing already and immediately a kind of drawing; but initiation into one practice presumes the other, insofar as this distinction is itself conceptual. Where there is no private language, concepts are in common—and Dermisache's mute ligatures insist as much, on a mutual silence in which a general readership consists.

As Gladman refers her practice of solitary drawing to questions of public space, the incidental features of everyday life assert themselves from within the movement of the hand, as a respondent rather than author of the city. This objectively subjective practice surely describes the kind of writing that bpNichol had in mind when he prescribed

30 Ibid, 18.

poetry to the masses, that everyone should write in tandem and cohabitate after the manner of this writing.

In an essay concerning Derrida's relatively few engaged remarks on the topic, Laurence Simmons proposes to understand drawing as a search, rather than a communication: "the physicality of the primary gesture of the drawing hand here must also be understood as an impulse to touch that which should only be an object of visual perception, to transfer a presence to a deep memory."[31] In this account, drawing remains a primary operation, but only subjectively, insofar as it follows from that which it would project.

Rather than suggest that drawing is an inalienable basis from which writing departs, we should consider the directionality of this attempted transfer, for the comparison ends in recursion. As Simmons asserts, "there can be no metadiscourse on drawing since all work on drawing is also a work of drawing."[32] Not only does drawing pass through writing, writing passes through drawing en route to its own publicity. Neither appears primarily. The texts under discussion here illustrate as much, differing in emphasis as any hand, any expression, must. The signatory gesture which inheres in drawing, then, is less a token of authorial presence than a bodily antecedent to form; in which sense drawing, too, becomes a practice of the letter. Simmons describes drawing as a search for a lost object rather than a communication, thus allying its purposes to writing, where language cinches an otherwise irremediable gap between communicants.

In *Calamities*, a philosophical daybook of beginnings, Renee Gladman describes the act of transcribing favourite sentences by Gail Scott on her living room walls. "I wrote them as if they were a geometry instead of a verbal consequence," she writes, and this practice of studious mural making mirrors the prose architectures, in which interrelated shapes appear as sentences.[33] It is with this invitation to an action, to relate to the relation of arrangement, that we may close the circle of this writing, having glimpsed tellingly little of what drawing includes and can do.

31 Laurence Simmons, "Drawing Has Always Been More Than Drawing," in *Interstices 11: The Traction of Drawing* (Auckland: enigma: he aupiki, 2010), 117.
32 Ibid, 115.
33 Renee Gladman, *Calamities* (Seattle: Wave Books, 2016), 44.

Limited
Omniscience
and Militant
Secrecy

"Their not-knowing seemed to energize them more than knowing ever could. That will be one of my arguments."[1]

—Renee Gladman, *The Activist*

The last decade has seen a surge in literatures of protest; not only poetry that doth protest, but documents of specific manifestations in specific locales, with the character of an exhortatory reportage. Galvanizing in its explicit combativity, such writing tends toward the time of an oceanic immediacy, even appearing at odds with the task of reading, as an afterthought presuming leisured contemplation. Rather than attempt a survey of these contemporary "protest poetries," which tend toward a pro-social and clamorous writing of the crowd, we could identify a stark alternative—an anti-social writing of the set, which emphasizes group formation on a collusory, even conspiratorial, principle.

Such writing, if we may already presume to speak of a tendency, counterbalances the ad hoc and carnivalesque with depictions of internecine uncertainty, evoking the difficulty of organizing in adverse conditions. The works under discussion here are often eerily de-specifying in their performance of a steely secrecy, from which

1 Renee Gladman, *The Activist* (San Francisco: Krupskaya Books, 2003), 107.

much information is withheld. Throughout Renee Gladman's novel *The Activist*, the identity of the conspirators and the efficacy of their actions are continually called into question, pending a reader's interpretation, perhaps analogous to the act of judgement in which consists a politics. Over the course of Roger Farr's collection, *IKMQ*, a socially disruptive cell rehearses its activity after the fashion of a slapstick algebra; cooking drugs, squabbling over politics, and conspiring to ambiguous ends. Elsewhere, the unnamed narrator of Kaie Kellough's *Accordéon* may or may not be a double agent for the sinister Ministry of Culture, which oversees an entire province's affairs with controlling intent. However non-forthcoming, each of these works depicts the private life of the fanatic; one who has sacrificed personal freedom to exterior conditions.

Seethingly quietudinous, this tendency harbours a radical potentiality. Without signposting any politics in particular, each of these pre-revolutionary mysteries enacts a practice of participation in uncertainty. More tellingly, the books under discussion here could be reclassified as "poet's novels," prose works that adapt the multi-perspectival and narrative expectations of the novel form, if only to baffle chronology and the parameters of inner and outer life after the permissions of experimental writing. This form is politically advantageous in an age of contextless manifestos, for the novel stages a finite totality, permitting a depiction of social reality that transcends an individual perspective. In this respect, the recurrent motifs of conspiratorial secrecy and concealment counterpose the novel's capacity to overview. The characters of such novels inhabit their worlds as we do our own; acting on partial information, living fragmentary lives in assurance that coherence is somewhere secured.

Invisible Bridges: Renee Gladman's The Activist

Renee Gladman's 2003 novel *The Activist* opens on a stalling, paranoid monologue by a "sympathetic field reporter" drawn into the cause of an insurrectionary cell, the "CPL," over the course of a story.[2] This narrator works in a "new era of reporting," we are told, "where every

2 Ibid, 13.

idea lights upon the public with the vivacity of a pre-pubescent," and the innocence-in-ignorance of this target demographic afflicts the reader, too.[3]

In snippets of reportage corresponding to an attempt at a disinterested record, the reader glimpses a strange dispute concerning the destruction of a city bridge. It soon becomes clear that the investigators are not attempting to establish whether or not the bridge collapsed as an act of deliberate sabotage; rather, they would seem to be concerned with whether it has collapsed at all, or if it even existed in the first place: "What we have is a smell of iron burning, but no visual evidence on site."[4] Pages later, we read that "the bridge remains intact today, despite reports that it is long gone."[5] An elite investigator remains convinced of its destruction, while scientists affirm that it still stands. Commuters attempting to cross the bridge are told by police that it has been destroyed, though it appears before their eyes. A subsequent report, potentially embarrassing to everyone, says that it isn't even clear whether there was a bridge there in the first place: "Now imagine how this sounds to people in other countries, or just on the other coast."[6]

One possible reading of this predicament would have recourse to a Baudrillardian commonplace concerning the anxiety of appearances in an age of simulacra, where the veridicality of every presentation is radically moot because all possible appearances are identically mediated or rehearsed. This thesis already seems quaint, for Baudrillard's lapsarian horror at mediation can be recast as a banal skepticism: reality is already virtual. But *The Activist* doesn't bother to ask whether or not the war is really taking place. Rather, its choral disputation portrays the decisional nature of politics, such that basic discrepancies in the objective record of an event correspond to incommensurable agendas.

On one hand, it seems that the alleged destruction of the bridge is state propaganda, readily refuted by any would-be pedestrian or motorist at a glance. In this "Emperor's New Clothes" interpretation, ideology not only fails to manifest phenomenologically, but is ironized

3 Ibid, 14.
4 Ibid, 20.
5 Ibid, 22.
6 Ibid, 30.

on sight but an obvious disjuncture between an official narrative and empirical fact. As one disgruntled commuter says, "they are blaring signs demanding that we stop. But what do they want us to do? We've all got kids to feed. Personally, I'm tired of pretending that I don't see the bridge."[7] (As Jacques Lacan would quip, "les non-dupes errent.")

On the other hand, a reader could experimentally credit the CPL with this action, construing its non-manifestation as an expression of the contestable terrain of politics in general. Here one confronts the philosophical question of the event; what constitutes an event, and can we ever be sure that we are witness to one? As Alain Badiou describes, any event implicitly postulates a number of corresponding subjectivities—fidelitous, reactive, and obscure. A faithful interpretation preserves the significance of the event, reorienting one's practices toward new information. Comparatively, the reactive response attempts to normalize an exceptional situation by denying it the status of an event altogether. The reactionary's explanations are invariably various: this was just a chance occurrence, it has no bearing on the moment nor the future, it is tidily historicizeable, and so on. In this light, reactionaries will always insist that the action failed, the bridge stands. An obscure stance in politics is possible, too; which in this scenario might resemble the lunatic assertion that it is unclear whether or not anything happened at all. All of these subjectivities converge upon the missing, intact, or imaginary bridge:

> What we have is an extreme form of civil disobedience. Something our public has never seen before. This is the situation we're facing: a shockingly high number of witnesses claim that the bridge is in perfect form, the President of our nation is convinced that the bridge has been exploded, another group asserts that the bridge has collapsed, not exploded, and a handful of researchers contests that there ever was a bridge.[8]

Further confusion concerns a map stolen by the CPL, a dynamically responsive document that metamorphoses with the city it describes and vice versa. Where the map presents a cognitive monopoly on representations, any action undertaken by the novel's eponymous activists

7 Ibid, 26.
8 Ibid, 30.

may have been entirely conceptual, sowing perceptual disunity among the map's inhabitants. The bridge, as a key to Gladman's many novels of civic concern, is either peacefully absent the landscape or violently destroyed depending on one's narrative credulity. This "truly embarrassing" predicament, elsewhere glossed as perceptual warfare, is not only immanently textual, but describes the postmodern predicament of the "atonal" world, one lacking the internal consistency that a master signifier affords.

The Purloined Map

The map is an object of special concern for the narrator, and a cause for anxiety: "If I'm wrong, then all this mutating indicates we've moved into an alternate reality, one whose principles of space and intention differ drastically from that which all our lives we've grown used to."[9] Ideology is again identified with categories of understanding, normative values suffusing space-time. This anxiety, however, impels the narrator to queasy treason, as she comes to identify the map as a threat to the group whose unity is constituted around its possession. Accordingly, she resolves to destroy the object altogether in order to forestall the demise of the group, to which she remains "utterly dedicated ... I would do anything for them," she protests.[10] The sacrificial sense of this gesture only concerns the map as a formal proxy or empty sign; a minimal requirement of group formation.

Guilty conscience notwithstanding, the map is not so much a telltale heart beneath the floorboards of a safehouse. Rather, the map should be understood as a purloined letter that constitutes a symbolic field by failing to appear within its bounds. In Gladman's thriller, there is a socially constructive tension between the map as a descriptive artefact and the map as guarantor, a signifier which stands for the possibility of a terrain in general; and our narrator is that obscurantist who would save the world by scrapping its symbolic basis. "Utterly dedicated" to the group in their capacity as separate individuals, she has nonetheless effectively miscognized the consistent effect of the group as subject.

9 Ibid, 93.
10 Ibid, 95.

This crisis of conscience corresponds to a formal-political impasse: the non-coincidence of a political formation with the desires or identities of its constituents. A political organization is not merely an aggregate of individual aspirations but a project to which one subordinates oneself. As the fictional insurrectionist Monique Wally asserts, detained on suspicion of terrorism, "it is impossible to live in this country and think of oneself as a group."[11] This thesis, a facetious endorsement of the Thatcherite claim that "society does not exist," is striking. Accused of conspiracy, Wally denies the claim that one may conspire in the first place, citing a common alienation. This alienation, and the difficulty of incorporation, is reflected in the contradictory endeavour of conceiving of *oneself* as *a group*; a superficially illogical formulation that is nonetheless descriptive of a certain kind of social, or specifically political, consciousness. Such constructive misidentification is mirrored, literally reversed, in the initial condition, where "country" denotes a social grouping in which it is nonetheless impossible to live. To belong to this de facto group of countrymen effectively forbids the conception of oneself as tributary of any organization in particular, which is overruled in advance. This is a concise instance of ideology, as both a positive logic of appearances and a kind of bad faith, recusing one of indecision.

Another activist, Alonso, spars over this problem of incorporation with a skeptical friend, Barry, the textbook fellow traveler. "In turning to you—" Alonso says of his attempt to address an outsider, "it's like I'm reaching my arm out of a whirlwind."[12] Whether this is a moment of frank doubt, a lapse into the genre of confessional, or something else altogether, the overture is interpreted as prideful heroics, perhaps an attempted recruitment. "See that's why I could never join one of your groups," Barry retorts. "Your whole life becomes its survival." Then, revealingly, "I would hate to need anything so much."[13]

The central philosophical problem of *The Activist*, which on some level concerns group formation vis-à-vis a galvanizing event, is written in its name: one cannot conceive of a solitary activist. More properly, the novel should be called *The Activists*, except this pluralization has

11 Ibid, 49.
12 Ibid, 98.
13 Ibid.

the unintended effect of disaggregating its subject by implication. The unitary subject of politics is not attained to additively, but as a matter of consciousness. From another perspective, the title derives its sense from the solitary bearing of the narrator-journalist, who runs afoul of her radical coterie insofar as she wishes to be both inside and outside of the group, to retain her private conscience as a counter to mass consciousness.

The next meeting of the CPL concerns the status of the mutating map. "Whose got the m-a-p," congregants whisper; and this matter of custodial uncertainty, the delegation of duty and risk, is juxtaposed with images of a football team playing across the park, calling to each other angrily, "where is the ball?"[14] Neither cause is frivolous, but political insurrection doesn't exclude the possibility of sportsmanship. Here again, comparison supposes the practical indifference of submersive and subversive activity.

Gladman's frequently opaque text puts the onus of decision on a frustrated but dedicated reader. This enacts a condition of politics that the novel would otherwise describe—that one's capacity to act is always limited by an unclear situation. One cannot know where one stands, and yet one must take a stand. In this respect, the text of *The Activist* eschews or complicates the phenomenological basis, or bias, of much politically charged writing, which treats the metabolic unity of the crowd; the biofeedback of its bodily manifestation. These exhortatory hallmarks tend to immediatism insofar as they are bound to the auto-corroboration of a sensory regime—the manner in which the world is readily disclosed to consciousness, which precludes conceptual negativity. Gladman writes sensuously of the embodied confusion and catharsis, eroticism and embarrassment, attendant upon participation anywhere—which is to comprise one's part, to be partial in the dual sense—but her vision notably declines the narrative omniscience that typifies the novel form, not to mention the après-coup of political accountancy.

Throughout *The Activist*, nobody knows what's going on. (In politics, Marvin Gaye's more-than-rhetorical plea necessarily precedes that of Lenin.) The pervading mood is one of paranoia, which is itself

a structure of knowledge. As a familiar slogan goes, "just because I'm paranoid doesn't mean they aren't watching me." Suspicion imbues incidental symbols with a worldly charge, and activist Alonso regards the park warily: "That beetle appears stuck to his arm. He's wondering if it's been planted there. He looks at Barry … Barry's thinking. Seems innocent. And the bug, not causing the expected itch … it seems innocent too."[15]

Total surveillance is expected, such that one's supervisor doubles as an addressee. In this way, the state beetle is a likely projection insofar as it condenses and refracts conviction. "Whatever the case, the existence of an auxiliary presence cannot be denied," the narrator states. "But how easy it is to become paranoid when you are an activist."[16] Just as those ardent in politics are consistently hystericized before complacent neighbours, reality administers a test of conviction. The perverse will of the activist then trains upon a dailiness commensurate with ideology itself. Surveillance licenses all kinds of strange behaviour, even carrying a whiff of insurrectionary success. In certain respects, surveillance culture shares a form with ideology, where every interaction impels a postulate as to the knowledge of the other, as an interpellative pivot: "Strangers ask you for the time and you are impelled to express your patriotism."[17]

In the Balance

Insurrectionary interiority requires a highly developed theory of mind, whereby one's "true" intentions are secured somewhere outside the merely interpersonal; pending a definitive, if secluded, act by which the duplicity of the agent—and every agent is a double agent—may be reproved or redeemed. In this sense, even the conventionally omniscient narrator, for whom the events of the novel objectively cohere, becomes a paranoid narrator; one whose purview has a speculative relation to totality, but whose vantage is embedded. Paranoid knowledge, a tautology, runs to totality insofar as it projects an ideal unity within which one may assume one's proper place.

15 Ibid, 99.
16 Ibid, 94.
17 Ibid.

A broad remark as to the storied debate on literary realism and left politics may be useful here. When Gyorgy Lukács wrote against the "so-called avant garde literature ... from Naturalism to Surrealism" in 1938, specifically refuting Ernst Bloch, he did so in defence of the practice of realism, understood to apprehend the totality of social relations. Championing the bourgeois novel of preceding centuries, Lukács decried contemporary developments toward psychological and experimental renderings of a narrator's interiorized perspective on reality, claiming that such writing abdicates the overview of its historical period, which dimension of the realist novel conveys literary representations of society to political consciousness. The fragmentary envisionings of experimental Modernism are then read as a straightforward retreat from reality.

But "what if authentic reality is also discontinuity?" Bloch offers, essentially arguing that avant-garde literatures are an ulterior, or higher order, realism in their fidelity to the discontinuous texture of capitalist society.[18] Lukács's rejoinder has recourse to crisis, for the appearance of discontinuity is only an immediate experience of a series of relationships that would otherwise go unremarked upon during periods of ideological unification. According to Lukács, the avant-garde has been contingently tasked to "systematize ideological states of flux," embracing the obscurity and strangeness of the historical situation and codifying it at the level of style.[19] For Lukács, the interior turn of the experimental novel occludes the proper intimation of totality that literature is uniquely capable of producing.

It might seem merely academic to relitigate the Bloch-Lukács debate today, though it was never satisfactorily resolved in the first place. Surely the debate was foreclosed by a deepening cultural gulf between two political realities during the Cold War; but as importantly, the terms of discussion from either side presume an alignment of art with reality, such that this matter cannot be resolved in either jurisdiction alone. Where Bloch construes private consciousness as a social map, Lukács accuses the expressivist avant-garde of deriving its incidental

18 György Lukács and Ernst Bloch in Theodor Adorno, Ernst Bloch, Walter Benjamin, Bertolt Brecht, and György Lukács, *Aesthetics and Politics* (London and New York: Verso, 2007), 31.
19 Ibid, 51.

symbols from an anti-social interiority, thus thwarting an "artistic dialectic of appearance and essence" supposed to operate within works of integrative realism. Both perspectives clearly await unity, not with each other as such but within an historical process of objective disalienation.

To anachronistically impose the stakes of this debate, insofar as they concern the political agency of writing, *The Activist* would on one hand appear to extrapolate a political ontology from the perceptual challenges of an isolated moment. On the other hand, however, the writer, whether as an infiltrating agent of surveillance or ulterior consciousness, is explicitly tasked with framing the contemporaneity of irreconcilable viewpoints.

Gladman's characters inhabit a pell-mell, atonal plane, akin to the "perfected non-world" of which Bloch speaks in his defense of the avant-garde's fragmentary envisioning. The novel's contestable map, as a medium of flux in totality, or totality in flux, is a symbol of this predicament, placed within the text. Without the "m-a-p" in its proper place, symbolizing the dialectical relationship of appearance and essence, representation and reality, things come unmoored. Accordingly, the reader does not share in the prioritized bewilderment of any single character, but partakes of these mutually conflicting perspectives at once, as an adjudicative sleuth or intellect.

Literatures of radical secrecy condense these tensions, unexpectedly extending the stakes of this foreclosed debate; neither retreating into interiority nor attempting panorama, but defying the mandate of both modes to depict a social space contracted by the time and formality of collective endeavour. The narrators of these novels are non-omniscient, rather eccentric of the world they would depict or motivate: Gladman's journalist infiltrant is that "auxiliary presence" herself, who sutures the group from without.

I is Another: Roger Farr's IKMQ

Roger Farr's *IKMQ* presents this uneasy feat of position as a grammatical ambiguity attending the first-person perspective in fiction. *IKMQ* relates the misadventures of a radical quartet: I, K, M, and Q respectively. The action transpires over the course of sixty-four vignettes, divided into four sections of sixteen, each named for a character. These

range from satires and redescriptions of iconic literature and film to recipes and instructions, written mostly in the third-person objective mode, disinterested and austere. The grammar of the book not only precludes flights of interiority—the sense of this world is not in this world—but gives the impression of a slapstick algebra, where logical formulae appear throughout, reducing social intrigue to abstract relations of equivalency.

Farr's gridlike design frames the bare requirements of narrative, as a permutation of formal elements. At the same time, Farr's nomination conspicuously foregrounds the extravagant materiality of the signifier. At many points, the letters cease to function as arbitrary placeholders and take on a material identity of their own, such that the character marked "K" is not simply designated by a letter, but shares an identity with that letter and its myriad appearances in the language, which become a heuristic means of accessing a material archive. In a section titled "Guggenheim," each character serves as a lexical index of four disparate sets, Metal Bands, Kyoto Signatories, Quakers, and Insults: M, for example, collates Morgoth, Myanmar, Mullins, and Moron.[20]

In many respects, *IKMQ* is a book about its own formal architecture. Early in the text, Farr's characters construct a house of cards corresponding to the number of stories ahead. Two consecutive paragraphs conclude with Q's announcement that the structure is complete: "but I knew this was impossible. A total of 64 stories was required, and there were only 18 cards left in the deck."[21] Rules of language games are clarified in transcriptions of meeting minutes.[22] The crew workshops writing together and discusses ideas for sections shortly to appear.

Amid these self-referential antics, however, an excessive element intervenes, after the fashion of a suggestive polysemy. As seen above, every sentence describing the activity of the character I appears to double as a subjective, first-person account of events—a grammatical ambiguity following from the past tense in which the book is written, in which the verb forms for first and third person perspectives coincide. This rule is broken to uncanny effect in a chapter called "Metaphysics":

20 Roger Farr, *IKMQ* (Vancouver: New Star Books, 2012), 61.
21 Ibid, 11, 12.
22 Ibid, 17.

> M pulls a caravan into the medina, opens the doors, and dis-
> appears. White walls baking in a Mediterranean sun. In the
> lower left corner, Q twirls a hoop with a stick, unaware that K
> is about to enter the scene. This long shadow next to K shall
> indicate the future. This flag flapping in the wind, the present.
> The only element missing now is the past. I paused, reassessed
> the composition, and drew a small, thin line, like this.[23]

All time is contemporaneous in this sketch, arrested in frame, and
the difference between past, present, and future becomes a matter of
proximity. As the text zooms out upon this vignette, "I" looms from a
position of authorizing posteriority, concentric of the foregoing action.
Farr plays upon this question of authorial priority—in the coyly titled
"Birth of the Author," K, M, and Q usher I into being, overseeing the
character's literal nascency. In the first-person, however, this scenario
relates the impossible, paradigmatically literary, fantasy of seeing one-
self as from without, as from before the very start. "I was born ... I
was a very special baby"; so would we all like to believe.[24]

According to Jacques Lacan, the third-person point of view doesn't
exist anywhere except projectively, as a negation of the reversible I-You
pair. The third-person perspective thus enacts the point of view of the
Big Other, both an ulterior subject and a name for the symbolic itself.
Ludwig Wittgenstein, a touchstone of Farr's text, takes a more or less
opposite line, insisting that the "I" is unreal, even going so far as to
outline a grammatical eliminativism in which the first-person would
be unnecessary.

Wittgenstein's distinction between factual and psychological uses
of the first-person pronoun depends upon the possibility of mistaken
attribution. To say "I have a bump on my forehead," following his
example, is to make a statement in which one could be deceived. To say
on the other hand that "I have a pain" is equivalent for Wittgenstein
to crying out, insofar as there cannot be any mistake as to the subject
of this pain. In the latter case, Wittgenstein goes further, emphasiz-
ing the non-equivalency of the statement "he has a pain" and "I have
a pain," where the former is ineffable and the latter impossible either

23 Ibid, 15.
24 Ibid, 10.

to share or to doubt. In Wittgenstein's account, pain cannot be shared, such that this class of first-person statements could be rephrased as a coincident reflex rather than a proposition.

Farr's text brackets psychology altogether, and the past tense in which the book is written complicates the difference between the first-person and third-person, where the former denotes qualitative immediacy and the latter permits incredulity. In Farr's text, however, where the shifter "I" works as any other third-person pronoun in its place, a statement like "I was in pain" becomes a merely factual assertion, permitting not only a mistake but a deception. This is the grammar of noir, of the detective story and its language of delayed discovery and self-doubt.

Farr's characters, insofar as these ciphers have character, cavort in tightly controlled chapters corresponding to so many restricted sets. This differential identity is purely extensional: I is an other—of K, M, and Q—rather than the privileged subject of the narrative. A lateral equality consists in reference to an excluded element, and it is only phenomenological convention that this element ought to be an I. This algebraic circuit drastically refines the closed totality in which any literary undertaking consists; rather than a panoramic romance, *IKMQ* becomes an exercise in motivated permutation.

Gertrude Stein makes a similar claim of her early epic, *The Making of Americans*, which at times resembles a work of disinterested set theory, despite the love that its author professes for her characters throughout. Stein's writing of life's repetition implies the completed history of everyone, or so she claims. But there is an essential relationship between Stein's indomitable "I" and the atomizations that she treats, insofar as this grand genealogical undertaking contains no history. In everybody's "just repeating," society reproduces itself as though everything had always been so. Although Stein's assertion of "bottom nature" is less fundamental than relational, these connections are nonetheless synchronic, apprehended at once. Ultimately and at every moment, Stein envisions an unmediated, arrested totality.

Perhaps in apprehension of this dilemma, Farr satirizes the humanist pretense of literary fiction as well as the proliferative quest for novelty that typifies experimental writing. In a chapter called "The Avant-Garde Never Gives Up," the quartet argues about the difficulty

of self-expression. "I had writer's block. K said there was no such thing as writer's block and that the problem I had was a big ego," the story begins. "Century after century of Private Citizen speaking to Public World has become tiresome, Q said. The liberal, neo-Habermasian notion of a public world was a con, K said, never mind the epistemological dilemmas associated with the valorization of the private individual. Or the citizen, M added."[25] K, M, and Q proceed to coach their friend through all kinds of procedural solutions to this imaginary impediment, describing generative devices used by Tristan Tzara, Georges Perec, Dan Farrell, Ronald Johnson, and others. "Done, done, done, M said. What about a story without the letter I, Q said. Impossible, I said."[26]

This statement of impossibility—that it is easier to imagine the cessation of society than of oneself—reads suggestively alongside Renee Gladman's provocation in *The Activist*, that it is impossible to "think of oneself as a group." Farr's text plays upon the opacity of action absent desire; yet the matter of attribution doesn't change events in the least. From a logical standpoint, I is an other, an agent among agents, secured by difference and displacement. Something fixes these elements in relation to each other; that is, some situation establishes them as provisionally capable of negating one another. (I is not K, M, or Q, K is not I, M, or Q, and so on.) Logical difference structures the visual manifestation of the signifier, however; and Farr's coy suggestion, playing the logical and material planes of reading against one another, is that I isn't even I.

Farr's vignettes are literal character studies, and this attention to the letter comprises a cipheral writing, in the sense set forth by Steve McCaffery: "writing of this kind shows a concern with the order of effects that connect with the incidentality of the signifier rather than the transcendentality of the referent."[27] Meanwhile, the psychologically opaque propositions comprising this text point up a clear limit to any logical or pictorial theory of language. The sense of this world is not in it, which, coupled with the uncanny parallax effect of its divisory

25 Ibid, 41.
26 Ibid.
27 Steve McCaffery, *North of Intention: Critical Writings 1973–1986* (New York: Roof Books, 2000), 19.

"I," opens again onto a re-compositional effort that in effect politicizes reading. The algebraic sitcom of *IKMQ* consists as only so many separate worlds or language games for want of a strong reading; elsewhere, perhaps relatedly, Gladman's activists are worldless for wanting a map. Because Farr's characters comprise a restricted set, the book has a visible horizon. Its actors are effectively enumerated by a series of tasks, the meaning of which is ultimately withheld the text. As a result, the militancy of this text reverts into puzzling quietism. Wittgenstein's description of mystical experience, "feeling the world as a limited whole," captures something of this literary predicament. In politics as in matters of religious perception, conviction sutures writing to a world, such that every fanatic may be said to contract totality.

Fanaticism and Representation

Philosopher Alberto Toscano traces the development of the fanatic as a rhetorical figure through various anti-colonial and abolitionist cultures, as well as the pathologizing discourses of early criminology. In criminologist Cesare Lombroso's work, as well as that of his contemporary Gabriel Tarde, the criminality of the fanatic is likely, if not assured. While both accounts fixate on anarchism as a site of fanaticism or misplaced religious zeal, Tarde's explanation is less etiological, referring to the collective social life enveloping every would-be fanatic. Tarde, Toscano explains, produces an incipient media theory, eventually praising the capacity of then-nascent publics to neutralize the physical intensity of the thronging crowd in their relative dispersion.[28]

In the works of radical secrecy discussed above, a fanatical actor or company sequesters themselves from the larger public, as a medium by which opinion is produced and tempered. This isolation isn't only a test of resolve, but a refusal of social vetting. Paradoxically at first, the relationship between a totalizing agent and the social whole to which they belong is one of contraction and repudiation. The fanatic rejects society, having a negative relationship to the affective agglomeration that becomes a public. In every case then, Toscano suggests, fanaticism proceeds by abstraction. The fanatic, whether political or

28 Alberto Toscano, *Fanaticism: On the Uses of an Idea* (London and New York: Verso Books, 2017), 23.

gnostic, professes a "passion for the real," in the words of Badiou, which necessarily stands in opposition to representation, typically assuming a negative form.

Here we could propose a relationship between social retreat and literary evasiveness—perhaps even to rehabilitate a Lukácsian ideal by the backdoor, insofar as many of these works of avant-garde experimentation reject realism specifically because of its representational grandeur. The novel of radical secrecy both presumes and negates novelistic totality, rather than attempting to disclose its subjective underside by fantastic means. Where the novel's world is presumed to cohere on a larger scale than individual experience, such works do much more than simply revert to that miniature scale: they challenge the transcendental coordinates by which coherence is secured without reifying the interregnal pell-mell of induced crisis.

Lukács attributes the fragmentary approach of the avant-garde to capitalist crisis: "In periods when capitalism functions in a so-called normal manner, and its various processes appear autonomous, people living within capitalist society think and experience it as unitary, whereas in periods of crisis, when the autonomous elements are drawn together into unity, they experience it as disintegration."[29] Fanaticism, Toscano says, also responds to crisis: "As [political theorist Michael Walzer] suggests, in times of normality the administration of things might indeed occlude the presence of political divisions; but 'when the old social hierarchies are challenged, coherence undermined, the world in pieces', then taking sides, with passion and a degree of intolerance, appears non-negotiable."[30] Taking sides, it seems that the experimental interiorism that Lukács decries and the fanaticism that crisis commends are two non-amenable approaches to social uncertainty.

Next to Last: Hubert Aquin's Prochain épisode

This tension comprises the melancholic temporality of Hubert Aquin's *Prochain épisode*: a monologic novel from 1965 in which a lovesick political prisoner narrates his failed action from a prison cell, transforming revolutionary happenstance into an ambient spy novel. Balancing the

29 Lukács and Blochs in Adorno et al., *Aesthetics and Politics*, 32.
30 Toscano, *Fanaticism*, 25.

florid pathos of Modernist psalmistry and the reticence of noir, Aquin places his narrator in the absolute present of expressionism, depicted throughout as a kind of purgatory. Set in the nineteen-sixties, against the backdrop of anti-colonial internationalism, *Prochain épisode* is a definitive novel of Québec's struggle for self-determination, which transpires alongside any number of Third World liberation movements despite internal contradictions.

Writing from his cell, Aquin's thwarted insurrectionist aspires to the standing of a Balzacian hero, an exemplar of integrity in motion, but feels painfully constrained by his own subjective incoherence. It was only ever for a lack of narrative certainty that he felt compelled to give himself over to a cause, he explains, and now that action has transpired without coherency, the captive hero lapses back into fatal reverie:

> Now that the deed is done and Balzac eliminated, the pain of vainly desiring the woman I love avoided, now that I've chopped my fury into devalued notions, I feel rested and I can look at the submerged landscape, I can count the trees I no longer see, recollect the names of the streets in Lausanne. I can easily recall the smell of fresh paint in my cell at the Montréal Prison and the stench of the Municipal Police cubicles. Now that I'm feeling free and easy, I let incoherence take hold of me again; I give in to that improvised stream, renouncing more from laziness than principle the premeditated plotting of a genuine novel. Real novels I leave to the real novelists. As for me, I flatly refuse to bring algebra into my invention. Condemned to a certain ontological incoherence, I take my stand. I'm even turning it into a system with an immediate application that I decree. Infinite I shall be, in my own way and in the literal sense. I won't leave a system I create for the sole purpose of never leaving it.[31]

The narrator's desire for an impossible coherence impels him to grand declarations of unconscious systematicity. Evincing a surplus of narrative over plot, identified with mathematical formalism, Aquin's *cri de coeur* appears avowedly literary and anti-social at once.

31 Hubert Aquin, *Next Episode*, trans. Sheila Fischman (Toronto: McClelland & Stewart, 2001), 6.

In an essay on *Prochain épisode*, Fredric Jameson foregrounds a perceived stylistic defect: "namely the obsessive and intolerable celebration of the first person, the grimacing and posturing of an in any case hollow subjectivity, the mimicry of an aesthetics of subjective expression whose paradigm, reduced to something as elementary as a cry or an outburst, seems to betray its own poverty by a repeated series of exclamation points."[32] For Jameson, this repetition corresponds to an identity-failure characteristic of the bourgeois novel, sharply differentiated from the egotistical sublime of Proust, for example, "whose meditative sentences slowly explore the contours of a complex and objective world."[33]

The action of *Prochain épisode* boils down to the interplay of three people: the narrator, his victim, and his beloved accomplice, K., whose eventual multiplication as a double agent secures "only an infinitely empty purely formal movement" in Jameson's interpretation.[34] This Oedipalized minimalism of plot ironizes the narrator's refusal of algebra; and Jameson considers Aquin's novel after a Lacanian model, where the political victim logically secures the conspiratorial pair, as the negation of their narcissistic bond.

This bond is a minimal requirement of fanaticism, if not the "minimal communism" that Badiou ascribes to conjugal love. But any sociality modelled on the pair remains essentially private, enacting an impasse of subjectivity that Lacan helps us to diagnose but not to overcome. The difficulty of conveying an absolute subject to an objective social whole is a quintessentially narrative problem, insofar as it requires movement, rather than logical immobility. As Jameson writes, Aquin's novel requires that the reader "take this play of three primal figures and positions as the impossible attempt to generate *narrative* itself out of the radical solitude and imprisonment of the individual ego or subject."[35]

K. allegorizes a sovereign Québec, which qua feminine remains the formally aloof object of courtly love. In this image, the bodily promise

32 Fredric Jameson, "Euphorias of Substitution" in *The Language of Difference: Writing in Quebecois, Yale French Studies* 65 (1983): 215.
33 Ibid.
34 Ibid, 218.
35 Ibid.

of nationhood is deferred, or consummated in abstraction. The masturbatory self-referentiality of this symbolization is literalized by the trope of confinement, Jameson finds; from which solitary standpoint political reality is disclosed as a "euphoria of substitutions." Thus the narrator's rehearsal of specific dates and place names from a revolutionary past grants some larger context, at the same time as this litany manifests a despecified historical sublime, where the action is always prior, elsewhere, monolithic and finished.

Finally, as a failed "terrorist," Jameson notes, Aquin's narrator lives up to a right-wing fantasy of the leftist, "who, like the homicidal maniac of an older social moment, is called upon to figure sheer Evil and to clinch the plot by explaining the inexplicable, producing an illusion of formal totality by way of the conventionalized illusion of motive and meaning."[36] Toscano observes this close association of fanaticism and formal closure as well, in an historical rather than literary setting. Within the pages of this novel, however, Jameson proposes that the hero's confinement simply allegorizes the situation of the revolutionary cell, pun intended: "Aquin's novel demystifies the 'terrorist' impulse and unmasks the poverty of the conspiratorial small group as so many fantasies of solitary confinement, and of an isolation which is that of the class isolation of even revolutionary intellectuals fully as much as that of the locked prison cell."[37]

Administration and Conspiracy: Kaie Kellough's Accordéon

Aquin's political allegory borrows plausibility from the genre of romance, which has a privileged historical and formal relationship to nationalist consciousness. *Prochain épisode* may allegorize a particular moment in the development of Québec nationalism, but the cultural antagonisms comprising Aquin's Québec transpire entirely within a colonial framework, between the subjects of two jealous nations whose relation to Indigeneity is conjointly suppressive and occupational. Decades later, the separatist fervour to which Aquin's central character attests has been absorbed into the paternalistic apparatus of

36 Ibid, 222.
37 Ibid, 223.

official Québecois culture, producing a politically ambivalent nation-alism that defies left-to-right spectralization.

Kaie Kellough's 2016 novel, *Accordéon*, portrays an entirely different Québec, a social nexus where the purchase of official language on mul-tiple objects of culture is only tenuously and bureaucratically secured. Kellough's novel demonstrates an alternative expressivism, one that encompasses myriad incompatible and overlapping perspectives on a common space, defying the solipsistic mandate of confessional prose ala Aquin. This contrast is especially striking where *Accordéon* com-mences from the coerced account of a captive narrator, immediately recalling the setting and conceit of *Prochain épisode*. "Everything I say is my confession, which I give of my own volition," the book begins.[38]

Although *Accordéon* appears to start after their arrest, Kellough's narrator is difficult to pin down: a timeless and metamorphosing pres-ence throughout the history of Montréal, a possibly homeless onlooker whose social invisibility makes them an omnipresent witness to the affairs of the city. *Accordéon*, accordingly, is a novel of overhearings and gleaned history; of alternative timescales and eddies of distractible attention. The narrative is presented as a dossier compiling the compli-cated testimony of our vagrant Virgil, annotated in sidebars by agents of the Ministry of Culture; a bureau charged with the upkeep and documentation of official Québecois identity. This is a futile endeav-our in a multilingual, cosmopolitan city, let alone one founded on stolen land.

Accordéon discloses a Québec that far exceeds the terms of Aquin's antagonism, though the constant threat of referendum is one ambi-ent texture of the narrator's daily reality: "Will there be a referendum to determine whether Québec becomes sovereign and separates from Canada? Everyone wants to know this. I know this because I am one among everyone, and I want to know this."[39] This assertion, of the necessary relationship between a group and a representative member, between abstract belonging and the desires of the individual, con-denses the demonstrative stakes of the text, which plays two notions of totality, qualitative and quantitative, interior and enumerative, against one another.

38 Kaie Kellough, *Accordéon* (Winnipeg: ARP Books, 2016), ANOT. 1.01.
39 Ibid, 1.03.S.

The ontological stake of the Ministry of Culture in this book-length interrogation concerns the existence of a mysterious, trans-historical apparition from local folklore—the Flying Canoe. According to an introductory note, the Flying Canoe may be "viewed as a symbolic decolonial event, emphasizing the ascent of the colonized over the highest steeples of the colonial establishment." Sightings manifest during moments of social upheaval, including the referendums of 1980 and 1995, the Oka Crisis of 1990, and the Student Strike of 2012. Whether an "Indigenous-futurist time machine" conveying the present to pre-European bearings, or an eschatological vessel of post-national rapture, the ontology of the Flying Canoe threatens the consistency of Québec society at its basis, and the Ministry is charged with the upkeep of this consistency.[40]

As regards this fanatical project, one gleans that the Ministry intends by 2025 to have "an updated list of all activities, habits, trends, thoughts, expressions, or other observable or unobservable phenomena that constitute Québec culture," the better to demarcate provincial custom from exterior conditions.[41] This itemization includes "all of the words, expressions and dialects, and every object that exists on this territory," a conceptual archive that is doubled in "the infinite library of the Ministry."[42] Kellough's satire takes the absurd implications of nationalism absolutely literally, and this playfully pedantic excursion into set-theory demonstrates the untenable formality of any such project. "This raises the question: if some thing is not catalogued by the Ministry, for instance, a particular type of head-covering, then is that thing a part of the culture, and further, does that thing even exist?"[43]

This demonstration hones in on the Islamophobia endemic to Québec culture, though not exclusively: "Recent items catalogued include the red square, preferably pinned (with a safety pin) to the right breast pocket or lapel, the pot and wooden spoon, commonly known as the *casserole* and used to make noise in the activity known as the *tintamarre*, and the hijab-as-controversial-religious-symbol, to be distinguished from the hijab itself, which is not admitted to

40 Ibid, 1.02.S.
41 Ibid, 1.02.0.
42 Ibid, 2.01.M.
43 Ibid.

the itemization."[44] Here Kellough marks the discrepancy between presentation and representation, where discursive ideality is not straightforwardly commensurate with a material presence. In the case of the hijab-as-controversial-religious-symbol, a paranoid fantasy supplants the object upon which it speculates, such that Islamophobia is part of right-wing Québec nationalism, while Islam itself remains exterior to this program. The Ministry's inventory of official culture affirms what everyone knows: that Islam is not the proper referent of Islamophobia, which is a complex of colonial superstition. Living culture necessarily eludes litanization, and the Ministry's agents debate the matter in a sidebar:

MC: What is the location of culture?

MC2: *Clever, but culture is decentralized. It has its hubs, but they can be equally in the downtown core of a major city or, if you were to return to Gail Scott, whom you mentioned earlier, in the mind of an attentive insect.*[45]

Over the course of *Accordéon*, our narrator is tasked with apprehending the massively diffuse operations of culture broadly construed, as an author-function; a cipheral Everyman; a proletarian pivot between objectivity and subjectivity; a diasporic speaker whose perspective collates distances; and a spiritual guide of sorts. The speaker's knack for totality requires a keen historical concept, compounding multiple temporalities and timelines, as well as a deeply sympathetic orientation toward civic space: "It is impossible to go anywhere in this cramped, huddled city without overlapping. The boundaries are off, one person is another."[46]

This proximity not only blurs perspectives but identities, insofar as the former tend towards attribution. Overhearing is a means by which "language belongs to everyone," and the narrator is gifted with the ability to hear across decades and neighbourhoods, through walls and past

44 Ibid. A small red square of fabric became a symbol of solidarity during the student strikes of 2012. The tintamarre is an Acadian tradition wherein people parade through their communities with noise-makers and homemade instruments.

45 Ibid.

46 Ibid, 1.03.N.

affective defenses. Consequently, the city of Montréal is disclosed as a field of antagonisms, however lovingly rendered. If "referendum" is a Ministry watchword, representing a spate of available determinations reduced to a binary option, it marks an artificial antagonism that our narrator, for whom all time and opinion is simultaneous, appears to reject. "Referendum" doubles as a term of rapture here, after which the city is abandoned to the narrator, who apprehends the true infinity of its myriad cultures, once and for all.

By controlling the minute details of culture, the Ministry attempts to direct the future. This is an impossible task, our narrator asserts, for "the future is immaterial" and not subject to classification or inventory. "The future is also collectively determined," after all, and subject to drastic revision.[47] All that escapes the careful planning of this branch accrues to the vocation of the Flying Canoe, as a kind of a folkloric counterpart to pataphysician Doctor Faustroll's gravity-defying skiff. Every night the Canoe departs the St. Lawrence River at a forty-five degree angle, soaring above the city and directing weather, physically transporting condominiums if required. As one representative of the Ministry remarks, "in this ability to size itself to the situation, the canoe is much like the future. Perhaps it is the future."[48]

The Canoe evades verification, which is the Ministry's raison d'être, for the Canoe is not an object of representation but stands for representation as such. Our narrator's own account of the Canoe's mutable form is subject to the meta-inventorism of their own surveyors, a plight of which they are all too aware: "I know that the Ministry knows that it is writing a book that isn't really being written, and that isn't really a book, but rather an eternally unfolding text."[49]

That said, the true loci of popular agency are unrepresented in the Ministry's text. One glimpses this disputatious energy during the wide publicity of the student protests of 2012, transpiring within earshot of the entire city, beneath the panoramizing view of police helicopters: "There is a vast difference between what is above ground and what is underground," our narrator reminds us. Meanwhile in a sidebar the

47 Ibid, 2.02.A.
48 Ibid, 2.02.U.
49 Ibid, 2.03.L.

Ministry strives to find a textual key by which to enter the Canoe.[50] A further annotation reasserts the uncertain status of the vessel, questioning its extra-textual consistency: "The entire island is held by the canoe. The island is the canoe."[51]

Here the Canoe figures as a key to creative cohabitation, much as the map empowers Gladman's activists to reorganize their world. All languages are spoken in the Canoe, our narrator explains, describing a voyage over the city, and passionate arguments are even encouraged among passengers. This fractious unity is the cause for which the Ministry must commandeer the vehicle, "too much a symbol of the unity of all peoples on this territory."[52]

Eventually, our narrator breaks down in front of a pharmacy during an arrest, asserting the right to take up space in whatever tongue, regardless of provenance. Somewhere en route to an expected beating and indefinite detainment, the narrator divulges the history of the Ministry, to disburden themselves and fortify the reader against further programming: "I have to decolonize my brain."[53] The Ministry, they explain, set out in the earliest years of colonization to write the entire permissible history of New France in advance, taxonomizing the terms of society so as to prohibit alternatives. "This is the main aim of the Ministry: to determine which realities our society performs. This is the conspiracy. This is why the flying canoe is so important. The canoe recognizes one reality alone: everyone exists, and all stories are equal."[54]

In Kellough's depiction of an extra-colonial democracy, immanent to the gathering that is a given city, the true conspirators are a political elite, restricting the agency of the general populace. Nonetheless, the incessant second-guessing in which conspiracism consists has a distinct social valence: "to believe in a conspiracy is to believe that others determine our actions."[55] Only after having been kidnapped by police does the narrator begin to question their true calling: "Perhaps I am here on a secret insurrectionary mission that even I do not know about. Perhaps I have led others into the heart of the Ministry, to

50 Ibid, 2.03.T.
51 Ibid.
52 Ibid, ANOT. 2.03.
53 Ibid, ANOT. 2.04.
54 Ibid.
55 Ibid, ANOT. 2.03.

plant a bomb in its centre and detonate it as they help me escape."[56] Ultimately, however, the narrator scraps the temptation to heroism: "I have no interest in writing anything, particularly not a tale of espionage. I don't even like detective and spy stories," they assert, converging upon the existential setting of *Prochain épisode*.

Minimal Morelia

"How should I set about writing a spy novel?" Aquin's hero asks at the outset of his withholding confessional, before gliding as a ghost through his own thwarted revolution; which is not quite the same as going undercover. In several respects, spy novels seem like the reactionary obverse to the writing of revolutionary secrecy described above. According to Jameson, these conspiratorial stories manifest a "degraded attempt ... to think the impossible totality of the contemporary world system."[57] The spy novel tends to centre on a contracted individual from whom much is hidden; even so, amid vast uncertainty, their capacity for action is furnished by the state. As importantly, this action doesn't correspond to the time of crisis, but to the suppression of its eventuality. The spy is an agent of the normal, whose activity, however seemingly anti-social, is covertly administrative.

Renee Gladman adapts this micro-genre in her 2019 novella *Morelia*, in which a first-person narrative unfurls from a place of confusion. The narrator awakes in a strange room, already assembling the pieces of a mystery; phenomenological at first, and only subsequently embellished with purpose: "If I'm right about where I am, soon it will be time for breakfast."[58] Wandering from a series of interrelated hotel rooms day after day, the narrator must make a delivery, the significance of which is highly uncertain.

All the reader knows is that the narrator is in possession of a sentence, written in any number of languages at once, which requires deciphering. In the meantime, that sentence is a weapon and a compass, a letter and a map:

56 Ibid, ANOT. 2.06.
57 Fredric Jameson, *Postmodernism, Or, the Cultural Logic of Late Capitalism* (Durham: Duke University Press, 1991), 38.
58 Renee Gladman, *Morelia* (New York: Solid Objects, 2019), 4.

> I need that ridiculous sentence. I miss it and think I might
> understand something about it now, like the meaning of the
> first word. But I need to see it next to the second one. There is
> a map somewhere, a map that vibrates when you rest your head
> against it. Some of the words in my sentence are calibrated to
> the vibrations such that when one pronounces them (were one
> able to) the map reveals its secret locations.[59]

The narrator moves through the fictional city of Sespia centripetally, and most of the people she encounters in its vacant squares and soundless interiors are intermediaries of a sinister, unspecified agenda. Hailing a car becomes a kidnapping; a strange morpheme metamorphoses into a street address; bridges materialize out of nowhere, as a foreign outpost crystallizes around an intentional agent. The city appears as a series of interpretive stations, "still opaque but eventually readable."[60] Here a standard novelistic tension—between narrative as a descriptive means and plot as trajectory—is conveyed directly to the rudiments of mystery. In Gladman's hands, the mystery story allegorizes the indefinite deferrals comprising language, where every meaningful construction implies a closed totality, though an inventory of meaning appears nowhere.

At the close of *Morelia*, a cognitive cargo is exchanged in a word. As the narrator boards a train, sentence and book in hand, it's clear that something has been finished as another mysterious journey has commenced, but no one, least of all the first-person operative, is to know what has transpired. The double agent flits in and out of society in order to maintain its coherency, and the legibility of Sespia appears to depend upon her mission. In this respect, Gladman's spy is a counterpart of the fanatic, insofar as her exceptional vocation transpires at a sacrificial distance from society, which authorizes this much subterfuge for the sake of its own consistency.

This text has an unexpected relative in the novel *Quicksand* by composer Robert Ashley—an opera libretto written in the form of a thriller, in which an aging composer leads a double life as international spy, eventually hastening a coup in an unnamed Asian country. Ashley's

59 Ibid, 16.
60 Ibid.

novel, like Gladman's, opens on its narrator sequestered in a hotel room, having just shot his would-be assassin. This demonstrates the more conventional temporality of noir, where the reader is plunged into the action and must play catch up. "Something is going to happen," Ashley's fictional operative confidently asserts. "The question is, What?"[61] His chronology is mixed up, and his instructions are delivered on a need-to-know basis.

Compared to Ashley's grisly opening, Gladman's novella lacks in incident; but the narrative scaffolding is similar. Each novel follows an agent in the field as information is gradually divulged and the task ahead of them takes shape. Both texts presume familiarity with a highly codified genre, that its conventions may be minimalized and rendered afresh. As Ashley's narrator is swept up in a revolutionary coup, *Quicksand* rapidly becomes a fated text. This, its narrator decides, will be his final assignment, and his eventual return to safety becomes an anti-climax: "I sulk around the house for a few weeks hoping I can get back to work on the opera that will probably never be finished," he relates dolefully.[62] The coda of retirement is an important trope of the spy novel, anticipating the subjective disappointment of the agent who acts only in service of the usual. After the occasioning crisis has been averted, our operative is abandoned to the stultifying order that he is sworn to protect.

Ashley's political fatalism is underwritten by an obvious cultural chauvinism that runs to crudely orientalizing extremes: his love interest and accomplice, affectionately named Pooh, is an Asian woman who pines for America even as she represents the local customs to a mercenary interloper, and the last chapter in the book is a heartfelt letter from Pooh to the composer. *"I have stopped wearing the makeup to make me 'white.' Your little talk about being who you are made me understand that I should be happy being who I am. I don't know white from brown anymore, and I am trying to talk my friends into thinking the same way. It will take a long time. Those ways of thinking are so deep in everybody."*[63] Her attribution of post-racial progressiveness to the foreign agent, and of a deep backwardness to her own people, extends into her

61 Robert Ashley, *Quicksand* (Oakland: Burning Books, 2011), 34.
62 Ibid, 146.
63 Ibid, 148.

postmortem of the revolution in which they have all but unwittingly participated: "*The transition is going to take a long time, even if most of the really bad men are gone. The corruption and distrust runs so deep. It has been going on for centuries. I fear that it will come back.*"[64]

Ashley's *Quicksand* relates diametrically to Aquin's *Prochain épisode*, insofar as the allegorical structure that Jameson imputes to Aquin remains intact. In each case, a national liberation struggle is identified with a feminine exemplar; although Aquin's beloved, the double agent K.—a homonym for one half of the cause of Québec—stands for betrayal, in contrast to the self-effacing fidelity of Pooh to our happily married narrator. K.'s unavailability and ulterior motivation marks the impossibility of change, while Pooh's welcome doubles as an apologia for foreign intervention. Where Jameson finds the self-fascination of Aquin's narrator to hinder political envisaging, one could accuse Ashley's special agent of a far deadlier egotism, which extrapolates an untenable worldview from a subjective fetish.

The conventional mystery story works toward the restoration of suspicious order. Ashley's novel performs this cannily, celebrating a politically uncertain victory, and even Gladman's *Morelia* accepts that the agency of the spy, who is always of one state or against another, is in fact the agency of their employer: "It's just that ever since I saw the train station I knew what I had to do. These words are a quote. The leader of my country said them. Even now this is he talking. Even now."[65]

What is it to Be Done?

More questions than conclusions issue from this preliminary survey, many of them familiar from seemingly irresolvable debates of the twentieth century. Is aesthetic difficulty politically recuperable? Does the uncertain text map the political present or re-express impediment to action? Gladman, Farr, Kellough, and many other writers of militant secrecy do not ask "what is to be done"; rather, their works stage a related question, "what is all this doing about?" As seen in each of their works, a great deal depends upon the reader, and the scale of each novel is hardly incidental to the immodesty of this demand.

64 Ibid, 149.
65 Gladman, *Morelia*, 40.

At minimum, works of radical secrecy must be decided by reference to the broader social conditions that they do not so much repudiate as oppose. These works thematize totality, however obliquely, often as an object of conscious attention—a quantum map or outlying vessel. Certain hallmarks—a fanatical conspiracy, an insurrectionary plot—allude to the cultivation of conviction, not only denoting fervency, but also a paranoid feeling of culpability before another. This affect typically attends pre-revolutionary politics, when one world operates within another, as a secretive enclave.

Aesthetic difficulty then corresponds to a durational experience of uncertainty—a training for the decisive moment, in anticipation of narrative retrospection. These remediations of doubt presume a subject eccentric of itself, as well as a symbolic reinitiation, corresponding to the proper thought of oneself as a group. "Whether this is a dream in which I'm captured or I've been captured and made to think I'm in a dream, I can't figure," Gladman's narrator confesses, having internalized the uncertainty in which she participates.[66] "I can't figure," she says, which we may read not only as a statement of uncertainty but as reluctance to manifest form amid the dreamlike chaos of a moment; as a failure to register on or off the page. Each of these novels ambiguates the commitment of an apparent narrator who is inside and outside of the collective plot at once.

Finally, to speak of avant-garde desires, these insurrectionary literatures appear symptomatic of a broader political impasse: a foreclosure on the vanguard party as a vehicle for galvanizing mass politics. In these works, drastic action is undertaken by an errant and autonomous vehicle, a constituency not numerically greater than the membership of your average punk band. Provocatively, these literatures of militant secrecy appear to address the party in its obsolescence by depicting it in its nascent form, as an inchoate social cell.

These intervallic literatures await an orientating event, as the interpretive point from which the interval derives its syntax. One thinks of Chernyshevsky and his circle, as a reminder that narrative texts depicting the internecine struggle of anarchist micro-collectives are assured a pre-revolutionary significance. Furthermore, as concerns

66 The Activist, 67.

fidelity to an event, it's as important to register that not only are we in a pre-revolutionary situation, but we live in a post-revolutionary wake as well. With fanatical insistence on the variability of the time between, and the viability of an induced event, the co-conspirators named here protect the standpoint of a present refuge from false futures, and their ranks from mere enumeration. Who knows what else they might do?

Supply
Chain Tanka

On Working, Walking, Writing

In November of 2018, I had the fortune of attending a poetry reading at The People's Forum, a "movement incubator for working class and marginalized communities," on New York's 37th Street. One braces to emerge from Penn Station into the evening din, and it's true that there are few such hospitable cracks in midtown's commercial veneer. But wherever the wealthy live or play, there are sure to be more signs of resistance than acquiescence. New York is first and foremost a city of cab drivers, janitors, nannies, line cooks, and countless other service industry workers, many of whom are also artists.

This evening's readers were from the Worker Writers School, convened by poet Mark Nowak, which organizes with trade unions and progressive labour organizations to facilitate the creation of work about work, among other topics of lived concern. In a recent book, *Social Poetics*, Nowak describes these workshops as "new spaces for imaginative militancy," extending the mandate of poetry beyond quiescent reflection and inviting solidarity between participants from across the world.[1]

Workers' Tanka

On this particular evening, working poets read from several booklets of tanka—a form of imagistic concision, inherited from Japanese

1 Mark Nowak, *Social Poetics* (Minneapolis: Coffee House Press, 2020), 177.

verse. Classically, tanka are poems of thirty-one syllables distributed across five lines, intended to distill a mood or occasion. Meaning "short poem," tanka was but one genre of waka, or "Japanese verse," although these terms became more or less synonymous between the ninth and nineteenth centuries. The perennial appeal of this classical form, such that one finds the Tanka Workers Collective writing class-conscious and emotionally relevant tanka today, follows from a thoroughgoing modernization in the first half of the twentieth century, many examples of which have been translated by Makoto Ueda and collected in the anthology *Modern Japanese Tanka*. Nowak names this collection as a point of inspiration, as Ueda places proletarian writing groups alongside and within a broader culture of Modernist experimentation.[2]

According to Ueda, tanka was resuscitated as a modern genre in the late nineteenth and early twentieth centuries, when the poet Yosano Tekkan and a number of other youthful voices set out to update the form amid anxieties about national decline and impending war. Tekkan's own neo-romantic reforms are better exemplified by the poems of his partner Yosano Akiko; but the template that endures today surely descends from the mandate of Masaoka Shiki, who proposed a writing of "shasei," or sketching from life. In addition to vernacular reforms, Shiki's realism advocated a close observation of nature, seeking to unify the popular appeal of haiku with the courtly connotations of tanka. As biographer and critic Janine Beichman explains, this initially meant combining the content of haiku with the diction of tanka.[3] At the time of his 1898 work, *Letters to a Tanka Poet*, Shiki advocated for a thirty-one syllable haiku, simply extending its thematic concerns into a longer, theretofore rarefied form. Eventually, however, Shiki conceded a difference in suitability, and Beichman describes a split between his poems of objective description, evacuated of a personal pronoun or standpoint, and poems of subjective interest, juxtaposing the author's vantage with a consoling surround. In Beichman's observation, tanka tends to the latter, reflective approach, often providing a personal gloss on a miniature vista. In either case,

2 Ibid, 126.
3 Janine Beichman, *Masaoka Shiki: His Life and Works* (Boston: Cheng & Tsui Co., 2002), 76.

Shiki's staunch naturalism and insistence on formal transparency typifies the genre to the present day.[4]

Shiki was notably liberal for his context, but some of the most politically suggestive writing of this renaissance follows the social realism of Ishikawa Takuboku, who eschewed natural scenery for depictions of personal desperation and class struggle. Ueda translates one of his most famous verses as follows:

> I work
>
> and work yet my life
> remains
> impoverished as ever
>
> I gaze at my hands[5]

This poem of personal contemplation certainly belongs to the subjective mode, as a first-person contemplation of reality; but the external world under examination is represented by the poet's own hands. Subject and object at once, divided against itself, this is an extremely economical figure of the poet's alienation qua worker. In *Social Poetics*, Nowak describes a writing exercise undertaken with the Refugee and Immigrant Support Services of Emmaus, in Albany, New York:

> I brought in copies of a tanka by Kunio Tsukamoto, a writer born in 1922 in the Shiga prefecture, who had witnessed a devastating air attack on his naval base in World War II. In Ueda's translation, the tanka employs parallelism; each of the first four lines begins with the structure "hands [verb] ..." and ends with an object with which these hands have interacted.[6]

In Tsukamoto's brief poem, hands are multiform, as likely to injure as to give pleasure, and by no means express one's own agency. The translation that Nowak distributes reads as follows:

> hands picking a rose
> hands holding a shotgun

4 Ibid, 98.
5 Makoto Ueda, *Modern Japanese Tanka* (New York: Columbia University Press, 1996), 54.
6 Nowak, *Social Poetics*, 127, 128.

hands fondling a loved one
hands on every clock
point to the twenty-fifth hour [7]

From this template, Nowak instructs his workshop participants to imagine their own fixed-based tanka, using their hands as a medium of recollection. One writer, credited pseudonymously, produced the following poem, his first in English:

hands hold phone
hands cook rice
hands touch door
hands point to the home in Iraq
hands write sentences [8]

In Nowak's reading, the self-reflexive concluding line refers not only to the composition of the poem, but to the mortal hands of legislators, who have the power to mete out punishment by writ. The ambiguity as to just whose hands carry out each of these tasks complicates the deceptively humanist conceit of the poem, which nevertheless alludes to the possibility of taking in hand the materials of one's own life, from utensils to directions and desires.

What commends contemporary tanka to work, and work to tanka? Occasional in inspiration, intended to distill something of the everyday, plain in diction and general in address; in any language, tanka would seem to support an adaptable realism, establishing a clear relation of the lyric subject to the external world. In a poem by Paloma Zapata, from a Tanka Workers Collective booklet, the trademark epiphany before nature takes place on stolen time:

Make up for lost time
I rush winter leaves from my feet
Don't leave me, don't leave
White rabbit just make it be
10 minutes late for my shift [9]

7 Ueda, *Modern Japanese Tanka*, 195.
8 Nowak, *Social Poetics*, 129.
9 *Tanka Workers Collective 1* (New York: Worker Writers School, 2018), 4.

Throughout the group's stapled anthology, flashes of poetic insight punctuate the strictures of shift work. As a writing of and on the clock, each poem conveys something of the parceled and pre-allocated time of personal epiphany, especially precious where the writer's attention is elsewhere obliged. At the reading I attended, cab drivers, nannies, a "former school secretary turned daycare provider under duress," and other workers presented their class-conscious poetry to peers and comrades, while others had to leave the daylong proceedings early to attend their jobs.

For the staple imagery of shasei, these poets employ symbols of a second nature—that of the workaday and capital. Dollar amounts and rent prices stand in for natural signs, recurring throughout the group's output as a gesture toward the effacement and monetary abstraction of the concrete particulars that poetry more often strives to represent.

Urban Tanka

Poet Harryette Mullen describes her 2013 book *Urban Tumbleweed* as a "tanka diary," corresponding to a series of daily walks around Los Angeles. If the impetus to this approach—a peripatetic attempt to meld thought and matter, "head and body"—is restlessness before an unfamiliar outdoors, the resultant writing offers as much clarity as complication. In a considered foreword Mullen troubles the categories upon which the micro-genre appears to depend:

> What is natural about being human? What to make of a city
> dweller taking a 'nature walk' in a public park while listening
> to a podcast with ear-bud headphones? What of a poet who
> does not know the proper names of native and non-native
> fauna and flora, who sees 'a yellow flower by the creek'—not
> a *Mimulus*?[10]

Mullen's more-than-rhetorical questions challenge the implicit nominalism of poetry, which deals less in taxonomy than the particularity of sense impression. This, too, doesn't entirely translate, and a reader greets a description of an impression; language as second nature.

10 Harryette Mullen, *Urban Tumbleweed: Notes from a Tanka Diary* (Minneapolis: Graywolf Press, 2013), x.

When Mullen speaks of each poem as an "occasion for reflection," we might take this somewhat literally: the poem is a contemplation of reality in a different, facing medium. Thus tanka betokens an ideal alignment of at least two objects, one of which is a poet, or poem. The author's initial lack of conversancy before the local flora is perceived as an obstacle to poetry, and a fortunate condition of globalization: "Trips to the botanical garden are opportunities for learning the names of plants from all over the world that have found a home here in California," Mullen says in her introduction, "a place defined as much by non-native as by its native species."[11] Los Angeles is a node of migration, overwritten by a multitude of languages and names. If anything, this ought to produce more and greater differential effects, multiplying signifiers over signifieds; and Mullen's point of departure for her tanka poems is already cosmopolitan, in spite of her self-professed insufficiency.

Mullen writes: "So I began the diary despite being able to recognize only the most common creatures, and feeling that I lack a proper lexicon to write about the natural world, when what we call natural or native is more than ever open to question." Accordingly, Mullen's tanka offer a "record of meditations and migrations" across diverse terrain, unevenly effaced by capital and industry.[12]

Perhaps the expectation that nature should have the consistency of names presumes a level of cognitive subsumption. But this sense of estrangement becomes a topic of concern throughout the 366 poems gathered here, which baffle any ideology of nature-as-given with an exemplary zen. Nature is already a specialism, marked apart from daily routine as a kind of privileged reading:

> Instead of scanning newspaper headlines,
> I spent the morning reading names
> of flowers and trees in the botanical garden.[13]

Mullen's writing of landscape includes multiple figures of enclosure and subdivision: "Chain-link fence, locked gate protect this urban/

11 Ibid, viii.
12 Ibid.
13 Ibid, 2.

garden," she facetiously implores.[14] An overarching theme of neighbourliness issues from this navigation of partitions:

> Yes, it is legal to harvest the overhanging fruit
> Of your neighbor's avocado tree.
> Just don't smuggle it out of state.[15]

The stateline is another arbitrary threshold superimposed on a teeming underneath, and picket fences appear as a scenic counterpart to razor wire throughout this writing. Mullen's snapshots of surroundings, however modest themselves, convey the suburban property owner's stake in nature to the nativist claims of the nation-states that such urban settlements recapitulate in miniature. This tanka reflects the plainspoken civics of Robert Frost's well-known poem, "Mending Wall," in which a speaker contemplates the adage that "good fences make good neighbors."[16] From the first line of Frost's verse, the wall is an object of suspicion, and yet remains an object of mutual repair. "Before I built a wall I'd ask to know/What I was walling in or walling out,/And to whom I was like to give offence," Frost's speaker opines.[17] Needless to say, walls are a charged symbol in the political imaginary, and any so-called neighbour who requires one on principle is probably a leering micro-fascist.

Conversely, Mullen writes invitingly: "Native or not, you're welcome in our gardens."[18] The natural repletion that exceeds an all-too-human economy becomes an object of comparative appreciation throughout these poems. On a bus, the "ladybug clinging to the window/didn't need to pay a fare."[19] Likewise, the natural world serves as a vessel for the poet-perceiver, whose attention is carried along by the objects she encounters on her way.

This ongoing demonstration echoes June Jordan's epistolary poem, "Letter to the Local Police." Written in conservative persona, from the perspective of a suburban property owner, the poem is an archly facetious takedown of the NIMBY type; an anti-neighbour, self-deputized and determined to control. "Dear Sirs," the poem begins:

14 Ibid, 5.
15 Ibid, 20.
16 Robert Frost, *The Collected Poems of Robert Frost* (New York: Quarto, 2016), 48.
17 Ibid.
18 Mullen, *Urban Tumbleweed*, 21.
19 Ibid, 11.

> I have been enjoying the law and order of our
> community throughout the past three months since
> my wife and I, our two cats, and miscellaneous
> photographs of the six grandchildren belonging to
> our previous neighbors (with whom we were very
> close) arrived in Saratoga Springs which is clearly
> prospering under your custody

Describing a well-kempt enclave as a legal ward or captive of the state, Jordan's speaker boasts of their own amateur snoutery and surveillance before coming to the point of complaint:

> I have encountered a regular profusion of certain
> unidentified roses, growing to no discernible purpose,
> and according to no perceptible control, approximately
> one quarter mile west of the Northway, on the southern
> side
>
> ...
>
> As I say, these roses, no matter what the apparent
> background, training, tropistic tendencies, age,
> or color, do not demonstrate the least inclination
> toward categorization, specified allegiance, resolute
> preference, consideration of the needs of others, or
> any other minimal traits of decency[20]

Jordan's complainant addresses the wild roses as an anthropomorphized rabble, which eludes an attempted floral profiling. Like Mullen, Jordan sees human variety reflected in an extra-human surround, such that its fanatical management analogizes the pathology of racism and prejudice.

"A Hodgepodge of What Lies Outside"

Mullen's synthetic tanka nonetheless gather around a seasonal word, or kigo—a fixture in traditional Japanese poetry and many English

20 June Jordan, *Directed By Desire: The Collected Poems of June Jordan* (Port Townsend: Copper Canyon Press, 2005).

language forms derived therefrom. Mullen, however, allows the formal determination of the poem to convey her language to the season, rather than presuming vocabulary to have transparent purchase on reality. One understands the poem to index the natural world, such that whatever it names becomes a facet of nature, placed at a remove from the poet.

This subtle reversal of lyric directionality contracts nature to the poem as an object belongs to a subject, or an outside to interiority. Many ideologies of nature issue specifically from the condensed attention marked by language: nature, Jacques Lacan quips, is "that which one excludes in the very act of taking interest in something, that something being distinguished by bearing a name. By this procedure, nature only risks being characterised as a hodgepodge of what lies outside nature."[21]

The extra-textuality of nature makes an ideal object for poetic speculation. But Mullen enrolls her poems in this relative hodge-podge, depicting a natural world that is more recursive than continuous. One could as soon imagine this work continuing on the model proposed by Donna Haraway, of a cyborg ecology that repudiates any hard and fast distinction between human and non-human, natural and unnatural, which Mullen's own ruminations invite. But *Urban Tumbleweed* offers no metaphysical ruling upon reality; rather, these poems hew to individual perception, and the sum of these moments is only implied.

The object of these poems may be nature broadly construed; and Mullen's writing attests to the complicated distribution of this object without proffering any timely program of assemblage or hybridity. Rather, Mullen's writing of the Los Angeles landscape—as so many sites of investment and policing, settlement and extraction, tourism and education, immigration and immiseration—situates it as a hub of international traffic and logistics. Mullen receives signs of globality from her immediate surround: from so-called invasive species to the facts comprising the morning newspaper, which arrives covered in local dew. While many of these sightings allude to a vast and historical movement of people and goods, others arrest the fluidity of contemporary supply chains in a moment's apprehension.

21 Jacques Lacan, *Seminar XXIII: Le Sinthome*, ed. Jacques-Alain Miller (Cambridge: Polity Press, 2016), 4.

Framing Ephemera

Theorist Alberto Toscano describes the influence of logistical regimes on aesthetics, and how the real abstraction of space and relation by capital produces correspondent motifs in the visual arts.[22] Toscano is occupied with film and photography, and while the linguistic abstraction characteristic of poetry is often naively presumed to operate at a further remove from reality, one might suggest that Mullen's interest in the plainspoken clarity of tanka, as an attempt to faithfully capture "the ephemera of everyday life," places this writing within reach of Toscano's larger thesis.[23]

Immediately, Toscano claims, "the logistical image" frames a preponderance of infrastructure over persons, as the looming image of dead labour. Such images are paradoxical, attempting to depict hugely diffuse networks of supply and demand, connected by constant motion, in a single frame. With important differences, Mullen's imagistic writing cleaves to the depicted moment as a flash of inspiration, furnishing images of the city suburb as a complex of relations, and a landscaped efflorescence of accumulated capital. Like the logistical image that Toscano describes, Mullen's tanka capture the motion of capital at a glance; first as a reified percept, and again as a poem.

In Toscano's discussion of the logistical image, a static representation derives from the larger movement of which it is an interval or node. Mullen's poems, too, are images arrested from a larger process, to which a sense of movement is restored at the level of the collection. However individually discrete, her daily poems are arranged in a yearbook that assumes the standing of an overarching concept; thus the discontinuous vignettes comprising this otherwise durational address are conveyed to totality at the level of conscious form.

This framework has ample precedent throughout Japanese literature, where multi-authored volumes gather the poetic output of a year. In these collections, the poet's own contingent sense impressions are organized after a seasonal conceit, such that each moment appears under the auspices of a master referent—a climate or an

22 Alberto Toscano, "The Mirror of Circulation: Allan Sekula and the Logistical Image," *Society and Space*, July 31, 2018, www.societyandspace.org/articles/the-mirror-of-circulation-allan-sekula-and-the-logistical-image.
23 Mullen, *Urban Tumbleweed*, ix.

economy, two terms that have merged over the course of the so-called Anthropocene.

More recently, the modularity of Mullen's tanka collection enacts a containerization of affect, situating subjective experience at the level of locality, while an overarching formality connects these moments of intentional perception. Where tanka often addresses itself to a climatological term like the season, it remains an apt medium for investigating the new global weather of the market:

> "Where does California's produce go?"
> shoppers ask in supermarkets stocked
> with Mexican avocados and Chinese garlic.[24]

Mullen's mediated nature includes the supply chain in which the various strata of Californian society are differently employed; many as seasonally remunerated agricultural workers, others as consumers of world surplus. The national epithets attached to each product designate the necessity of logistics, but also resonate with Mullen's garden poems, addressing the de facto worldliness of a state to which few species and people are themselves native—though in a bitter irony, this relationship is policed by the settler state itself.

Policing Poetry

Nothing is unnatural in these poems: worker bees are "technological" while a helicopter circling overhead is "a curious dragonfly."[25] Of course, the helicopter needn't be analogized to insect life to qualify as natural in itself, hovering by the laws of physics all the same. But this folk figuration is of importance where even money features as a sighting, not a medium of exchange; found bills are "rumpled greenbacks," not immediately monetary but picturesque, perhaps a shelled insect or a leafy growth. Figurative language already evinces an excess signification that itself belongs to, or denotes, nature; and the metaphorization of money is clever where analogy is itself a form of exchange.

Bertolt Brecht famously cautioned that one "one cannot write poems about trees when the forest is full of police." But what of a scenario

24 Ibid, 59.
25 Ibid, 11.

in which the forest itself is a police apparatus? In Mullen's poems, the helicopter recurs as a sonic keynote and visual staple of the police state:

> We're jerked awake as helicopter blades beat air.
> Light glares from above. An amplified shout
> orders a fleeing subject to halt.[26]

Figures of repression recur throughout these poems with a sinister insistence, on the fringes of poetic apprehension. Police appear synonymous with property, and poems of macabre reportage depict multiple means of enclosure:

> Confronting the suspect, police use lethal
> force against a disorderly mountain
> lion trespassing in a private yard.[27]

The territorial obliviousness of the poem's lion mocks at the demarcation of private property. At the same time, the portrayal of the lion as a legal suspect, thus susceptible to lethal harm, evokes police executions of Black men as intruders in their own communities. By subjectivizing the lion as a suspect, the poem slyly alludes to the dehumanizing language wielded by murderous police against their victims. As these poems traverse an ambiguous continuum between nature and subjectivity, Mullen reminds us of the strategic value of these terms for racist power. Another poem treats the matter of police brutality forthrightly, where the word that cinches the verse, "misapprehended," evokes both a failure of recognition and a wrongful arrest:

> Visiting with us in Los Angeles, our friend
> went out for a sunny walk, returned
> with wrists bound, misapprehended by cops.[28]

These scenes provide an important counterpoint to any suburban idyll, in which the conversancy and curiosity of the individual poet presumes a degree of physical safety and mobility. Throughout these poems, Mullen interrogates the accessibility of her surroundings, finding them policed and protected, from some at the behest of others.

26 Ibid, 45.
27 Ibid, 102.
28 Ibid, 94.

These moments of political gravity anchor the text, which follows the movement of the poet through a minutely differentiated landscape, its various privatizations represented by way of mundane detail.

Salad Phenomena

These poems hew closely to the individual perspective on a small event, which might lapse into private reverie were Mullen not so insistent on showing her reader the social processes behind each poem:

> When you complain about the worm
> in your salad bowl, our server assures us,
> "That is how you know the lettuce is organic." [29]

This poem of consumer hesitancy opens onto multiple possible readings. Where the trope of California lettuce can't but resonate with the Salad Bowl strike of the nineteen-seventies, the worm in the produce—recalling a site of production and thus spoiling the diner's experience—evokes not only a cosmetic blemish, but the hidden element of labour in the presentation. In this reading, "organic" also denotes the perseverance of living labour in a highly exploitative agricultural sector, which the logistical, or in the case consumer, image altogether omits. As a scene of misgivings, this tanka also reads as a sly quotation of a poem by Takuboku Ishikawa, in which some unspecified quality of a picturesque plate gives the author pause:

> the color
> of fresh vegetable salad
>
> is so pleasing
>
> I pick up the chopsticks
> and yet ... and yet ...[30]

In Mullen's poem, nature figures as an unseemly irruption, and service as second nature. Even the blemish that suffices for proof of nature is commodified. With reference to this search for an earthier salad, a later poem fondly envisions value restored:

29 Ibid, 27.
30 Ueda, *Modern Japanese Tanka*, 58.

Mom grew these leafy collards in her organic
garden. She picked them this morning.
Tonight they go well with our cornbread and yams.[31]

These small solicitudes, and the feeling that attends the sharing of
food, resist the imperatives of the market. Tangentially, the bestselling
book of Japanese tanka poetry, *Salad Anniversary* by Machi Tawara,
published in 1987, begat a wave of enthusiasm known in Japan as "salad
phenomenon." Tawara's poems are conversant in pop-culture, com-
prising a semi-episodic narrative of young love; but the world that she
romantically inhabits is overwritten by capital nevertheless:

"One basket 100 yen"
Tomatoes lined up at the storefront
wear a disgruntled look [32]

This poem by Tawara depicts contradiction at market, where an
anthropomorphized produce is placed at odds with its posted value.
Where the poem sees to formal capture, Mullen's and Tawara's writing
both reflects and replies to the commodity form. Perhaps it is fitting
that contemporary tanka treats the produce aisle as a kind of garden,
for it is here that the most various and dependable flora are replen-
ished before one's eyes, belying an enormous sum of labour. At every
moment, imperceptible relations form the basis for poetic receptivity.

Climate Tanka

Nothing threatens the immediacy of perception so directly as climate
change, which bears urgently on the apparent even as appearances
conceal its catastrophic progress. Perhaps denialism is less viable in
California, a state particularly susceptible to everything from drought
and wildfire to rising sea levels. As per historian Mike Davis, this ele-
mental assault has manifested any number of popular apocalypses in
film and literature—fantasies symptomatic of social unrest and cap-
italist crisis. Mullen's anecdotal evidence of these ravages is no less

31 Ibid, 61.
32 Machi Tawara, *Salad Anniversary*, trans. Julie Winters Carpenter (New York:
 New Directions Press, 2015), 89.

frightening for being factual, for the time of these poems coincides with the time of encroaching fire, so commonplace as to furnish the landscape and its poetry a keynote.

> Blast of hellish breath, infernal scourge,
> parched wind that whips and scorches. Green
> torches, oily eucalyptus trees, bursting into flame.[33]

Here one can see Mullen searching for language appropriate to the enormity of her representational task. The poem is pulled in multiple directions as descriptive modesty gives way to abstraction over a series of fragmentary clauses, conjuring scenes of divine punishment. The plain speech that typifies Mullen's tanka is momentarily augmented by conventionally elevated means, as the lines assume an alliterative bounce, while internal rhyme (scourge, scorch) binds the stanza. This sonic abstraction contradicts the purposes of description, at the same time as it mimetically enacts an elemental intensification within the poem's own language. As powerfully, the next poem proceeds factually, describing the victims of the forest fire with taxonomical specificity:

> Pilots drop tons of water and fire
> retardant on two-hundred-foot flames
> engulfing juniper, oak, and ponderosa pine.[34]

Such poems, captioning actuality, help to localize the various moments of a truly global crisis, which can only be apprehended cumulatively and comparatively, in impossible overview. Importantly, Mullen understands that catastrophe doesn't always manifest cathartically, as a billowing hellfire or obvious emergency. As often, the uneven distribution of risk that broadly describes climate change manifests a tranquil scenery, depending on one's perspective:

> For the middle of July in a drought stricken
> year, more than a few lawns in the neighborhood
> are looking incredibly green.[35]

33 Mullen, *Urban Tumbleweed*, 16.
34 Ibid.
35 Ibid, 15.

The appearance of business as usual is itself a commodity secured at great cost, always outsourced to others. As a cumulative effect of this quotidian registry, Mullen sketches a variegated everyday that is commensurate with a terrain of struggle, and champions a localism that is intrinsically connected to the global in obvious and surprising ways.

Working Writing

Mullen's tanka diary parcels a vast totality into vignettes of startling clarity, localizable and beckoning connection in their specificity. Insofar as these poems allow a reader to treat the sensible loci of vast systems, whether capitalism or the weather in which it intervenes, they visualize logistics in its most companionable guise; as given over to the apprehension of a consumer.

While this relationship seems passive, the networks by which commodities circulate today multiply sites of possible intervention, even as they hold workers at a distance from one another. Mullen's macrostructural assessment of totality, for which nature is a romantic synonym, transpires as a flash of consciousness, while her larger project links these instances as part of an urbanistic whole. This use of poetry—to elucidate one's immediate surroundings and heighten conversancy—clearly operates throughout the work of the Worker Writers School as well.

In the Tanka Workers Collective booklets, individual poems enact resistance to a process that remains indifferent to reflection, as in the following poem by Kele Nkhereanye:

> Early morning walks to work
> You see more cars than people walking
> You can notice parks and gardens
> Beautiful trees with various types and sizes
> Mornings are yours to experience peaceful joy [36]

As a cognitive claim on surroundings, Nkhereanye's poem manifests tranquility on the unremunerated time of a pedestrian commute. This nonetheless counts toward the feisty workerist aesthetic of the group, which insists on naming the necessity of labour to nature's upkeep; a factor that art often omits. Work already divides our experience of the

36 *Tanka Workers Collective 3* (New York: Worker Writers School, 2018), 3.

world, such that the moments of private reflection prized by poetry must be stolen back from the clock. The same may be said of those moments of intimacy in which human vocation consists:

> Torn between a need
> to make a decent living
> and caring for mother through
> the final chill of hers
> and every soul's winter [37]

This poem by J. Reyes evinces a grace and solicitude for age and death with ample precedent in tanka. But the filial concern owing the poet's mother is subsumed under the category of social reproduction where one's chances for survival, or for a dignified death, remain at market. Together and separately, the Tanka Workers Collective insistently convey the moments of feeling that poetry distills to the monetized time from which those moments must be reclaimed. In every case, the individual's perception is honed with reference to the overarching term of "work"—a necessity to which each of us is differently obliged. Work is the season of this poetry, which as a collective enterprise attests to the impossibility of separating one's impressions out from the social conditions of their delivery.

Much as Harryette Mullen's tanka diary conducts a reader's attention to the political geography of possible experience, the poems of the Tanka Workers Collective bring the world to consciousness, by raising consciousness to the order of the world. Both projects defy the quietism that political naysayers allege of poetry, without making a slogan of perception. More powerfully, it's difficult to read either body of work without reconceiving of one's experience as writing on the spot, which vocation both ennobles and contradicts the necessary epithet of worker. This attests to the results of Nowak's workshop, and the suggestive power of Mullen's tanka diary before a convoluted everyday. Both projects sit at the junction of art and reality, placing the smallest of poetic means within a larger context, whether ecosystem or economy, and insisting on the social basis of individual perception. Like poetry, this insight travels with a reader, on a solitary walk or in a crowded commute.

37 *Tanka Workers Collective 1*, 3.

Thanksgiving

How might one write lyrically of everyday life, both recollected and projected, when its terms are almost totally captioned by capital? *Thanksgiving*, a book-length poem by Ted Rees, faces this subsumed world with raging gratitude, finding prefigurative vitality amid commercial desolation, and freedom in circumscription. With determined negativity, Rees writes in opposition to the world-as-is, as a defensive reflex:

> … His knuck tats read
> 'FUCK WORK,' but he works
> and imagine that:
>
> a wood-fired pizza outlet
> happy hour now,
> delivers nightly.[1]

In torqued succession, the mod cons of consumer demand contrast the scene of work, as signifying fingers contradict their circumstances of employment. Similarly, this poem accepts some serious constraints on individual performance, both historical and formal. In the distinctly American pastoral of *Thanksgiving*, natural signs and their occasions are mediated by the market, such that meaning appears an appetitive directive from above and below at once; first as craving, then as nostalgia. Call it "seductive parking," or a "sticky cul-de-sac": as Rees movingly demonstrates, even the cheaply interchangeable scenery of strip malls and exurban sprawl is libidinally suffused by use.[2]

1 Ted Rees, *Thanksgiving* (New York: Golias Books, 2020), 4.
2 Ibid, 3, 18.

Page over page, Rees tarries with the ingestible grotesquery of the capitalist present. The poem itself is titled after a sandwich, named for a national holiday commemorating the ongoing colonial occupation of North America. "To name a sandwich/The Thanksgiving is a shame," Rees proclaims, and the shame assigned to this repast contaminates the poem by association; for what then would it mean to name a poem after this disgraceful sequence?

Cranberry sauce stains,

cranberry sauce stains
and these linens are fragile.
End the metaphor.[3]

This staple of the autumn table leaves its mark, imparting pangs of consumer regret to the laundered conscience of America, whose flaxen fragility Rees duly notes. "I also know guilt—" he continues, and it's clear we are embarked upon a non-platitudinous poem of serious moral compunction. "Extermination/the day's word, every day's word," Rees avers, and "still they ask to stop//for froyo yummy," a detour demonstrating the repressively selective lightness of occupation. As Rees writes, "the search for meaning persists/amidst legacies//and Cinnabon shops"; in a dupe's paradise that cannot be entirely evacuated of sentiment, nor exonerated of the history it crests atop.[4]

One might describe *Thanksgiving* as a poem urged on by its own conditions, which are then represented as form. In a visually striking arrangement, the poem gathers momentum over so many tercets of seventeen syllables each, resembling haiku in their compact regularity. This foregrounding of artifice produces a contradictory intensity, building an essaying continuity from a poetic means prized for compression. Clearly, *Thanksgiving* isn't a collection of haiku in the customary sense, of so many discretely seasonal vignettes. Rather, its multi-clausal argument spans stanzas, while a strict syllabic subdivides the current.

Rees's haiku-length stanzas function as units of measure, rather than scenically sufficient settings in themselves, only heightening a poetic tension between form and experience. Quantitatively identical

3 Ibid, 5.
4 Ibid, 6.

but qualitatively disparate, these tercets oversee the exchangeability of signs implicated therein, as simple metrical values. This preponderance of form contradicts the imagistic qualities for which haiku is prized; and suitably, the poem's natural scenery encompasses brand names and slogans, mass-produced artifacts and marketing portmanteaus, situating the poem in the undifferentiated season of capitalism.

The poignant militancy of this poem surely consists across such an acknowledged tension. Subjective possibility begins amid vast processes of accumulation, occupation, and monetization, and the poet-observer finds themselves in the interstices of only seemingly contiguous manufacture:

> My complex begins
> in the fissure preventing
> the appliances
>
> from touching, recess
> what forgotten drippings there,
> such cathected grease ...[5]

Rees writes in desirous proximity to the scenes and surfaces of service, to an unsanitary abyss, and so many related figures of ensnared attention underwrite the poem's progress. In sumptuous detail, *Thanksgiving* follows a needful subject through a labyrinthine consumer landscape; but for all the roving subjectivities enrolled in the poem's point-of-view, containing shopping malls of multitudes, Rees insists on the recollected lyric-I as a vehicle of political experience:

> I am forgetting
> my purpose here: to spit on
> Plymouth Rock, okay?[6]

This regurgitative task literally reverses the path of gustation, refusing to imbibe of patriotic propaganda. Otherwise, this righteous interruption, in which the poet breaks momentum to express contempt for the conditions subtending the preceding flow, evinces nothing like

5 Ibid, 8.
6 Ibid, 10.

a cheap dismissal of poetry in the name of an ulterior politics. Rather, Rees treats the poem as a medium of consciousness; appropriate to the task of disclosing reality, not only as a series of impressions, but as so many intrinsically social relationships.

This reassertion of purpose functions as a kind of refrain, recurring throughout the poem as one might pinch themselves, and the poet's purposes are many: to spit on Ulysses S. Grant, "to scan/for listening methods," "to find Gary Mathias" of the Yuba County Five, and more.[7] In each case, this transposable self-affirmation sutures the poem to reality, however hostile or isolating, and furnishes the speaker personal traction. "I grew up queer and lonely/just walking around//such leafy enclaves," Rees confides before enumerating youthful exploits.[8] This catalogue, of theft and arson, idleness and sex, gathers around a breathtaking assertion of inconsistency: "I do not regret/interludes re: my subject."[9]

These separate recesses of life are indexed by a base plaint, "I was broke," as though experience itself could be an object of exchange. With this motive in mind, Rees's lack of regret exemplifies a louche refusal of the terms by which life is evaluated, and the surplus poeticity of a tossed-in end rhyme further emphasizes this prodigal glee.

> ... I was broke
>
> so stole eggs and bread.
> I was broke and lazed in bed,
> spying my dreamlife
>
> in labor vortex.
> I was broke and lived on cock,
> too much? Laundromat
>
> was too expensive,
> I was broke! ...[10]

As concerns the poet's own make-work formation, Rees professes an ambivalent fidelity to punk and its strained intimacies. This DIY ethos

7 Ibid, 15, 21, 68.
8 Ibid, 35.
9 Ibid, 35.
10 Ibid, 36.

is clear from the infrastructural fixation of the book's projected insur-
rections, negating empty trade unto a glamorous utility, and repeating
the poem's modular conceit in a thematic register:

> Here's the pitch: an office park
> that's overtaken
> by dull vacancies
>
> becomes the new headquarters
> for a radical
> anti-state cult org.[11]

As a metrical allotment preceding any content, Rees's tercets func-
tion as a formal analogue of this prefabricated regularity. Rees glosses
strip malls and office buildings with revolutionary optimism, regarding
their consistency as formally hospitable, however otherwise deployed.
These depots are nonetheless sites of satiation and spirituality, pleas-
ure and boredom, of social necessity: "'Worshipping/at a mall might
sound strange,'" Rees quotes, but this drive-through evangelism must
sustain somebody.[12] As "the lifelong glimpse/into strange windows at
dusk" elicits empathetic pangs of non-belonging, any descent into sub-
urban desolation invariably finds its social purpose.[13]

Perhaps this is one calling of the poem—to order and inhabit an
otherwise external sequence of signifiers, sentimentally at that, becom-
ing formally commensurate with a subject. This is a true Romantic
mission, which may be referred to Coleridge's famous decree:

> No plot so narrow, be but Nature there,
> No waste so vacant, but may well employ
> Each faculty of sense ...[14]

Thus Rees relates to found surroundings, oscillating wistfulness
and a protective irony that impedes passive reception. And yet, as suits
conditions of capitalist subsumption, the poem's every scenery is sub-
ject to development, vernacularly rendered:

11 Ibid, 50.
12 Ibid, 23.
13 Ibid, 46.
14 Samuel Taylor Coleridge, *The Complete Poems* (London and New York: Penguin
 Books, 1997), 138.

> This location has since closed
> that's the sound I want
>
> empty lot in spring
> it's what is called meadowing [15]

Incredulous of the poem's own working vocabulary, Rees evades and critiques lyric transparency at once, addressing nature at a grammatical remove, as an object of management. This is no simplistic pastoral placed atop stolen land, however; Rees troubles this interloper's optic, writing at the limit of what it is possible for latter-day pilgrims to say given the real constraints of history. Accordingly, the poem scrutinizes "a diffusion of/terra nullius patchwork/ideologues," inculpating the mobility of academic arrivistes, politically complacent poets, and Rousseauian obscurantists, before alluding to the conditions outside the text that must be absolutely opposed. [16] Addressing the disappearances of Indigenous women by name, Rees purposes his verse at extra-poetic redress for injustice:

> … Start a large fire
> burning underneath
>
> the fucked condition
> in which we must commit to
>
> such searches … [17]

Where this unfinished negativity bears on the present, the poem culminates in civil allegory, with a street scene; someone playing music at a burned house, life transpiring at cross purposes to rubble, "and signs reading/everything must go." [18] Enjambment has the effect of endorsement here, making fire sale signage into a statement of principle, and construing an index of so-called under-consumption as a call for a destructive jubilee. Here too, the poem's characteristic surfeit of form serves a categorical function before an incorrigible world, anticipating new and unforeseeable content.

15 Rees, *Thanksgiving*, 18.
16 Ibid, 17.
17 Ibid, 68.
18 Ibid, 85.

Notably, this oppositional bearing never lapses into nihilism; quite the opposite, as Rees risks gratitude throughout, for a reality of someone else's making, and a fraught world wanting change. Omnivorously allusive and effected with uncanny rigor, *Thanksgiving* feels like a gift; a timely fulfillment of the Romantic vision of poetry as a form of experience, and an instrument of dissonance that only sounds of life.

Sun on the Avant-Garde

Lyn Hejinian's Various Positions

Does poetry have a public? This question circulates amongst indebted writers, whose fretfulness attests less to poetry's obsolescence than to a crisis of its present contexts—from a pyramidal contest culture to the MFA as creditor and style guide. Professed anxiety concerning the public standing of poetry appears somewhat ironic, however, where a workshopped writing of lyric intimacy presumes to span two spherical privacies, reader and author, by more or less proprietary means. Poetry has been a method of sequester, and to bemoan the simple absence of reception under present conditions is only to note that it eludes a fickle market.

This situation both commends and forecloses much coterie writing, not to mention the fantasies of autonomy commonly associated with the epithet "avant-garde," supplementing a perceived lack of broad appeal with the positive self-appraisal of a closed scene. These group tendencies often begin in opposition to a perceived hegemony of style, then strive to formalize their own work as a counter-institution. Everybody knows how this story ends—today's avant-garde becomes tomorrow's institution, thus susceptible to criticism from traditionalists who place themselves on the side of an imaginary public only by dint of secondary exclusion.

This oscillation of opinion surely accounts for the fate of many twentieth-century avant-gardes, up to and including the Language writing of the nineteen-seventies—a theoretically heady current whose

constituent texts emphasize indeterminacy and interpretation. Since the inception of this influential school, politically and professionally motivated realists have stated their opposition in so many versions of the question: does Language poetry have a public? If not, and for want of one, whose interests does it serve instead?

Positions of the Sun, a 2018 book-length poem by poet Lyn Hejinian, posits a series of better questions: what poetries are already of the public? Are the self-exceptionalizing desires of artistic avant-gardes politically recuperable? Where might one locate the university in this equation, as a site of labour and a space of study, however altered by financial incentivation? How do individuals relate to larger demonstrations of agency and feeling, in and between moments of struggle? Composed between April 2008 and July 2015, the prose poems collected in this book correspond not only to the time of financial crisis but to the seasons of popular protest, insofar as these eruptions correspond inseparably themselves. The poem proceeds against the scenery of a university under an austerity regime, and the activity of the Berkeley Solidarity Alliance, a group responding with student and faculty pickets to a series of brutal cutbacks at the University of California, though it is far from straightforward reportage on the excitations of protest. As a work of theory on the social scale of a novel, *Positions of the Sun* tends closely to the cognitive framework of social experience, and the collective context of cognition, attempting a commensurate poetry.

After the fashion of Hejinian's *My Life*, a modular work of memoir published in 1980, *Positions of the Sun* is composed of abruptly abutting propositions. Where the approach of *My Life* conveys the discontinuity of personal memory, the present work feels densely argumentative by comparison: a polyvocal and often polemical essay on group formation and dissensus—"mimetic of interconnectivity."[1] As Hejinian issues major theses on psychoanalysis and society, dreaming and reality, myriad persons cross her path in their ungainly actuality; and *Positions of the Sun* carefully inventories the spaces of these shared encounters, embedding its abstract propositions in a particular time and place, amongst a particular group of people.

1 Lyn Hejinian, *Positions of the Sun* (Brooklyn: Belladonna*, 2018), 161.

Out of Sequence

How can a work of personal writing render the parameters of public space? To start, Hejinian assigns her paragraph a categorical function. The text of *My Life* was initially composed of thirty-seven sections with thirty-seven sentences each, a number derived from the age of the author at the time of writing—an ex post facto numerical constraint producing frugal, fugal, and fractal effects. Likewise, the text of *Positions of the Sun* is formed by a tension between quantitative completion and qualitative openness. But *Positions* proceeds indeterminately, where each chapter corresponds to a two-week span of writing, allotted in advance to the transcription of unfolding events. The text runs to twenty-six such sections, with an additional coda. This number calls to mind the Roman alphabet, a closed set of characters that remains endlessly generative in its re-combinability. In a demonstration against simplistic pictorialism, Hejinian presents an alphabetical list poem with line breaks for each letter, allowing an arbitrary symbol, in this case an apple, to index a restricted system:

> Alphabet, use of apple in
>
> Barrel, rotten apple in
>
> Code, alpha for apple in
>
> Dapple, apple rhymes with
>
> Eden, apple not really the fruit in
>
> Fall, apple falsely figures in man's
>
> Gloss ...[2]

The imposed order of this vocabulary mocks at the prospect of closure, let alone definitive description. But Hejinian's text is not so clearly tiered as the odd litanizing gesture would suggest. The alphabetical rule deciding enjambment complements Hejinian's formal predilection for sentences instead of lines, offering a kind of tiered or sequential punctuation. (In Hejinian's 1978 poem, *Writing Is an Aid to Memory,* the

2 Ibid, 126.

indentation of each line is determined by the place of its first letter in the alphabet, conveying the surplus signification of the glyph to each stanza's shapeliness.)

Hejinian's poetics strain against linearity, hence the emphasis on cardinality rather than order. This produces a range of formal effects identified with the initial output of Language writing: in particular, the sort of readerly assemblage that Ron Silliman famously terms "the New Sentence." The name is somewhat provocative, for what was new about the New Sentence, in the mid-seventies at least, had nothing to do with sentences themselves, but with their placement in a paragraph consisting entirely of digression as a formal method. In the writing heralded by Silliman, "the paragraph is a unit of quantity, not logic or argument," such that the expectation of sequential revelation is abandoned, and each sentence may be explicated only with reference to the "total work." In many of Hejinian's projects, these formal parameters are set in advance of the act of writing and only await population by subjective incident, much as an empty calendar of days anticipates unforeseeable activity.

Timed Writing

Beyond this produced opacity, there is ample diaristic precedent for Hejinian's numerically constrained outline, affording two weeks to the aggregation of each chapter-stanza. This time-based approach recalls the writing practices of Bernadette Mayer or Steve Benson, for example, both of whom use temporal constraints to thematically delimit a creative exercise in its lived specificity. Mayer's book-length poem *Midwinter Day* documents December 22, 1978, from start to finish, while her 1994 epistolary, *The Desires of Mothers to Please Others in Letters*, spans the duration of a pregnancy. Steve Benson's usually extemporaneous works are often composed within specific material parameters, such as a gifted notebook, where limited space dictates an allotment of time only in retrospect of composition. With these extra-textual constraints in mind, the title of Hejinian's text assumes regulatory importance, as the sun charts the arc of each day, its movement relative to standpoint.

The diurnal generality of this poem only multiplies its publics—for this is not the lapsed time of a quantitative conceit, but the messily

qualitative time of social experiment, narrating a season of protest. In this staging, Hejinian makes political demands of style: how can the finite and self-referential weft of a given text address the social totality of which it is a quirky specialization, other than symptomatically? *Positions of the Sun* comes as close to novelistic representation as discontinuous poetry can manage, using a spate of proper nouns to index and attribute the manifold activity of a nebulous assembly. Hejinian herself alludes to the appearance of seventy discrete characters in her afterword, whose individual activity both focuses and reframes the bustle. Most of these names are several—Askari Nate Martin, Roy Robinson Trelaine, Alice Milligan Webster, Lorna Kelly Cole—giving the impression of a genealogy or census, two equally exhaustive genres.

These are not the only proper nouns that populate the text, which slows at one point to enumerate the storefronts flanking a passage through the city in capital letters, a typographical belligerence equivalent to the effects of signage.[3] This list offers a conflicted portrait of nominally public space, alternating business names with a parenthetical remark as to their services. Hejinian assumes a stance of utopian contrariness toward these tacky fixtures, which nonetheless allude to a suppressed collectivity in their brazen publicity:

> ELMWOOD HEALTH AND MERCANTILE (previously the ELMWOOD PHARMACY, but Vicki the proprietor couldn't afford to keep on the dour pharmacist, and the whole place is within a few days now of going out of business altogether) ... PAPYRUS (one of a chain of greeting card, wrapping paper, specialty invitation shops, with rapidly changing personnel); LORA'S CLOSET (a children's clothing shop, specializing in used clothes, wooden toys, and seconds); FILIPPO'S (a mediocre Italian restaurant); BLOOMING ALLEY (a flower stall situated in the alley connecting the West side of College Avenue to a small parking lot) ... YOUR BASIC BIRD (a pet store, its interior a cacophony of parrot calls, budgie squeaks, and fluttering canaries and finches) ... LOLA (a gift shop); LULULEMON ...[4]

3 Ibid, 86.
4 Ibid, 27.

Historically, the literary catalogue has a vexed relationship to the cities it would name, both overriding and attesting to the specificity of place. As Louis Aragon confesses at the outset of his psychogeographical memoir *Le Paysan de Paris*, one literary precondition of the documentary urge that he visits upon a favourite passage of the city is its assured destruction, in order that his written impressions may supersede actuality. To such thinking, the city is a given user's dream; whereas the literary overlay that Hejinian sets forth is less a version than an emanation, with far too many named corollaries to disappear into a narcissistic user's reverie.

Structure and Cities

This formal difficulty of both cities and texts is addressed directly throughout Hejinian's writing, which is itself constituted by the tension between preplanning and occupancy. In his book *Annihilated Time,* poet and critic Jeff Derksen explicitly identifies Hejinian's writing with an architectural analogue, that of the Megastructure:

> The Megastructure is situated at the end of a grand modernist instrumentalist gesture of social and spatial planning which sought to extend into the totality of life, and at the beginning of a postmodernist project of collage, historical references, and vernacular use of architecture that opened toward the current emphasis on flexibility. [5]

By now, the megastructure is an icon of a bygone futurism, cynically applied throughout the capitalized city, but Derksen's essay propounds a literary afterimage of the megastructure as a utopian accommodation of uncertainty. For Derksen, the characteristic underdetermination of content or utility describes Hejinian's modular concept of writing, redeeming structure rather than any contemporary virtue such as flexibility—making a dialectical assertion of totality from within the present moment. "Within the city's buildings, the immediate is under perpetual translation and transmission," Hejinian observes, which insight commends any representational pretense to form.[6]

5 Jeff Derksen, *Annihilated Time: Poetry and Other Politics* (Vancouver: Talonbooks, 2009), 178.
6 Hejinian, *Positions of the Sun*, 39.

This structural predicament extends into an argument, as *Positions of the Sun* presents a major essay on the contemporary situation of the so-called avant-garde. Hejinian begins from the relatively credulous standpoint of reception in order to assert marginal insouciance:

> How does a writer, or a serious artist of any kind, make it possible for someone to understand, and then to care about, what he or she is doing? It isn't out of arrogance that the avant-garde writer doesn't linger very long over the problem (if there is one) of accessibility implicit in such a question. One key goal of the historical avant-garde was to assert the primacy of art's autonomy, from which would extend its authority and its self-evident right to significance.[7]

This description condenses a megastructural conceit: the writer cannot accurately anticipate the value of their work, but can attend to structure and design. Hejinian rejects this fantasy of creative autonomy, which may only express a division of manual and intellectual labor. Rather, insofar as many avant-garde movements aspire less to the future than to immortality, Hejinian insists upon the historical context of these groundbreaking desires.

Hejinian clearly rejects the artist's plea of extra-historicity, instead describing an artistic partition within society. And her restatement of the problem of autonomy as a question of accessibility impels this essay's initial question: does poetry have a public, or alternately, what sort of public does poetry project? As Hejinian puts it: "What schemes bind accessibilities together, what tapes keep sites off-limits, and what are those sites, seemingly so distinct from what's accessible?"[8] This line of questioning helps to demystify popular accusations of willful difficulty leveled at experimental language arts, where problems of restricted opportunity and access are often attributed to style as though its syntax or vocabulary were already and inherently private.

But the public language of Hejinian's text is not concerned with the university in general as a dispensary of knowledge or style; rather, these sentences address the University of California as a contestable site of employment and investment, narrating pushback by students

7 Ibid, 106.
8 Ibid.

and campus workers against massive tuition hikes and layoffs. Such material concerns offer a far better place from which to start a conversation about accessibility and school, where the latter reproduces class values as discourse. Given how often Hejinian's contemporaries in the Language school are shallowly derided as remote academicians, it seems especially important that a fight to decommodify education—a fight both for and against the university—serves as the backdrop to this essaying poem. From this context, one might formulate several important questions. On one hand, how often do detractors of an academic tendency simply fault the object of study for the difficulty of acquiring an education? On the other hand, more pressingly, how has the university shielded radical, if not expressly avant-garde, desires from politics, during the Cold War in particular? Hejinian poses these questions only obliquely, appearing to propose a popular experimentalism, immediately forged from the material of social movement.

In Dreams

Throughout *Positions of the Sun*, Hejinian offers a robust description of the relationship between the individual and the collective, where the meaning of the former term is derived from a higher unity and wants organization. Hejinian's trademark parataxis conveys this relationship, too—for where a reader's attention is concerned, any two sentences in succession have the appearance of a logical sequence; so it appears as if the answer to a question—"what are those sites, seemingly so distinct from what's accessible?"—when the text continues: "We know of a person sleeping that he or she is alive but we wouldn't say, as he or she sleeps, that he or she is living his or her life."[9] This Wittgensteinian linguistery, extrapolating a normative rule from common usage, belongs to a poetic micro-genre at which Hejinian excels; for the separate persuasiveness of such sentences, corresponding to respective "language games," is coyly mitigated by the drifting registers of the so-called Language poem.

 If this suggestion—that wakefulness is predicative of living—appears intuitive, it isn't because nothing transpires in sleep; but

9 Ibid.

because the sleeper remains a passive recipient of oneiric content, inaccessible to others. Hejinian derives a suggestive theory of the popular unconscious from this description of sleep as a social lacuna. "Avant-garde art is an art of shared wakefulness (and perhaps an art of insomniacs)," she declares in manifesto-like fashion.[10] To this view the social, as the proper medium of artistic activity, is a common dream. (Throughout the text, the privations of sleep are spatialized: "This isn't a city that 'never sleeps.' There's no bus service between 1 and 5 am. The city is knotted."[11])

With this turn, Hejinian personalizes an impasse of many historical avant-gardes, recasting the Modernist work of intra-referential autonomy as a form of social withdrawal, lacking symbolic traction. Over the avidly bibliographizing course of *Positions of the Sun*, Hejinian moves back and forth between *The Psychopathology of Everyday Life* by Sigmund Freud and *The Critique of Everyday Life* by Henri Lefebvre, implying something like a revolution of their common object. The tension between antisocial sleepiness and open language is vividly rendered in a dream vignette:

> I dream of boards that are made of words instead of wood—"sayings": colorful slats composed of graffiti, white, pink, aquamarine (the colors with which kitsch seashell objets are decorated). The walls of the subsequent shack, built of these words/boards, are fissured with cracks; the shack is cold and public. I come to this profound conclusion about the nature of language: everything by virtue of it is permeable. Then I dream of a beach; in the dream the word for it is plague, then plage, then page. But I no longer have dreams like that. Dreams are false secrets. That dream is locally trapped in the running after names.[12]

Wordplay is key to any poetic project, and slippage is assured. But in this passage, Hejinian comes to reject the private interchangeability of things. Hereafter, whatever fond node of association becomes a word, all are elaborated together, as a public syntax. In this respect,

10 Ibid, 107.
11 Ibid, 40.
12 Ibid, 111.

dream interpretation is not antithetical to public life, but a conceptual recuperation of previously cordoned psychic and emotional space. The dream quoted above appears to allegorize such an endeavor, for the house of sticks that Hejinian describes is less a prison-house of language than a shanty of common and recombinable material.

Hejinian's description of the individual unconscious as "locally trapped" resembles a Marxist critique of psychoanalysis associated with the work of Valentin Voloshinov, whose work finds some of its few American executors in the milieu of Language writing. Commencing from the standpoint of structural linguistics, Voloshinov rejects the postulate of the unconscious altogether, preferring to treat this reservoir of proto-social information as ideological runoff. With grand sociological ambition, Voloshinov proposes that a theory of language ought to include an apprehension of the totality of conditions shaping practical use, in which meaning consists. There is no personal symbology, Voloshinov decides, proceeding from a close but partial reading of Freud (in whose account the personal and historical contingency of unconscious material is already clear). This turn from psychology to social linguistics emphasizes use above all else, such that Voloshinov's categories have very little descriptive purchase on the useless, extravagant, and even secretive activity of the unconscious.

Near the outset of this book, Hejinian dwells at some length on Freud's work around bumbling and deferral. Linguistic slips may betray something like unknown knowledge, but the fact of this substratum tempts Hejinian to consider other socially irrecuperable material: "a secret so secret that nobody knows there's a secret is an example of uncaptioned knowledge."[13] This highly original description of the unconscious presumes organized repression. The unconscious, Voloshinov writes in *Freudianism: A Marxist Critique*, "abhors words. We cannot acknowledge our unconscious desires even to ourselves in inner speech."[14] Voloshinov finds this secrecy—call it uncaptioned— inadmissible, and Hejinian's rejection of dreams as "false secrets" surely involves the status of this captioning, by which socially moot material becomes accessible to thought and action.

13 Ibid, 31.
14 V.N. Voloshinov, *Freudianism: A Marxist Critique*, trans. I.R. Titunik (London and New York: Verso Books, 2012), 54.

Throughout *Positions of the Sun*, dream vistas blur with quotidian intrigue; named vectors of mass demonstration and cohabitation extend a discontinuous soliloquy. One might say that the text is only so many captions on captions, enacting a powerful suggestion—"that one possible intention of avant-garde poetry is to obliterate secrecy, so that nothing in it is the outcome of a compulsion to tell."[15] In this description, the compulsion to tell is itself a means of separation, as the formal effects of lyric intimacy depend upon secrecy—the speaker vaults an arbitrary wall erected within language and affect in order to bestow the emotional spoils of selfhood upon a similarly alienated neighbour. "For a writer of bourgeois inwardness, the highest achievements are dreams," Hejinian affirms, which brook no arbiter beyond oneself.[16]

Encyclopedic Ambitions

Dreams essentially consist in displacement, in which respect they are already language. Hejinian asserts the constant necessity of interpretation that inheres within the everyday: "I am not against interpretation. On the contrary, it is an activity I tend to engage in with near abandon, seduced by the cognitive pleasures and constructive possibilities it promises, though usually, at interpretation's end, I'm aware of the arbitrariness, or incompleteness, or gratuitous weirdness, or obviousness, or heavy-handedness of its outcome."[17] In light of this gratuitousness, it seems obviously strange to speak of an end to interpretation, which serves here as a word for an individual's agentive stake in the social. Likewise, Hejinian's interest in dreams remains Freudian insofar as it is interpretative rather than cryptanalytic, "syntactic rather than semantic," preferring a kind of social allegory to the private substitutions of metaphor.[18]

Throughout *Positions of the Sun*, Hejinian elaborates upon the massively multi-interpretive endeavor of dreaming collectively. In this respect, the heterogeneous voicings of the text are resolutely non-exhaustive in their attribution. "Perhaps encyclopedic ambitions are

15 Hejinian, *Positions of the Sun*, 110.
16 Ibid, 84.
17 Ibid, 45.
18 Ibid, 110.

best fulfilled unsystematically," Hejinian writes, marking the tension between totality and multiplicity that Derksen describes by way of the megastructure.[19] If anything, one might suggest that this particular avant-garde text is less architectural than urbanistic in its setting and design.

On this point, Hejinian sets out to reclaim the term "avant-garde" from synonymy with "weakly categorical" labels such as "innovative" or "experimental," insofar as these denote little more than stylistic tendencies, lacking political vision.[20] Hejinian's own avant-garde desires entail a transformative disposition toward reality. "In the early days of the Language Writing scene, it was not just structures and methods we changed," Hejinian relates: "we also changed each other."[21] Accordingly, *Positions of the Sun* is a text with a social form, whose seventy-odd characters work on reality together, whether arranging music or protesting in the streets.[22] If "the paratactic present" of this writing is intended to resist the allure of unseemly generalization, it nonetheless tends to a picture of totality.[23]

Positions of the Sun

To this end, the sun remains a central metaphor, as the title of the book alludes to an everydayness that cyclically divides linear time. "Chronology is not the proper syntax of time," Hejinian asserts, and her account of human activity as so many concurrent eddies in a stream effectively spatializes the temporal conceit organizing the text, reconstituting the tension that Derksen describes between empty form and unanticipated content.[24] "Everyday life (vernacular repetition) is everything that forms common grounds," Hejinian says, alluding to a manner of cohabitation in the language of both poetic and architectural antecedent.[25] After the suggestion of Henri Lefebvre, one of Hejinian's primary interlocutors, one may read the solar conceit as

19 Ibid, 126.
20 Ibid, 44.
21 Ibid, 28.
22 Ibid, 126.
23 Ibid, 32.
24 Ibid, 156.
25 Ibid, 42.

a cross-rhythm to mechanical progress, postulating a less alienated human presence on the earth.

The eponymous positions of the sun not only correspond to times of day, but describe a source of energy that suffuses all the life on earth, indicating a standpoint of collectivity. Hejinian begins with a generic aubade: "The sun is rising." This metaphor extends throughout the text, blessing every endeavor: "O sun on the avant-garde," Hejinian exclaims, reestablishing the self-professed specialism of her company upon a shared planet.[26] According to Georges Bataille, earth's sun is a blinding emblem of pre- and post-scarcity, an obviously communist beneficence, and Hejinian voices a similarly pagan paean: "Were the sun able to see everyday life to its depths, it might think heretically, with us."[27]

This language of heliocentrism and heresy evokes enlightenment: a program of exaggerated independence undergirding many avant-gardes. But Hejinian rejects this focal metaphor for a more comprehensive solar allegory, derogating the ideal of a single individuated intellect. Her speakers are each of the sun without anyone presuming centrality unto themselves. In this crowded equality, the book describes a phased practice of cohabitation and collaboration, attuned to named and unnamed masses. "The sky above is clear, the moon is in phase. On the other side of the world the sun shines. There are many solar allegories—"[28]

Hejinian uses this glaringly evident sign of totality to organize registers of difference, suggesting a calendrical and categorical analogy to the megastructural conceit by which Derksen reads her earlier work. In this respect, as a record of inchoate struggle and an inquiry into the sentimental basis for collective engagement, *Positions of the Sun* comprises a major extension of a singular life-writing project, canvassing beyond the author's dreamlike recollection in a spirit of public creativity, and remaking the contexts of its political legibility.

26 Ibid, 110.
27 Ibid, 102.
28 Ibid, 159.

In the Path
of Totality

"Vegetation is uniformly directed towards the sun; human beings,
on the other hand, even though phalloid like trees, in opposition to
other animals, necessarily avert their eyes."
—Georges Bataille, *The Solar Anus*

In moments of unbearable intensity, people are ever more alike. This
final equality, however, is forestalled, even suppressed over our sep-
arate days, where collective interests are calendrically diffused and
our common element is condescended to, like the vapour to which it
returns. These days everybody talks about the weather, but the point
is (not) to change it.

As a prelude to a Gaian crisis theory, the political economy of
Georges Bataille may be said to construe the market as a weather,
insofar as both systems emanate from the irradiance of the sun, a life
source and final limit. In drafting his general economy, this ultra-left
librarian-pornographer took pains to demonstrate its commensurabil-
ity with the scale of cosmos; again, "the dependence of the economy
on the circulation of energy on the earth," originating with and mod-
elled on the sun's ceaseless beneficence.[1] "Minds accustomed to seeing
the development of productive forces as the ideal end of activity refuse
to recognize that energy which constitutes wealth must ultimately be
spent lavishly (without return), and that a series of profitable oper-
ations has absolutely no other effect than the squandering of profits."[2]

1 Georges Bataille, *The Accursed Share*, trans. Robert Hurley (Ann Arbor: Zone Books,
 1988), 19.
2 Ibid, 22.

This thesis, of the interconnectedness of all industry in the broadest sense, falsifies enterprise and privacy alike—and furthermore, tempts bodily retort. According to the "global outplacement and executive coaching firm," Challenger, Gray & Christmas, Inc., 87.3 million workers across the United States of America were poised to cost the capitalist class $694 million during the total eclipse of August 2018: the estimated losses caused by a convivial twenty-minute walk-out, in the works for one hundred, if not thousands, of years.

In 1133 CE, King Henry I of England died upon eating spoiled eel, apparently precipitating a total solar eclipse. This cathartic episode lasted for four minutes of darkness and mourning, and opened onto many more of war: another favourite catastrophic expenditure of energy. But for those 240 seconds, there was only *festival*—the kind of giddy jubilee in which Bataille perceives an intimation of equality and continuity between persons, otherwise repressed: a revolutionary Saturnalia whilst kings decompose.

No sooner than one conceives of a sovereign entity, self-evidence withstanding, its dispatch is conceptually assured. We know there is a sun, such that today we cannot meet its gaze. But this endurance foreshadows a properly unthinkable cessation, for as philosopher Jean-François Lyotard notes in a moment of teleological fury, puerile yet irrefutably correct, "the death of the sun is a death of mind," beyond which there is no correlate to thought.[3] As our sun will burn out in some five-billion years, one might say that the universal mind marks a kind of postdated oblivion, too.

In the interminable meantime, the industrial sun remains a model of production for production's sake. For fourteen days in March 2017, the state of Arizona was gifted free power by its neighbour California, and this was not the first time, either. On another sunny day in 2017, Germany produced so much renewable energy that power prices "went negative," such that people were effectively paid to consume. This doesn't quite corroborate Bataille's pronouncement that, as energy transformed, our future communism ought to model itself on destructive excess. The colonial problematic of the Anthropocene prohibits any merely orgiastic praxis; anarcho-gluttony on behalf of whom?

3 Jean-François Lyotard, *The Inhuman: Reflections on Time*, trans. Geoffrey Bennington and Rachel Bowlby (Stanford: Stanford University Press, 1991), 10.

Describing himself as a "drop of sun under the earth," philosopher Frantz Fanon refuses the acculturated curse of racism for an identification so general that it bypasses the colonizer's edict in its otherworldliness.[4] In this poetic description, the author figures not as reflective consciousness but as refracted life-force. We should bear this identity in mind when, in *The Wretched of the Earth,* Fanon speaks of reclaiming resources from the colonizer, "to re-examine the soil and mineral resources, the rivers, and—why not?—the sun's productivity."[5]

Indeed, why not? As utopian technocrats optimistically report, world energy needs could be met in solar power using only 1.2% of the surface area of the Sahara desert. But American experts have peculiarly selective definitions of both "world" and "need," as befits the interests of an imperial core. Final consumers of the sun's energy could never be final enough. If scarcity is simply the result of stymied synthesis, we may yet need another sun, one for the working and the wretched.

Can we start to regard our star as such an ancient novelty today? In a poetic inventory of upsetting consummations, Bataille identifies the fiery annulus of the eclipse with the anus of night: the sun's rays find their ready, greedy counterpart in restless masses, the eclipse burns in the mirror of our eyes. Desire redeems indecency. Then it is good not to succumb to the technical illusion that we die as we dream, irredeemably separate. Anything can prompt a walkout. Should the sun cease to provide for everyone, why not blot it out and start again.

4 Frantz Fanon, *Black Skin White Masks,* trans. Richard Philcox (New York: Grove Press, 2007), 27.

5 Frantz Fanon, *The Wretched of the Earth,* trans. Constance Farrington (New York: Grove Press, 1963), 100.

Writing Multitudes

The Political Desires of Jordy
Rosenberg's *Confessions of the Fox*

In every political epoch, the role of art comes up for reappraisal—
whether better to edify or illustrate, to sing or to condemn. These
purposes are not so separate; but even in this moment of upheaval, it
remains unfashionable to think of artworks as instructional, let alone
socially beholden. Where high art franchises and so-called literary
schools package opportunities for secluded contemplation, popular
culture favours only so many positive representations, leaving the
world in which these circulate more or less unchallenged. By this
fatally familiar logic, the future once again looks like the present,
with more options.

This optical verve feels ironic given our moment's anxious stakes:
whether with respect to an environmental precipice, the escalating
crises of capitalism, brutal restrictions on free movement for migrants,
or recent legislative attempts upon the civil rights of trans people, the
US political imaginary tends increasingly to project a landscape vacated
of any human detail whatsoever. Against this backdrop, one ought to
insist, any politics of representation must also exert a demand for a
world in which it is possible to exist.

Jordy Rosenberg's debut novel, *Confessions of the Fox*, makes
this radical demand, relating the life of a transgender outlaw in
eighteenth-century England as a militant survival manual for the
present day. A certain amount of historical redress is implicit in this
representation. But this isn't simply a question of visibility, which may

only open onto new regimes of media and state supervision. Rather, Rosenberg writes in conviction of the radical capacity of narrative to counter the intolerable circumstances it depicts. Accordingly, this historical fiction doubles as twenty-first century agitprop, insistent upon the subversive afterlives of language and its subjects.

The Historical Novel

Historical fiction itself has a vexed relationship to politics, in both reactionary and radical versions. Officially, the genre reassures its reader with depictions of an unchanging human essence, whose existential predicament persists across classes and societies. By the same stroke, writing about history authorizes the most extravagantly simplistic depictions based on present-day mores, guiltlessly imputed to a distant past. It seems that such fictions can neither escape the present in which they are written, nor the factual scaffold supporting their fantastically embellished past. This predicament is both a difficulty and an advantage, depending on one's designs.

Transpiring between early eighteenth-century London and a New England college town in the present day, *Confessions of the Fox* presents as a story within a story: a found manuscript narrating the life of master thief and jail-breaker Jack Sheppard, with annotations by erstwhile Marxist academic Dr. R. Voth, forced by disciplinary action to navigate the snares of an investment-driven university. Over the course of the novel, Rosenberg discloses two lives of queer fugitivity, centuries removed, and lets the correspondences speak for themselves: Jack is a trans man living at the outset of a hostile surveillance society, and for that matter, so is Dr. Voth, however differently.

This formal device—of two parallel plots corresponding to different timescales, obscurely but essentially related—is common to much contemporary historical fiction, but Rosenberg's works differently, insofar as the seam between these stories, and the object upon which they gradually converge, is the very text that the reader holds in their hands. This may appear quaintly postmodern at a glance, but this is not a work of literary subterfuge; rather, Rosenberg offers a constructive vision of what the novel containing history might say to the present situation of its readership.

In his 1937 study of the historical novel, literary critic György Lukács makes a Marxist case for the form. Historical novels, he writes, are not simply characterized by a past setting, but by the explicit depiction of history as process. The historical novel thematizes social transformation, in which each of its characters stands for a condensed stake.

Lukács begins with the historical context in which the genre itself emerges, during the economic and social transformation of England in the eighteenth-century. Already a post-revolutionary country, Lukács adds, England's working people have themselves experienced an awakening of some historical agency, however unevenly. This primes England in particular for the development of the social novel, which addresses the historical specificity of its milieu by realistic means. For Lukács, the historical novel emerges as both a critique and consequence of capitalism, which contradictory totality it would disclose. For this reason, Lukács tirelessly defends its hallmarks—elaborate moral typologies, the characteristic omniscient narrator—against the tricks of a literary avant-garde that he closely identifies with psychologism and private interiority.

Communist playwright Bertolt Brecht, perhaps Lukács's most renowned antagonist, argues against the normativization of the novel on political grounds. "The oppressors do not work in the same way in every epoch," Brecht writes. "Reality changes; in order to represent it, modes of representation must also change."[1] To impose novelistic form, itself historically contingent, upon contemporary experience gives the impression of a fixed human nature, mystifying the relation of social mores to a mode of production. Brecht's own solution to this impasse famously recommends a mixed technique, encompassing pastiche, satire, and all manner of meta-textual devices.

Sheppardiana

With the context of this formal debate in mind, *Confessions of the Fox* appears a curious synthesis: an historical romance, set against the social backdrop that enables such a thing, embedded in an unevenly textured

1 Bertolt Brecht in Theodor Adorno, Ernst Bloch, Walter Benjamin, Bertolt Brecht, and György Lukács, *Aesthetics and Politics* (London and New York: Verso, 2007), 87.

work rife with rhetorical signposts and stalling digression. This boundary breaks down, but only after one has noticed its importance.

The twofold plot is spurred to motion when a precariously employed scholar, Dr. Voth, happens upon a sheaf of papers at a university book sale, dated from 1724 and appearing to be the "lost Sheppard memoir" of philological lore.[2] Voth sets himself to transcribing its contents, if only to distract from the aftermath of a relationship during a period of academic probation. As the source text exceeds Voth's expectations, offering a glimpse of queer community amid the violence of early capitalism, his footnotes digress generously, gradually disclosing a biting satire of the liberalized academy and its increasingly obscene marketization. These plotlines converge upon each other in myriad surprising ways, as history springs to life as a matter of direct, and implicating, concern.

Where the life of Jack Sheppard is concerned, *Confessions of the Fox* fulfills a Lukácsian criteria, depicting large-scale social change as manifest in representative miniatures. Its hero is introduced from the gallows, having lived in glamorous shadows after escaping a grueling indenture. Jack's lover and partner in crime, Bess Khan, arrives in "a place of shopping and Hollowness," from the countryside in 1713, and immediately falls upon a preacher inveighing against world trade.[3] In these situating details, the narrative of Jack and Bess transpires against the conditions of the development of the historical novel proper: global processes of colonial dispossession and capitalist accumulation shape and constrain their lives and desires.

In the novel's present, Rosenberg's formal means descend from slightly more Brechtian directives, preserving a commentary on the historical action. In this sense, *Confessions of the Fox* approaches what Amy J. Elias calls "metahistorical romance," a postmodern development of the historical novel that self-consciously addresses the temporal distance it would overcome.[4] The interruptions and addendums work to place the sublime enormity of History at a distance, resisting vulgar presentism and necessitating that a reader locate themselves somewhere

2 Jordy Rosenberg, *Confessions of the Fox* (New York: One World, 2018), x.

3 Ibid, 25.

4 Amy J. Elias, *Sublime Desire: History and Post-1960s Fiction* (Baltimore and London: Johns Hopkins University Press, 2001), 46.

along its wake. This layer elucidates historical material, by alienating it from the textual setting within which it "naturally" appears. In novels like *Confessions of the Fox*, one may observe a constructive tension between the linearity of narrative and the essentially concentric structure of historical movement, such that any text crests over and includes its antecedents.

Other Operas

The action of the Sheppard narrative roughly corresponds to that of John Gay's 1728 work, *The Beggar's Opera*; and more notably, its twentieth-century rewrite by none other than Brecht himself, as librettist for composer Kurt Weill's *Threepenny Opera*. Both texts mythologize the exploits of a character Macheath, based on the historical Sheppard, who was already something of a folk hero by the time of his execution in 1724, which occasioned a carnivalesque procession through the streets of London. Rosenberg's plotting plays plausibly upon this history, for a biography, rumoured to have been written by none other than Daniel Defoe, was apparently sold at the gallows, securing Sheppard's literary posterity on spot.

Appearing a mere four years after Sheppard's death, the hero of Gay's opera is more hapless womanizer than self-avowed anarchist; though in a concession to popular genre and goodwill alike, the fictional Macheath evades death in the end. Brecht's Macheath is more rapacious, a figure of both class resentment and subversive amoralism, likewise pardoned at the last minute in an improbable jubilee. Brecht's ambivalent depiction of a criminal milieu is nonetheless politically crystalline: the desperation of its actors is obverse of the sanctioned cruelty of bourgeois society. "Food is the first thing, morals follow on," Macheath inveighs in song, which interrupts the action with the force of annotation.[5]

Following a decision of both prior adaptations, Rosenberg's novel hews tightly to the viewpoint of the underclasses, typically relegated to a satirical subplot. This is put across by the arcane terminology of canting language; an argot of the streets, proficiency in which attests

5 Bertolt Brecht, *Collected Plays: Two,* trans. Ralph Manheim and John Willet (London and New York: Bloomsbury Methuen Drama, 1994), 145.

to criminal vocation. "D'you jaw the bear garden?" Bess asks Jack on first encounter: "I do flash," comes his reply, affirming their common society.[6]

Rosenberg amplifies the political articulacy of these texts and extols their real-life inspiration, but this is no simple rewrite. In equal and opposite fashion to the repressions of record, *Confessions of the Fox* proposes a defiantly revisionist account of these popular heroes. In the manuscript that Voth discovers, jailbreaker Jack is evidently a trans man, and his escape from servitude coincides with the subjective momentum of self-affirmation. Meanwhile, textual clues reveal Jack's philosophical lover-accomplice, Bess, as South Asian. A footnote expands upon this divergence from previous depictions: "Given that London was not by any means a white city in the eighteenth century … we have to take the unquestioned nature of Bess's characterization as white as less a reflection of 'actual' history than as the occlusion of it."[7]

Plague Years

Insofar as the meta-historical novel sets out to depict the very conditions that permit the emergence of class consciousness, Rosenberg places Jack and Bess in the crosshairs of early capitalist accumulation. In a pivotal soliloquy, Bess narrates her childhood as a Fen Tiger— subsistence fishers of the eastern marshlands—and her firsthand experience of the enclosure of the fens. Otherwise, the London they inhabit is a node of trade, de facto multicultural, through which untold numbers of commodities, including humans, pass.

This mobilization of bodies is a vector of plague, and Rosenberg depicts the racial panic around its containment. "Given the increase in plague in Chandernagore and the East Indies," a bulletin reads, "and the vast potential for the transmission of this plague by merchant vessel, not to mention *in particular the lascar sailors* swarming these parts—it is thought appropriate, and hereby ordered, that additional watchmen be appointed to the plague ships in the interest of the *Publick's Health*."[8] In such measures one perceives the glaring contradiction between

6 Rosenberg, *Confessions of the Fox*, 42.
7 Ibid, 31.
8 Ibid, 176.

the global circulation of commodities and the relative restriction of labouring bodies, scapegoated for the health crisis of which they are the foremost victims. The allegorical bearing of historical fact on present circumstance is not to be missed.

Not only must Jack and Bess evade the clutches of Jonathan Wild, Thief-Taker General, whose henchmen preconfigure a modern police as they protect Wild's own criminal monopoly; they must also skirt the sentinels who oversee the movement of those marked for contagion on account of their class, race, or occupation. "Plague's an excuse they're using to police us further," Bess declaims, lapsing miraculously into academic tongues to decry the "securitizational furor" overtaking the city.[9] This anachronistic outburst summons the work of philosopher Michel Foucault, who found a striking precedent for contemporary social control in various methods of urban quarantine, in many ways predicting the criminalization of AIDS. In the plague town of Foucault's example, vulnerable sections are subject to pyramidal measures: a hierarchy is established according to vectors of plausible concern.

Daniel Defoe, the historical Jack Sheppard's close contemporary and possible biographer, concludes his 1722 novel, *A Journal of the Plague Year*, with an observation of the paradoxical optics of outbreak. At the height of the epidemic, Defoe explains, one would rarely see an obviously afflicted person in the streets, for the virulency of the infection was such that most would expire soon after the onset of symptoms. Conversely, the appearance of visibly stricken people in public spaces was a gradual sign of widespread immunity. The greater the visibility of plague, Defoe notes, the less deadly its effects.

With Defoe's anecdote in mind, one might bear further with Foucault, for whom plague rules supersede the leper colony as a paradigm of social control, insofar as the invisibility of the former affliction permits all manner of advantageous proxies. Rosenberg critically depicts the mood of this scaremongering: Jack and Bess read about "living ghosts" in Applebee's Original Weekly Journal, a paper for which Defoe himself is thought to have written.[10] These are citizens

9 Ibid, 117.
10 Ibid, 115.

heedlessly acting out in late stages of infection, spreading disorder and shoplifting in the throes of death. Unlikely for obvious reasons, this fantasy nonetheless speaks volumes about the rhetoric of prejudice, in which a terrible power over everyday life is imputed to those most oppressed; an obscure intimation of the collective strength that shadows every underclass.

"Bursting with Histories to Tell"

Against this ominous backdrop, Jack and Bess, marked for both exclusion and attention, attempt freedom and survival. Bess continues sex work while Jack thieves with virtuosic ease, garnering a reputation in the underworld. Jack's exploits are politically demonstrative, too; for, in a magical realist development, Jack's proficiency stems from a preternatural knack for listening to the voices of commodities. In a toy shop, these mount to cacophony: "the Mayhem was unrelenting, but it was resolv'ng into a kind of meaning. It wasn't just sound—it was desire."[11] Within earshot of Jack, each object issues shrieks of thwarted purpose, an occult clamor that betrays the social essence of each and every seemingly discrete item: "they wanted him to take them."[12]

As a commodity-whisperer, Jack intuits the demonstration that Karl Marx sets forth in the first chapter of *Capital*—that every object, once it enters into the market, is cleaved between use and exchange value: "Jack had learned that commodities understood much more about themselves than their buyers could ever begin to grasp. They were bursting with Histories to tell. A commodity that had escaped the infernal cycle of production-display-sale was a happy, content object—returned to serving a purpose."[13]

In this fantastic development, Rosenberg conveys the humanist Marx, principally concerned with the problem of subjective alienation, to the objective analyses of the commodity form that would supplant this topic by the time of his opus. According to Marx, commodity fetishism occludes the social, such that relations between people

11 Ibid, 102.
12 Ibid, 103.
13 Ibid, 155.

assume "the fantastic form of a relation between things."[14] This observation underwrites Jack's rapport with the bric-à-brac he would restore to usefulness. "Frankly, like anything else, they wanted to be loved."[15]

"Two Chousers on the Run"

This is a romance, after all, and its insurgent energies anticipate a world in which it is possible to love, both physically and freely, without persecution or privation. In its first pages, Jack goes to the gallows rhapsodizing about cunnilingus, what else, in an impressively purple tongue: *"Oh death that comes for me—O God of the Water-Mill—at least she once took me in her hands and mouth—at least she once spread her legs for me—at least I once dilat'd with her musk in every pore—at least once was I thus Found and Lost—"*[16] This ecstatic outpouring is for Bess, with whom Jack experiences a joyful self-actualization. If anything, their love attests to emancipatory chance, a feeling preconfiguring a better world: "Two chousers on the run are permitted questionable decisions based only in some miraculously Syncopated moment," one reads, as though everything depends upon the practice of this liberty.[17]

Not only does Bess's recruitment effectively politicize the otherwise listlessly dispossessed jail-breaker Jack, but aspects of his physical transition proceed in her care. This is a major plot point, but the narrator otherwise declines to indulge the prurience of a cis readership, in spite of Jack's, and Voth's, frequent braggadocio. Euphemistic displacements proliferate as the characters talk dirty to one another, but the found manuscript and its representation never stoop to sexological invasiveness; a sure sign in Voth's estimation that the Sheppard papers may well be "the earliest authentic confessional transgender memoirs known to history."[18]

The plot, as ever, only thickens. As Voth persists obsessively in unraveling the mysteries of this text, his research is commandeered by

14 Karl Marx, *Capital Volume I*, trans. Ben Fowkes (London and New York: Penguin Books, 2004), 165.
15 Rosenberg, *Confessions of the Fox*, 155.
16 Ibid, 10.
17 Ibid, 200.
18 Ibid, 122.

shadowy bureaucrats, whose interest is itself invasive. Working under contract to P-Quad Inc., a pharmaceutical company with a hand in academic publishing, Voth is forced to comply with ludicrous demands upon his time and integrity. To the reader of both texts, P-Quad's proprietary designs on Voth's research clearly parallel those of the novel's chief villain, the Thief-Taker Wild, upon Jack. Not only does Wild seek revenge for a perceived humiliation, corresponding to the motivation of his *Threepenny* counterpart, Jonathan Peachum; he is also looking to corner the market in a testosterone elixir that Jack has unwittingly, then cravingly, lifted in a recent heist. This "strength gravel," developed by a cast of mutineers along the course of colonial accumulation, could as soon affirm one's being as enrich its only vendor at market, and Wild's stake consists solely in the latter.[19] In Rosenberg's fictionalized account, the autonomy of queer and trans life is negatively implicated in the privatizing drive of capital from its earliest emergence.

Containing Multitudes

Put differently, the history of capitalism is nothing but a history of resistance, collective in its very essence. As Voth attends to the irregularities of the Sheppard manuscript, he begins to sense a hydra-headed multiplicity to its address. It soon becomes clear that these pages are not so much a time capsule as an intergenerational collaboration, subject to alteration in underground circulation by nameless guerrilla scholars. In this, the historical plot converges upon the contemporaneity of the text.

This Pynchonesque twist turns a niche artifact into a trans-historical manifesto for radicals; a textual embodiment of queer community spanning centuries, whose practices of inter-annotation ambiguate the fixity of any inherited record. This speaks to the readerly necessity of interpretation, too: compare John Keene's *Counternarratives*, which allows a first-person account of slave revolt in a religious outpost, dated 1630, to quote from the work of Audre Lorde. As any historical record is itself a product of power, retroactively secured, the revolutionary must bring their own strength and intellection to bear

19 Ibid, 220.

on the illusion of distance and fixity. In an address to the reader, Voth explains: "I've come to the inescapable conclusion that the confessions of Jack Sheppard contain, as they say, *multitudes*," echoing the Spinozist trope of an absolutely general social body. "Put more simply, they are not exactly a singular memoir. They are something else."[20]

This "something else" confronts what scholar and activist C. Riley Snorton calls "the problem of history as a mode of organizing time according to antiblack and antitrans 'rule,'" which operates at the very inception of civil society.[21] Accordingly, the archive Voth uncovers is not simply a vehicle of representational novelty, but intervenes in the matter of history. Here textual integrity entails fidelity to an idea, without which any document would remain closed and archaic. As seen, apocryphal events may prompt important application in the present, to which end *Confessions of the Fox* functions in several registers—as popular history, as softcore pornography, and most importantly, as political agitation. That these purposes frequently coincide speaks to something on the order of utility, and to the capacity of language to move bodies.

Sentimental Solidarity

If the political calling of the novel is to encapsulate historic change, the problem of the genre's own historicity remains. This was Brecht's misgiving: that a representational means may be too closely bound to the conditions that it would depict. Throughout *Confessions of the Fox*, Rosenberg plays within this tension, eventually imagining a text that changes, too; an epic in its occasions rather than in incident. The revolutionary presentism of the novel, which asserts that Jack and Bess are our contemporaries, that their struggles are our own, must be contrasted with an inert historicism that assigns to everything its isolated place, as though history were so many books and not a movement.

This reading bears directly on the present; and as surely as reality changes, *Confessions of the Fox* is an historical novel for our time—repeating neither the dialogic realism that Lukács prescribes, nor the

20 Ibid, 259.
21 C. Riley Snorton, *Black on Both Sides: A Racial History of Trans Identity* (Minneapolis: University of Minnesota Press, 2017), ix.

carnival of formal elements one may idealize as Brechtian, but nonetheless thick with occasions for radical critique. As Dr. Voth discovers, this book, like the history that it depicts, remains unfinished; and a spirit of revolutionary futurity puts the onus of a happy ending on a reader's politics.

As long as the state escalates violence, legislative and otherwise, against queer and transgender people; as long as mass incarceration persists at unprecedented rates; as long as colonialism effaces the earth and displaces whole cultures; and as long as people own nothing of the wealth that they create, stories such as that of Jack and Bess are of pressing importance—for every detail of their world that one may recognize as more or less the same today screams only of the need for total change.

The Metaphysical Detectives

Guilt, Grace, and Gaze Throughout the World of *Twin Peaks*

In a 1948 essay, "The Guilty Vicarage," poet W.H. Auden confesses his addiction to the detective novel. "The symptoms of this are: Firstly, the intensity of the craving … Secondly, its specificity—the story must conform to certain formulas … And, thirdly, its immediacy. I forget the story as soon as I have finished it, and have no wish to read it again." Because of the compulsive behavior that such books encourage, Auden decides, they "have nothing to do with works of art."[1] No sooner has he declared literary disinterest in the genre, however, than he proceeds to redeem his vice in high Freudo-Anglican style:

> The interest in the thriller is the ethical and eristic conflict between good and evil, between Us and Them. The interest in the study of a murderer is the observation, by the innocent many, of the sufferings of the guilty one. The interest in the detective story is the dialectic of innocence and guilt.[2]

1 W.H. Auden, "The Guilty Vicarage," in *The Compete Works of W. H. Auden, Volume II: Prose: 1939–1948*, ed. Edward Mendelson (Princeton: Princeton University Press, 2002), 262.

2 Ibid.

The standard murder mystery, Auden suggests, may be formalized as an allegory of the Fall. The format is straightforward enough: a closed community, unspoiled for being so, goes about its business, until a crime occurs that forces its participants to shed this illusion. Not only is the mythic innocence preceding banished by this irruptive, as yet unattributable, act; there follows a suspenseful moment during which everyone must bear the moral repercussions equally. For as long as the identity and motive of the murderer remain unknown, guilt is distributed throughout the populace. Everyone appears a probable killer, albeit for their different reasons, all of which are plausible enough. What is required for redemption of the townsfolk, head by head and as a social whole, is the assumption of guilt by an individual. By this time, however, the investigation will have shorn the townsfolk of their collectively professed innocence.

The restoration of tranquility requires a sacrifice. In Christian scripture, Christ dies on behalf of humanity, damned from shortly after creation. A staunch trinitarian might observe the ultimate identity of accuser and proxy accused, but otherwise, the metaphysical detective is a late inquisitor who gifts the township ontic innocence whilst corroborating an ontological guilt. The murder mystery that Auden describes is a miniature that proceeds by totalization; and thus appears parochial only in order that every disturbance be distributed absolutely throughout.

Who Killed Laura Palmer?

The television series *Twin Peaks* is set in the fictional town of Twin Peaks, a peripheral setting closely resembling Auden's ideal village. Local affairs are broken by odd intimations of a world beyond: foreign investors in pursuit of business opportunities, or, as urgently, federal agents sent to investigate a murder. By the time of a viewer's arrival on the scene, the entire situation of the show has crystallized around such a disturbance, and a corresponding question: Who Killed Laura Palmer? Defying procedural expectations, this question looms for a full season and a half, and perhaps longer: the killer's ontological status remains uncertain, his power assured to exceed the lifespan of those he possesses. The question Who Killed Laura Palmer? indexes and conditions the social link in Twin Peaks. All of the township asks and is

accused at once; and the investigation threatens to out any number of banal transgressions, as it confronts each individual with the necessity of being seen.

So how do we see the people of Twin Peaks? "The characters in a detective story [should be] eccentric (aesthetically interesting individuals) and good (instinctively ethical)," Auden reminds us, which precludes neither mischief nor malfeasance.[3] One distinction of *Twin Peaks* is to permit its characters something more precious than innocence, which they are not, as no one is; rather, it affords the murder's retinue the dignity of their desires. A soap-operatic intensity of scheming feeling drives the plot, more joyfully sordid than the slow-burn bafflers later to be branded Lynchian; as the writers, David Lynch and Mark Frost most notably, manage by rapid juxtaposition to achieve tone of unbearable levity. An infinitely transmutable evil stalks the woods, and yet this presence hardly distracts from the town's daily, and adulterous, affairs.

These banal fixtures furnish the show its trademark ambience; that of a dreamlike realism, a total confabulation in which each sign, however asinine, must be presumed articulate. There are two categories of object at hand here, red herrings and theatrical rifles, though the distinction between the two is only established in retrospect. This ambiguity spans airs of poignancy and menace, and seeds the obsessiveness with which viewers of *Twin Peaks* swap trivia in the truest sense, as trivialities tempting future aggrandizement; or, to etymologize for a moment, as object-nodes that are themselves a crossroads between worlds.

Auden states that there are five elements to the detective story: "the milieu, the victim, the murderer, the suspects, the detectives."[4] The *milieu* we have discussed and will return upon. It is inventoried by the question Who killed Laura Palmer? Laura is the emblem of the show for fulfilling the contradictory requirements of literary *victimhood*, as put forth by Auden: "[She] has to involve everyone in suspicion, which requires that he be a bad character; and he has to make everyone feel guilty, which requires that he be a good character."[5] Of all the physical doubles that proliferate throughout the worlds of David

3 Ibid, 264.
4 Ibid.
5 Ibid.

Lynch, the most important are those pairs divergent in desire but identical in name and body. The *killer* must be one who reserves the right of omnipotence, who is willing to transgress the most basic socially constructive prohibitions: little wonder that debauched father figures abound behind closed doors, across the border, or beyond curtains. The *suspects* are "a society consisting of apparently innocent individuals, i.e., their aesthetic interest as individuals does not conflict with their ethical obligations to the universal. The murder is the act of disruption by which innocence is lost, and the individual and the law become opposed to each other."[6]

The most important detail as it bears on *Twin Peaks* is the role of the detective, who represents an ethical ideal in contradistinction to the aesthetic turmoil of his or her surroundings. "In either case, the detective must be the total stranger who cannot possibly be involved in the crime; this excludes the local police and should, I think, exclude the detective who is a friend of one of the suspects."[7] The tension between the aesthetic and the ethical maps onto the contradiction between the salvific figure of the detective and the inertial, maybe culpable, institution of the local police.

This convention demands the implacably wholesome Dale Cooper's appearance in Twin Peaks, whose love affair with his newfound surroundings contradicts his allegorical bearings. If anything, his gradual integration into the life of the town foreshadows his decades-long arrest in nether-regions of reality. Cooper defies the expectation that once the mystery is resolved and innocence restored, the law is supposed to retire.

This is precisely what does not happen after the close of the initial case, when Cooper is stripped of rank and plans to stay on as a resident in Twin Peaks, having become happily acclimated. Such contentment is an unsuitable development from the standpoint of the law, and Cooper's retirement plans culminate in his captivity in the room beyond the woods. Much of the action, and the stalemate endured by viewers for two-and-a-half decades between seasons, proceeds from the false ending of the investigation by familiar standards. Innocence was not restored in customary fashion, but a sacrifice was nonetheless required.

6 Ibid, 266.
7 Ibid.

Waiting Rooms

The time of the resurrection, of the event consummating the revelation, is that of a foreclosed-upon chronology. This time corresponds to an interval between two events, the latter of which will secure the meaning of the first. "I'll see you again in 25 years," Laura Palmer says to Dale Cooper in the final episode of season two, a quarter century before the anticipated return.

By the time of *The Return*, *Twin Peaks* is no longer economized after the fashion of a television soap opera. Throughout the original run, resurrectionary time—a time for the kindling of fervent belief in between two equally impossible events, corresponding to the cultivation of fanaticism or fidelity—was regulated from week to week by the serial form. This suspense was only concentric of the climactic break enacted by each cut from subplot to subplot, character to character, intrigue to intrigue.

Twin Peaks: The Return is set in the time of waiting. Or rather, in a space of waiting properly called time. A young man sits in a concrete

Fig. 26. Snoqualmie Falls, Snoqualmie, King County, Washington.
(National Park Service, Library of Congress Prints and Photographs Division Washington.)

room watching for something, who knows what, to appear before him, behind glass. Elsewhere, the detective whose return ensures our interest sits placidly in an armchair, receiving counsel from the dead. As has become Lynch's trademark over the intervening years, long takes and pregnant silence, all manner of visual and aural static, escalate to near-unbearable intensity by way of a viewer's excessive interestedness. Nothing becomes something before one's eyes and ears, only to recede once more into the doubtful terrain of moot detailing. A lushly evocative soundscape enfolds what scant dialogue appears. Angelo Badalamenti's distinctive score, a character unto itself, arrives late to the scene, and in the meantime the viewer endures a feeling of emptiness in repletion, or the opposite: depth signifying lack. Silence doesn't exist except in relation to stimulation, and Lynch befuddles typically exclusive regimes of formal austerity and sensuous aestheticism by eerie juxtaposition.

Discoveries and Secrets

Deleuze and Guattari differentiate between literatures of secrecy and discovery, closely associating each of these modes with the novella and the tale respectively. This distinction has to do with temporal foreclosure, for the time of the novella is suspended in retrospect of a reader's interest: "Everything is organized around the question, 'What happened? Whatever could have happened?'"[8] By contrast, the tale, however fatalistic (formulaic, even), impels the reader forward: "an altogether different question that the reader asks with bated breath: What is going to happen? Something is always going to happen, come to pass."[9]

Perhaps the seam between seasons one and two of *Twin Peaks*, still divisive of opinion, corresponds to this distinction. Season one addresses the township as so many pre-established secrecies. Season two, which resolves the initial mystery by episode nine and promptly devolves into a cat-and-mouse game between Dale Cooper and his nemesis Windom Earle, tempts its viewer with revelation after revelation. And much has been made of the 1991 finale, directed by David

8 Gilles Deleuze and Félix Guattari, *A Thousand Plateaus: Capitalism and Schizophrenia*, trans. Brian Massumi (London: Continuum, 2004), 212.
9 Ibid.

Lynch after a fourteen episode absence, which draws a veil of obtuse symbolism around an increasingly corny caper, restoring the plot to unbreachable secrecy.

Fire Walk With Me, a feature-length prequel released after the cancellation of the television show, is split down the middle in analogous fashion. Like Lynch's *Lost Highway*, it is two more or less separate movies, abandoning an established plot mid-course never to return. The film deepens the mystery for the first third or so of its running time, before abruptly embarking on an over-vivid play-by-play of what we already know to have transpired, corresponding precisely to eye-witness accounts from the pilot episode. This sequence capitulates to the spectacular in its straightforward representation of sexual violence, which otherwise remains on the side of the properly unrepresentable for much of the series.

Fire Walk With Me approaches the format of the television procedural, which typically begins with a graphic depiction of the crime, even revealing the identity of the perpetrator at the outset, only to let the detectives in on their established identity gradually throughout. The viewer is placed on the side of the villain as much as the detective, which idealized conflict pardons the social element enveloping both charismatic actors. The procedural reassuringly depicts a "mind-your-business" ethic, by which structural innocence is assured. With the appearance of Windom Earle in Twin Peaks, the original series veers dangerously close to this motionless dualism, where no one's position is importantly altered over the course of events. Tellingly, the series lapses into the irredeemably banal metaphor of a game of chess for the duration of their mutual antagonism.

Auden's ideal detective story is not marked apart from such tales of good-versus-evil for that it relativistically dispenses with these judgements; rather, for a suspenseful moment commensurate with the time of reading, these identifications are uncertain. Notably, one of Auden's own requirements of the detective story is that he may forget the plot entirely upon completion, for in the end all is resolved without remainder.

Pending this relief, one proceeds deductively. "You will never know what just happened, or you will always know what is going to happen: these are the reasons for the reader's two bated breaths, in the novella

and the tale, respectively."[10] For Deleuze and Guattari, the novel integrates the two forms, novella and tale, "into the variation of its perpetual living present."[11] How novelistic is the world under discussion here? The present of *Twin Peaks* is belied by all manner of eerie phenomena, which allude to other times and spaces, and Cooper's own divinatory means of detection concern this extra-literary reality. Deleuze makes a special example out of detective literature:

> The detective novel is a particularly hybrid genre in this respect, since most often the something = X that has happened is on the order of a murder or theft, but exactly what it is that has happened remains to be discovered, and in the present determined by the model detective.[12]

The "model detective" is the literary personality par excellence, for as a kind of divine interloper in a closed community, he is more a reader of the book in which he appears than a character. Cooper's present collates multiple realities, and his character appears a crucial intervention in the detective genre and the novel form alike. Compare D.A. Miller's work on the nineteenth century novel as an oblique expression of new regimes of governmentality:

> Crucially, the novel organizes its world in a way that already restricts the pertinence of the police. Regularly including the topic of the police, the novel no less regularly sets it against other topics of surpassing interest—so that the centrality of what it puts at the center is established by holding the police to their place on the periphery.[13]

This, adapting Auden's terms, describes the difference between the fallen world of social realism and the punctured Eden of the detective story. Miller's nineteenth century novel presumes panopticism: the "closed circuit" of delinquent society portrayed by Dickens, for example, describes the quotidian intrigue of life in Twin Peaks, or any other Eden. Here the detective is extraneous; his presence disturbs the town

10 Ibid.
11 Ibid.
12 Ibid, 213.
13 D.A. Miller, *The Novel and the Police* (Berkley and Los Angeles: University of California Press, 1988), 2.

little more than the murder he is there to investigate. If anything, the murder of Laura Palmer threatens to upset the essentially delinquent character of the town's social functioning. In the case of detective fiction, where a police investigation centers the plot,

> its sheer intrusiveness posits a world whose normality has been hitherto defined as a matter of *not needing* the police or police-like detectives. The investigation repairs this normality, not only by solving the crime, but also, far more important, by withdrawing from what had been for an aberrant moment, its "scene."[14]

This explains the omnipresence of police throughout the essentially secular bourgeois novel, whose limited jurisdiction attests to "the existence of other domains, formally lawless, outside and beyond its powers of supervision and detection."[15] Within the economy of the nineteenth-century novel, the supernatural and the police are already formally allied on account of their transcendent status.

Police in the Machine

In his essays on nineteenth-century literature, Joachim Kalka relates the fascination of Friedrich Schiller with the supernatural detective story, as well as the police motif more generally. Kalka compares two works of Schiller's: *The Ghost-Seer*, a supernatural tale of conspiracy, and its proposed counterpart, a fragment entitled *The Police*. While *The Ghost-Seer* inventories a "vast machinery of deception," *The Police* sublimates this paranoiac feeling, offering a romantic view of state bureaucracy: "The fascinating thing about Schiller's Police is that the whole mass of conspiratorial secrecy that in *The Ghost-Seer* is still on the dark side, the side of evil, has passed to the good apparatus of state order," Kalka explains.[16]

For Kalka, Schiller's fragment preconfigures the crime novel; which genre, in his words, "tends to deify the detective and denigrate the

14 Ibid, 3.
15 Ibid.
16 Joachim Kalka, *Gaslight: Lantern Slides from the Nineteenth Century* (New York: New York Review of Books, 2017), 13.

police."[17] *Twin Peaks* certainly plays up this jurisdictional animus, which is ameliorated in the town of Twin Peaks by the mutual embrace of local law enforcement and the FBI. Cooper finds himself deputized over the course of a burgeoning friendship with the local sheriff, while the boorish obstinacy of Albert Rosenfield gives over to a stiff respect. Within genre conventions, this rapport denotes a synthesis of romantic individualism and romantic bureaucracy.

In this, *Twin Peaks* offers a model of ethical life exceeding small-town morality. *Fire Walk With Me*, on the other hand, retains the contradiction between outside investigators and local law enforcement as a limit. When Agent Desmond, an apparent protagonist, disappears without a trace, this represents the suppressive victory of the delinquent milieu over its exterior truth. Kalka presents Schiller in outline:

> A vast amount of action must be handled, and it must be ensured that the spectator is not confused by the great variety of incidents and the number of characters. There must be a guiding thread that holds everything together … [the characters] must be connected to one another directly or through the surveillance of the police, and finally everything must resolve itself in the audience chamber of the Lieutenant of Police.— The true unity is given by the police.[18]

The vocation of the police in Schiller's draft is to recuse the populace of complication and to gift them happiness. It is a transcendental institution, tasked with "unifying disparate realities."[19] At the start of *The Return* this station is abandoned. From panoramic shots of the New York skyline to the scrolling titles informing us which would-be suburban desert faces the viewer at a given moment, the conspiratorial coziness of Twin Peaks is blown open onto intimations of a cold globality. The police as a benevolent tool of surveillance, beholden to a socially concerned narrativist à la Schiller, are nebulized after Miller's description. The vertiginous panopsis of *The Return* concerns the absence of a central character or throughline, much as the violently corrupt institution of the police lacks a subjective or ethical principle apart from "power."

17 Ibid, 15.
18 Ibid, 9.
19 Ibid, 15.

The metaphysical police of *Twin Peaks* must be understood after this fashion, however difficult to square with the blameworthy and brutal institution of actually existing law enforcement. The relative racial homogeneity of the fictional setting would not be coincidental where this suspension of disbelief is concerned, as a negative condition of the village setting. The village is a place of ritualized harmony between the aesthetic and the ethical, individual will and general laws, to follow Auden closely. *Twin Peaks* depicts a peaceable relation between the detective and the police, and the police and the township—a relationship that must be sacrificially secured. Fredric Jameson finds these utopian desires at work in another acclaimed detective serial, *The Wire*. Jameson even praises the collusory culture that evolves within a small team of detectives after the intuitive transgression of one of its ranks:

> The lonely private detective or committed police officer offers a familiar plot that goes back to romantic heroes and rebels (beginning, I suppose, with Milton's Satan). Here, in this increasingly socialized and collective historical space, it slowly becomes clear that genuine revolt and resistance must take the form of a conspiratorial group, of a true collective.[20]

Of course, the fraternal propensity of an actual police to falsify evidence, perpetrate violence, and protect their own from outside inquiry is far from a model of utopian life but definitive of an irredeemable institution. Jameson's proposed allegory squares badly with reality, but this "becoming-detective" of the police is not unrelated to the dialectic of aesthetic and ethical interest that Auden ascribes to the Miltonic village mystery. The law must learn love, as love must replace the law. As Auden concludes, the detective story relies upon "the phantasy of being restored to the Garden of Eden, to a state of innocence, where he may know love as love and not as the law. The driving force behind this daydream is the feeling of guilt, the cause of which is unknown to the dreamer. The phantasy of escape is the same, whether one explains the guilt in Christian, Freudian, or any other terms."[21]

20 Fredric Jameson, "Realism and Utopia in The Wire," in *Criticism* 52, no. 3–4 (Summer/Fall 2010): 359–372.
21 Auden, "The Guilty Vicarage," 269.

Paradise Locked

In Freudian as well as Christian cultures, guilt originates the social contract. Consider Freud's myth of the Primal Father, whose despotic whims resemble the omnipotent delusions of the murderer in Auden's schematized detective novel. In Freud's fantastic description, an egalitarian society is erected in the stead of this tyrannical figure upon dispatch, on the condition that no one attempts to take his place. This accords with the Christian description of the "lawman" who must arrive from without to restore innocence to the fold, and eerily suits the vision of *Twin Peaks*, where so many family patriarchs are passing avatars of a collectively repressed depravity. As psychoanalyst Joan Copjec writes, "society is installed under the banner of the son who signifies the father's absence," an observation easily transposed from Freudian to gnostic tones.[22]

Book three of *Paradise Lost* begins with the following argument:

> God sitting on his Throne sees Satan flying towards this world, then newly created; shews him to the Son who sat at his right hand foretells the success of Satan in perverting mankind; clears his own Justice and Wisdom from all imputation, having created Man free and able enough to have withstood his Tempter; yet declares his purpose of grace towards him, in regard he fell not of his own malice, as did Satan, but by him seduc't.[23]

In spite of the free will of the offenders, the eventuality of the offense is perceived by an omniscient God at the time of their creation. Even before Satan has alighted upon earth, the choice of sin is foreseeable, such that "the Son of God freely offers himself a Ransome for Man" in humanity's infancy. At the outset of *The Return*, Cooper is held in a space between two worlds, a "false dissembler" at large in his stead. One needn't decide that Cooper is on a simple hero's journey; rather, one may observe a resurrectionary temporality, such that an ontological debt precedes any ontic intrigue whatsoever. The a priori

22 Joan Copjec, *Read My Desire: Lacan Against the Historicists* (New York and London: Verso Books, 2015), 13.
23 John Milton, *Paradise Lost* (London: Penguin, 2000), 52.

damnation of any Eden is a condition of being seen, therein or anywhere. The great corroborator of humankind's agency would be the romantic hero Satan, who in a sense was waiting in the garden at the time of God's creation.

Copjec describes another staple of detective fiction, the locked-room scenario, in which a corpse appears somewhere held to be unassailable, in a space to which no one has access, foreshadowing or following the example of a breached Eden. Copjec adapts Alfred Hitchcock's example of a scene where two men are examining an automobile assembly line, marveling at the perfection of its products, when suddenly a car door opens and a body drops out:

> Once the complete process of the car's production has been witnessed, "once the measures of the real are made tight, once a perimeter, a volume, is defined once and for all, there is nothing to lead one to suspect that when all is said and done," some object will have completely escaped attention only later to be extracted from this space. So, if no hand on the assembly line has placed the corpse in the car, how is it possible for another hand to pull it out?[24]

The Return sets forth at least three such scenarios, from very different viewpoints. A solitary young man sits in a secure loft above the New York City skyline, watching a glass box for something, he knows not what, to appear. In South Dakota, an inscrutable crime scene materializes like a puzzle in a locked apartment, covered in the fingerprints of a man who wasn't there. Most strikingly, the Cooper-Jones body swap depicts the locked-room scenario from an unexpected vantage. Dougie Jones, meat decoy, responds to his materialization in the Black Lodge as though the corpse on the assembly line itself: "That's weird," he reports on being whisked away.

The architecture of *The Return* may be described after the manner of what Copjec calls the "lonely room": "office buildings late at night, in the early hours of the morning; abandoned warehouses; hotels mysteriously untrafficked; eerily empty corridors; these are the spaces that supplant the locked room."[25] Something is in the room that shouldn't

24 Copjec, *Read My Desire*, 169.
25 Ibid, 191.

be there, but that something is the room itself. Evacuated of desire yet haunted, these are the chambers of irremediable secrecy that characterize the forerunner to detective fiction, supernatural horror, and its morally ambivalent relative, noir. Kalka makes this case for Schiller's fiction, and as Auden suggests, the detective story is already a secular counterpart to the supernatural tale, where both secure normalcy by reference to an excess: a paranormalcy or impossible irruption.

Exceptions

For Auden, the detective story narrates a dialectical remediation of individual and society after such time as the two have entered into opposition. In this respect, though the detective story must be counterposed to the police narrative, Schiller appears to insist that the latter (non)genre is absolutely prior, as it (negatively) constitutes the order to be disturbed. Miller's agreement is logical, not genealogical: "Historically, it would be absurd to derive the novel from the detective story, whose 'classical' period of development neither precedes nor even … coincides with the novel's own. More accurately, the detective story first emerges as an aborted function *within* the novel," one that exceptionalizes the role of the detective in order to establish lateral relations of guiltless scrutiny.[26]

Copjec observes that the suppression or dispatch of the Primal Father inaugurates a culture of benign surveillance, which describes the closed society of the novel in Miller's Foucauldian study. Problems of political modernity—which is to say, of constitutive enumeration—resound throughout the genre of detective fiction "which, classically, begins with an amorphous and diverse collection of characters and ends with a fully constituted group."[27] Political identity, says Jacques-Alain Miller, as the formal self-identity of the citizen, is necessarily *sutured* by reference to an excluded element. Likewise, writes Copjec,

> the group forming around the corpse in detective fiction is of this modern sort; it is logically "sustained through nothing but itself." The best proof of this, the most telling sign, is the

26 Miller, *Paradise Lost*, 51.
27 Copjec, *Read My Desire*, 172.

fiction's foregrounding display of the performative: in classical detective fiction it is the narrative of the investigation that produces the narrative of the crime.[28]

This describes the scenario of *Twin Peaks*, as a self-reflexive instance of the detective story. The question Who Killed Laura Palmer? inventories the characters of Twin Peaks, whose mischief is of equal interest to the murder. What conveys so many isolated trysts and transgressions to one another, however, is their possible relation to a master signifier that at no point appears. "Laura," one suspect whispers furtively, as another screams grief stricken. This invocation binds the whole, in the absence of the thing it names. "But if the relations among the suspects are differential," Copjec asks, "what then is their relation to the corpse?"[29]

At this point, content inculpates structure. *Twin Peaks*, like *Blue Velvet* before, appears to relish its depictions of violence against women. By depicting violence, an author lazily conveys to the viewer that the perpetrator is irredeemable, thus may be sacrificed with relish and impunity. Leo Johnson is a pariah of this type; as is Frank Booth, and more recently, Richard Horne. The moralizing double transgression of the revenge motif can only operate within an economy of jouissance. In any case, one must assume responsibility for the depiction in its originality: "it is the narrative of the investigation that produces the narrative of the crime."[30]

This narrative produces a group, which it consolidates only insofar as a final signifier is missing. This condition, says Copjec, underwrites detective fiction as well as romantic devotional, seeing as the absence of this final signifier, securing all that came before, is also the cause for which there is no sexual relationship:

> This signifier, if it existed, would be the signifier for woman. As anyone with even a passing acquaintance with the genre knows, the absence of this signifier is evident in detective fiction not only in the nontotalizable space that produces the

28 Ibid, 174.
29 Ibid.
30 Ibid, 175.

paradox of the locked room but also in the unfailing exclusion
of the sexual relation. The detective is structurally forbidden
any involvement with a woman.[31]

The courtly soap opera of *Twin Peaks* renders this prohibition heavy-handedly. Cooper's undoing as a chaste ascetic follows his self-described lapses of judgement in love. He is lured to the Dark Lodge in pursuit of Annie, immediately after counseling Sheriff Truman back from the brink of madness; Truman having compromised one set of instincts for another by falling in love with a conspirator against him. In the traditional fraternal culture of the detective story, love inculpates the detective in the delinquent element from which he must be subtracted for the plot to hold together.

From a different angle, Jacqueline Rose discusses the anxiety that attends the appearance of a female detective, whose process of deduction produces a paranoid excess of criminal conspirators. This paranoia corresponds to a heightened cinematic awareness of the body of a woman, "reduced to the question of ... what is at stake in constituting her as the object (and subject) of the look."[32] The female detective's attunement to a generalized obscenity is her unique credential, exemplified by the character of Diane throughout *The Return*, whose contempt for a bureaucratic law enforcement agency that has not only failed to protect her but sheltered her assailants places her beyond jurisdiction.

Throughout the first two seasons, Diane exists in name only, as the ubiquitous addressee of Cooper's daily monologue. This invisible role corresponds to the generic veneration of the beloved in courtly literature, and it is after this idealized distance that one should understand her traumatic encounter with Cooper's rapacious double, and her ambivalent reunion with a more temperate detective in the bleak finale. Diane's own violent subtraction from the plot, not to mention her eyeless captivity in the body of another, attest to a well-established structure. The motivational signifier "Diane" operates without referent, as a range of formal effects that contradict her assertions of

31 Ibid, 179.
32 Jacqueline Rose, *Sexuality in the Field of Vision* (New York and London: Verso Books, 2005), 220.

subjectivity. When Lacan stated provocatively that "la femme n'existe pas," he surely meant to demonstrate something like the difference between the "Diane" of microcassette and the Diane of her own desires, at large in the world during an uncounted interim. Most notably, the character's articulate refrain, "fuck you, Gordon" is addressed to the character of Deputy Director Cole, played by Lynch himself.

Cooper's love, like his reluctance to leave the town of Twin Peaks, proves fatal to his vocation as detective, which also happens to name the genre that *Twin Peaks* surpasses and perfects. The hackneyed antagonism between Windom Earle and Dale Cooper (Moriarty and Holmes) is compressed into and foreshadows an important structural coincidence more typical of noir; the ultimate identity of the detective and his or her quarry. Copjec describes how, as a function of the forbidden signifier binding the plot, pace is regulated by a "revolving door" dynamic, such that the detective and his or her other cannot occupy the same space. This structures the noir subgenre, wherein detection proceeds on the basis of identification: "it is argued that the detective comes to identify more and more closely with his criminal adversary until, at the end of the noir cycle, he has become the criminal himself."[33]

There is No Double of the Double

This is the fate that befalls Dale Cooper, whose blameless integrity as a character is visually secured by a physical double throughout *The Return*. Two Coopers, one good and the other evil, might appear simplistic on the face of it, but Lynch knows when more is better. For the True Cooper only partially re-enters the world in the shape of Dougie Jones, a third likeness and hapless cipher. This ridiculous figure triangulates the good-versus-evil dualism of the doppelgänger motif. What, after all, does it mean for so illogical an excrescence as a "third double" to appear? By conducting our sympathies in Dougie's direction, Lynch and Frost affirm that one may only be multiplied in one's physical aspect, while the spirit is elsewhere intact; thus giving the lie to the spontaneous visual morality of the double and *Twin Peaks* more generally.

33 Copjec, *Read My Desire*, 180.

Dougie Jones is a fleshly medium, shorn of guilt and awareness alike, enacting a childlike innocence that the double typically protects. In *The Double: A Psychoanalytic Study*, psychoanalyst Otto Rank speculates that this psychic projection originates from a desire for immortality. As for the later bearing of this omnipotent double upon its mortal likeness, Freud notes the irony that any figure meant to extend one's life is likely to be greeted as a deathlike omen.

The proliferation of doppelgängers throughout Lynch's filmography, and *Twin Peaks* especially, corroborates this feeling of dread. Otherwise, to resume a television series twenty-five years after its last episode makes every character a double of their past self in a real sense. But the recurrence of familiar faces must be read alongside the repetition of any number of other details: "Finally there is the constant recurrence of the same thing, the repetition of the same facial features, the same characters, the same destinies, the same misdeeds, even the same names, through successive generations."[34]

Freud's description of the uncanny double bears especially on Lynch's intervention in the detective genre, where the nightmarish return of the same corresponds to the constricting lineages constitutive of a too-familial small-town milieu. Furthermore, the structure of the detective story depends upon everybody being possibly other than they seem. For as long as the crime remains unsolved, every person must be regarded as an unreliable double of their would-be criminal equivalent. Early in *The Return*, Bill Hastings, a mild-mannered school principal, is not only unable to convince his wife that he is innocent of a grisly murder; he appears unable to entirely convince himself. Hastings sees himself as we see him, as an object of suspicion.

Lynch's films are themselves conjoined on the basis of eerie resemblances, where visual quotations accrue to an obsessional insistence. In addition to the inanimate cameos comprising his mise-en-scène, Lynch keeps the same stable of actors on retainer, exploiting the overdetermination of familiar faces with a keen understanding of cinematic transference. This is a formal postulate of film noir, which produces pangs of betrayal in a viewer by placing a face typecast "heroic" in

seedy straits, and Lynch appears to savour the discomfort of attach-ment developed over the course of a career.

Across recurrences, *The Return* summarizes not only the world of *Twin Peaks*, but all Lynchiana, suggesting that his long-term viewer has never left that world. The northwestern "vicarage" of Twin Peaks is situated as a kind of diorama in a fictional America, as soon encom-passing the California of *Lost Highway, Mulholland Drive*, and *Inland Empire* as it does the New York and South Dakota of *The Return*. As the affairs of a township are counterposed to those of a country far exceeding any panoramic overview in its logistical and supernatural extension, a viewer must concede the genre of detective story to its fallen equivalent, noir; which is to abandon any belief whatsoever in innocence, which postulates the integrity of a garden somewhere, or a correspondingly benign civic.

Private Gardens

Innocence is only ever fantastically secured, and typically borrowed at that. As Geoff Bil demonstrates, the scenery and symbolism of *Twin Peaks* is rife with appropriated and misplaced imagery associ-ated with Indigenous North American culture, and its metaphysical underpinnings rely heavily upon neocolonial cinematic tropes.[35] As Bil emphasizes, Annie Blackburn's environmentalist speech against the Ghostwood development quotes Chief Seeathl's partially apocryphal address upon the surrender of land in 1854. However strategically misquoted, this speech exacerbates the stakes of the village mystery; for not only does the proposed development stand in contradiction to Annie's holistic worldview, the entire town in its placement would be transcendentally suppressive. There is no pending re-unity, no cath-artic unveiling of localizable guilt, because the garden society in its fictive unity remains a violent culprit.

Where the relation of *Twin Peaks* to coloniality is concerned, Lynch employs many Western tropes alongside those of the detective story, similarly metaphysicalizing the frontiers upon which the genre

35 Geoff Bil, "Tensions in the World of Moon: Twin Peaks, Indigeneity and Territoriality," in *Senses of Cinema*, July 2016, www.sensesofcinema.com/2016/twin-peaks/twin-peaks-indigeneity-territoriality.

depends.[36] The peripheral setting of the Western depends upon a contrastive threshold, in order that a romantic (or Satanic) outlier may pursue their own redemptive purposes. In this respect, the Western inverts the values of the detective story: rather than a romantic detective-interloper redeeming a closed society, a prodigal figure proves the disunity of an uneasy social unity. This all-American genre presumes hypocrisy of its mercenary actors, and its colonial bad faith consists as much in the fallenness that it depicts as in its racist caricatures.

The cruelty and discomfort of *The Return* has everything to do with that it is set in an atonal world, a world without a master signifier. And this signifier is strikingly not Laura Palmer in this case, but the detective Dale Cooper himself. For the avid viewer, his disappearance creates a traumatic rend in a familiar setting. Cooper's bodily multiplication illustrates as much, and the expanded geography of the television show mirrors this vertiginous worldlessness. Quite literally, Cooper has been established as both an object of sacrifice qua criminal excrescence and the agent of deliverance qua detective, who is always and necessarily newly arrived on the scene.

For the residents of Twin Peaks circa *The Return*, the mention of Cooper's name is greeted with slow or stoical recollection. They do not know what has befallen him, but nonetheless experience an emptiness or lack. The Log Lady offers Hawk as much: "something is missing and you have to find it." That something is perhaps less purloined than misplaced, while a surfeit of incompatible theories prevents the viewer from discovering a message already in receipt.

Very quickly, *The Return* becomes a show about the time of watching *Twin Peaks*. For all of their withholding silences, Lynch and Frost stage reunion after reunion with a lunatic generosity, resolving decades old affairs with real feeling. Blurring digital video art and lush photography, Lynch enacts physical violence upon the image rather than the actor, who is more likely to vanish from the screen upon expiry than

36 There is much to unpack in the relationship between Deputy Hawk and Sheriff Truman's offices where these conventions are concerned, more than this essay may approach with any sensitivity, but it seems fair to suggest that the "metaphysical police" of *Twin Peaks*, particularly where their company accords with the panshamanic calling of Dale Cooper, are again supposed to represent a kind of harmony between agencies or cultures that are otherwise in narrative, and political, contradiction.

to mime the throes of death. And the younger generation that congregates inside the roadhouse may as well be gathered at their TV sets, thrilled to participate in the church of an institution.

When Cooper reappears to rescue Laura once and for all, traveling through time to lead her away from the scene of her own murder, he understands his action to endanger everyone's consistency, and warns his friends as much: "There are some things that will change. The past dictates the future." By resolving the mystery in advance, Cooper revokes the condition that constitutes the fictional town. Leading Laura through the woods and away from the scene of the crime, Cooper assumes an Orphic figure, whose sin is reminiscence rather than hindsight per se. Cooper has Laura too much in mind, and when the finale depicts her likeness in a state of poverty-stricken purgatory, it becomes clear that his attempt to surgically alter events has failed in retrospect of our fascinated viewership.

In "Laura's" final scream, Lynch issues an incredible thesis as to the self-referential reality of trauma, which doesn't require the authorization of an original event. As Lacan remarks, repression and the return of the repressed coincide. Cooper has ventured back in time, eradicating the symbolic basis of the world in which he has been living, of which the viewer is an only witness. The last sound that reverberates is an affective remainder of an experience that has narratively revoked, such that it can no longer be addressed.

The Guilty Vicarage

Many of Auden's observations from *The Guilty Vicarage* are echoed in a passage from *New Year's Letter*, to reiterate his thesis briefly in rhyme:

> Delayed in the democracies
> By departmental vanities,
> The rival sergeants run about
> But more to squabble than find out,
> Yet where the Force has been cut down
> To one inspector dressed in brown,
> He makes the murderer whom he pleases
> And all investigation ceases.

Yet our equipment all the time
Extends the area of the crime
Until the guilt is everywhere,
And more and more we are aware,
However miserable may be
Our parish of immediacy,
How small it is, how, far beyond,
Ubiquitous within the bond
Of an impoverishing sky,
Vast spiritual disorders lie.[37]

The organization of *Twin Peaks*, as a mystery that mustn't be solved, accords as well with a better known and considerably less anxious poem by Auden, *Musée des Beaux Arts*. The poem offers an ekphrastic commentary on Pieter Brueghel's painting *The Fall of Icarus*, in which Auden finds the "human position" of suffering affirmed as something daily and horizonal, no cause for which to skip one's morning coffee. If Brueghel's propensity to embed catastrophic narrative detail in a teeming and indifferent landscape is pertinent—think of the opening credits to *Twin Peaks*, surveying a natural sublime which dwarfs the human scale of melodrama—it is only because the landscape gathers around such an integral detail. In *Twin Peaks*, "everything turns away quite leisurely from the disaster," because the disaster is the condition of indifference itself.[38] It is this barely perceptible rend, occasioning the morbidity of the gaze, that Lynch directs over and over again.

But in the first case this composition has a name, one that the trees whisper, one from which everything proceeds; and the failure of this binding detail to appear is both a limit to interpretation, let alone enjoyment, and the enabling condition of both. As Lynch withholds this term to set a world in motion, it seems right to consider the cosmology of fallenness that underwrites any fantasy of repair. But until that indefinitely delayed reunion, our viewership continues to attend these scenes of trauma as a kind of church; which is to acknowledge a certain guilty interest in the first place.

37 W.H. Auden, *Collected Poems* (New York: Random House), 203.
38 Ibid, 179.

Acknowledgements

"Zac Descending" appeared in *The Believer Logger*, June 2017. Thanks to Hayden Bennett for soliciting and shepherding this work.

"Book-Sex and Multi-Specificity" was written in 2017 for a collaborative zine called "Five Extremities of the Nineteen-Eighties," which remains unpublished. Thanks to Kay Gabriel, David W. Pritchard, Andy Robinson, and Zach LaMalfa for their contributions and dialogue with this piece.

"The Hospital of History" appeared in *Blind Field Journal*, April 2019. Thanks to Max Fox for the lovely translation of the work under discussion, and to Jo and the Blind Field Collective.

"What characterizes a god?" appeared in *Berfrois*, April 2020. Thanks to Russell Bennetts and Amanda Gersten.

"Extreme Remedies" appeared in *Social Text* as part of an online folio dedicated to the work of Kevin Killian, May 2020. Thanks to Marie Buck for assembling this collection and including this work.

"Writing Drawing/Drawing Writing" appeared in *Berfrois*, June 2018. Thanks to Russell Bennetts, as well as Coach House Press, Ugly Duckling Presse, Siglio Press, Wave Books, and Christopher Stackhouse for their generous permissions.

"Limited Omniscience and Militant Secrecy" originated as a presentation at the conference "Apolitical My Ars," hosted by the Philadelphia Avant-Garde Studies Consortium, December 1, 2017. Thanks to the co-panelists and PASC for the hospitality.

"Supply Chain Tanka" appeared in *periodicities: a journal of poetry and poetics* in August 2020. Thanks to rob mclennan for the invitation, and Mark Nowak and the Worker Writers School.

"Thanksgiving" appeared in *The Poetry Project Newsletter* #261. Thanks to Kay Gabriel for the invitation and enthusiastic edits, and Christopher Catanese of Golias for getting the book to me in multiple media and multiple countries.

"Sun on the Avant-Garde" appeared in the *Full Stop Newsletter*, September 2019. Thanks to Rachael Guynn Wilson for the book, and Helen Stuhr-Rommereim for the helpful edits.

"Writing Multitudes" appeared in *The Believer Logger*, October 2018. Thanks to Hayden Bennett for the space and impetus.

"The Metaphysical Detectives" appeared in *Sonder Magazine*, now *New Critique*, June 2017. Thanks to Josh Mcloughlin.

This book wouldn't exist without the careful work of Irene Bindi, for which I'm eternally grateful. Many of the essays would not exist were it not for Kay Gabriel and Hayden Bennett, who commissioned much of this work and provoked its content over the course of many conversations. Sasha Amaya, Christina Chalmers, Claire Donato, Ryan Fitzpatrick, Emily Janakiram, Mia Kang, Nora Kipnis, Landon Gray Mitchell, Kendra Place, Colin Smith, Janelle Trenaman, Bonnie-May Wadien, and Madeleine Watts gave life and context to this work over the years it takes to gather a sustained thought. Thanks to Scott Fitzpatrick for the cover artwork, Terry Corrigan for the design, Taryn Sirove for proofreading, and Matthew Stadler and Tobi Haslett for their generous words. I'm grateful to Todd Besant and Bret Parenteau of ARP Books for all of their work on this book and beyond. Thank you to Lynn and Bruce Popham for everything.

Many other people were part of the formation and reception of these texts, and though I am sure to forget some names, warm thanks to: Andrea Actis, Jonathan Ball, Vannessa Barnier, Jacob Becker, Dodie Bellamy, Sarah Borbridge, Kelsey Braun, Marie Buck, Erin Buelow, David Buuck, crys cole, Rob Crooks, Charlene Diehl, Stephane Doucet, Ian Dreiblatt, Pam Dick, Jackie Ess, Jessica Evans, Joel Robert Ferguson, Angela Forget, Max Fox, hannah_g, Jay Gaunt, David Glickman, Maxine Gordon, Joseph Grantham, David Grubbs, Shuja Haider, Marie-France Hollier, Billy Hough, Stephen Ira, Talitha Kearey, Will Keyes, Kirby, Danielle LaFrance, Zachary LaMalfa, Katie Long, Simone Mahrenholz, Janis Maudlin, Amye McArthur, rob mclennan, Joel Mierau, Sam Neal, Greg Nissan, Mark Nowak, Geoff Olsen, Paul Phillips, Matthew Pieknik, Casey Plett, Colin Popham, Elizabeth Popham, David W. Pritchard, Andy Robinson, Benjamin Robinson, Dan Ryckman, Eric Schmaltz, Caycie Soke, Laurel Squadron, Cheryl Pearl Sucher, Andy Taylor, John Toews, Rachel Valinsky, Joe Warkentin, Sam Weselowski, Gleb Wilson, James Wilt, Naomi Woo.

Special thanks to all of the writers and artists discussed throughout these pages for their work, without which there wouldn't be anything for me to say.

Cam Scott is a poet, critic, and non-musician from Winnipeg, Manitoba, Treaty 1 Territory. He is the author of the poetry collection *ROMANS/SNOWMARE* (ARP Books, 2019) and the chapbook *WRESTLERS* (Greying Ghost, 2017).